UNDERSTANDING EXPOSURE
3RD EDITION

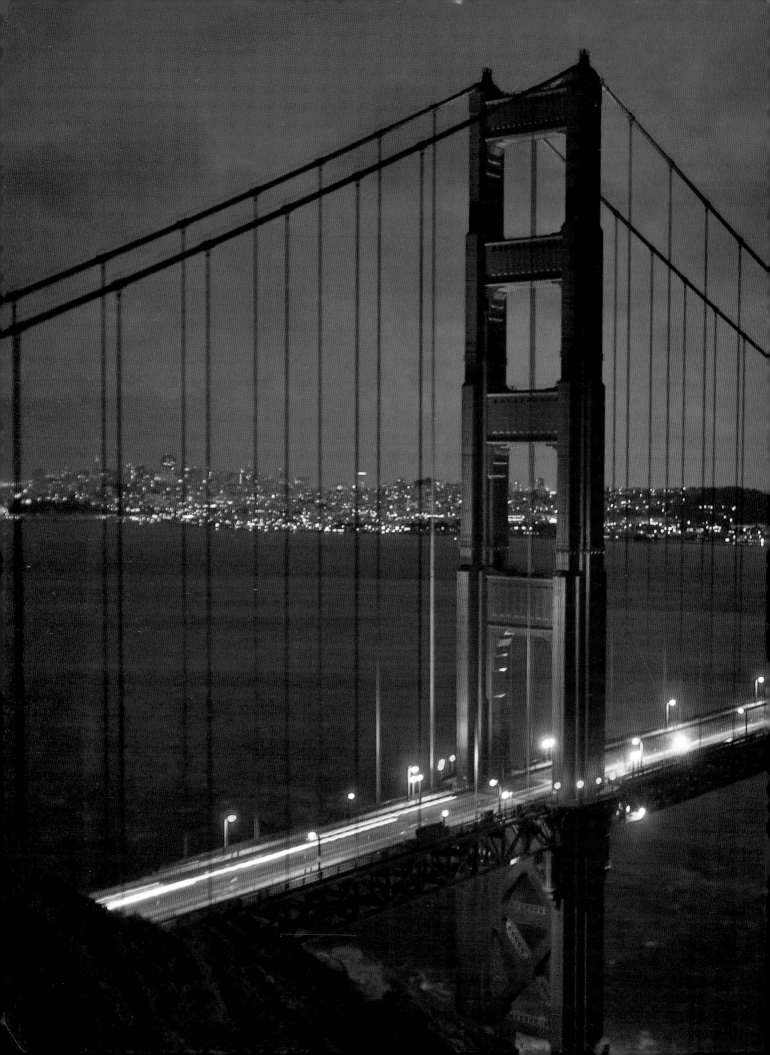

UNDERSTANDING
EXPOSURE

3RD EDITION

How to Shoot Great Photographs with Any Camera

BRYAN PETERSON

AMPHOTO BOOKS

AN IMPRINT OF THE CROWN PUBLISHING GROUP/NEW YORK

ACKNOWLEDGMENTS

Clearly, I would not have the successful author's life without the full support of the following people who, for reasons perhaps known only to them, just keep on believing in me: Victoria Craven; Julie Mazur; and my incredibly patient editor, Alisa Palazzo; and Bob Fillie, the best darn graphic designer in New York!

Page 1: 70–200mm lens at 120mm, ISO 100, 1/3 sec. at f/14
Pages 2–3: 28–70mm lens at 28mm, ISO 200, 2.5 seconds at f/8
Page 5: 28–70mm lens at 32mm, ISO 200, 1/13 sec. at f/14
Pages 6–7: 17–55mm lens at 20mm, ISO 125, 1.6 seconds at f/2.8
Pages 8–9: 12–24mm lens at 14mm, ISO 100, 2 seconds at f/5.6
Page 10: 17–55mm lens at 22mm, ISO 125, 6 seconds at f/14
Pages 12–13: Nikon D2X, at 15mm, ISO 100, f/4
Pages 40–41: 70–200mm lens, ISO 100, f/22 for 1/125 sec.
Pages 78–79: 70–200mm lens at 175mm, ISO 125, 1/320 sec. at f/2.8
Pages 100–101: 75–300mm lens at 300mm, 1/60 sec. at f/16
Pages 144–145: 12–24mm lens, nine-exposure multiple exposure with Lee Sunset filter

First published in 2010 by Amphoto Books, an imprint of the Crown Publishing Group, a division of Random House, Inc., New York.
www.crownpublishing.com
www.amphotobooks.com

AMPHOTO BOOKS and the Amphoto Books logo are registered trademarks of Random House, Inc.

Library of Congress Cataloging-in-Publication Data
Peterson, Bryan, 1952-
 Understanding exposure : how to shoot great photographs with any camera / Bryan Peterson. — 3rd ed.
 p. cm.
 Includes index.
 ISBN 978-0-8174-3939-2 (pbk.)
 1. Photography—Exposure. I. Title.
 TR591.P48 2010
 770.28—dc22
 2009043770

Printed in China

Design by Bob Fillie

10 9 8 7 6 5 4 3 2 1

Third Edition

Every photograph is a lie, but it is within that lie that a mountain of truth is revealed! And the climb toward that mountain of truth is greatly accelerated when one's steps are rooted in the simple understanding of exposure.

—BRYAN F. PETERSON

Contents

INTRODUCTION

On a recent field workshop, one of my students got wind of the fact that I was writing still another revision of *Understanding Exposure*: "Are you seriously writing another revised edition of *Understanding Exposure*?"

Considering I was working on the third edition, my initial response was a simple one: "You bet I am! And you know what they say, the third time's the charm!" His question was certainly a fair one, and my response was not an attempt to be flippant nor did it suggest that the first two attempts had fallen short of the mark—quite the contrary, in fact. I'm incredibly humbled by the sales of both the first and second editions of *Understanding Exposure*. And so perhaps the better question might be, "Why mess with a winning formula?" To be clear, I am not messing with the winning formula, but since the release of the second edition of *Understanding Exposure* in 2004, a great deal of change has taken place in the photo industry, and unfortunately, those changes—changes that imply a positive message about exposure—have, in fact, created even more confusion among photographers.

Still, I'm pleased to say that the formula (or what I call the Photographic Triangle) for successful exposure has not changed one iota since the inception of photography-or since I wrote the first edition of *Understanding Exposure* back in 1990—despite the digital age we're now living in, and will be living in for what I'm guessing is years and years to come. A correct exposure was, is, and will always be a combination of *your choice* of the right size hole in your lens (the aperture), the right amount of time this light is allowed to remain on the digital sensor (the shutter speed), and sensitivity to light (the ISO).

Back in the day, the pinhole camera proved to be a terrific tool for recording an exposure; it was much like a lightproof shoe box that held a piece of light-sensitive film and had a hole in it, and as far as I'm concerned, the digital cameras of today are nothing more than lightproof shoe boxes with a piece of light-sensitive "film" (the sensor) inside. Granted, they don't look like lightproof shoe boxes, but they perform in much the same way as those first cameras, albeit with the ability to record a single image a bit faster.

And yet despite these similarities, there are several reasons why I find it necessary to update *Understanding Exposure* yet again. Since 2004, when the second edition was published, the Digital Age was, in many respects, in its infancy. Now that the Digital Age has grown up, it's also fair to say that more shooters than ever before—especially those who are just starting out in photography—are more confused than ever before, and for this, I hold the camera manufacturers responsible.

In manufacturers' attempts to make so much of the picture-taking process automated, the once-simple manual cameras of yesterday are, in fact, today reminiscent of the cockpit of a Boeing 747. And I don't know about you, but I find the cockpit of a 747 amazingly intimidating! The once-straightforward shutter speed dial on the camera body and the aperture dial normally found on the lens have taken a backseat to dials that are crammed with "features" such as Landscape mode, Flower mode, Portrait

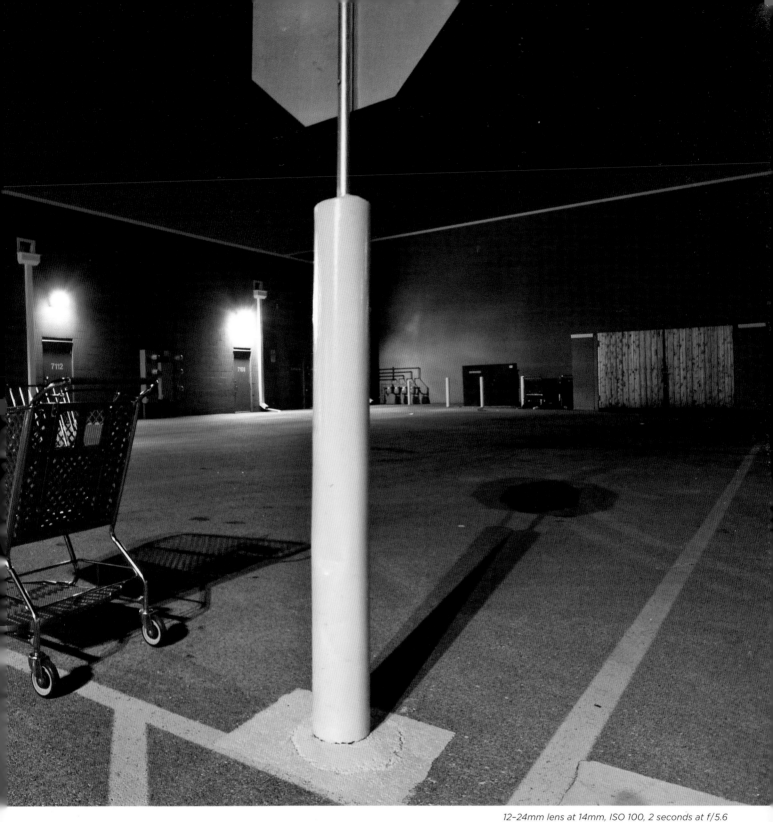

12-24mm lens at 14mm, ISO 100, 2 seconds at f/5.6

mode, Aperture Priority mode, Action Sequence mode, Sports mode, Group Portrait mode, Shutter Priority mode, and Program mode. There's even a Bee on Flower mode!

Combine all of that supposed automation with auto White Balance, auto ISO, and auto Flash, and you've got a *huge* recipe for frustration. Attesting to the frustration are the many shooters who've discovered that automation works only sometimes and only with some subjects. As my e-mail in-box shows on a daily basis, there's nothing worse

(or perhaps more embarrassing) for beginning photographers than when they're asked, after taking a really nice image, how they did it—and have absolutely no clue!

I recall with vivid detail one photographer who truly had a remarkable eye. She had only been shooting with her new Nikon D300 and her 18–200mm zoom lens for eleven months, yet she was receiving a great deal of attention from her peers. As the attention increased, so did the questions—namely, "How did you expose for that?" or

"How did you expose for this?"—and as the weeks turned into months, she found herself avoiding any discussions about her work, chiefly for one reason: She honestly did not have a clue how she did it. In fact, in her first e-mail to me, she credited "dumb luck" for much of her work, at least in the area of exposure. And she also expressed a great deal of frustration at not seeming to be able to "get her head around exposure." I, of course, suggested she start with a copy of *Understanding Exposure*, and it was about three weeks later that she wrote again, exclaiming that "it all makes such perfect sense! I get it, and I am shooting in manual exposure mode!" As every student in my online classes and in my on-location workshops soon learns, the only time I use the word *auto* is when I have a student named Otto.

Understanding exposure is *not* hard at all, as more than 300,000 photographers have already discovered. The only requirement is that you throw away your camera instruction manual *after* you reference it to learn one thing: how to set the controls to manual. And here's a clue: On every DSLR, you will find the symbol M, and when the dial is set to M, you're in the copilot's seat, about to go on your maiden voyage. Sure, setting your camera to M might seem scary at first, but no worries, since I, as the captain, am sitting right next to you. Then, following the first chapter of this book, you *will* be flying solo! And once you being to experience the freedom of truly flying on your own, you'll ask yourself, "What ever possessed me to think I couldn't make a manual exposure?" Honestly, it's that easy! With manual exposure, the world of truly creative exposures opens up, and not surprisingly, with each and every page you turn, you'll be enjoying even greater photographic journeys, as you soar from one location to the next!

In addition, in this third edition I've replaced over half of the photographs with new ones, which not only gives the book a freshened-up appearance but also enables me to broaden the covered topics. And to this end, I've also included two new and invaluable subjects that also have much to do with making successful exposures today: High Dynamic Range (HDR) photography and electronic flash. My important yet simply basic primer on the use both of your camera's electronic flash and of ring flash are invaluable for those of you who may one day migrate toward the world of macro photography.

HDR photography has been a real boon to many experienced shooters, as this method of image-making opens the door to a whole new world of "extreme" exposures, but as you will learn, HDR photography is still rooted in the basic fundamentals of the Photographic Triangle; in other words, HDR photography still relies on *you* to pick either the most creative aperture or the most creative shutter speed.

17–55mm lens at 22mm, ISO 125, 6 seconds at f/14

Flash photography is a subject that I've never addressed before in this book, and the reason was really quite simple: Most readers of the previous editions were inclined to do most of their picture-taking outside on weekend outings or their annual vacations, where the use of flash wouldn't normally come into play. And perhaps most of all, flash was, until a few years ago, a complex enough subject that it really needed its own book, so I reasoned that the subject of flash couldn't really be addressed in a few pages. Obviously, that has changed, and the ease of on-camera flash is now one of the things for which camera manufacturers really deserve credit. Simply put, automated through-the lens (TTL) flash delivers on its promise of "foolproof flash exposure" far more often than not, and the information I provide in this third edition of *Understanding Exposure* is just enough to get you started on the road of creative flash exposure.

And finally—and unlike the first and second editions of *Understanding Exposure*—this third edition will allow you, the reader, and I to have a much stronger connection, thanks in large part to the technology that exists today: namely the Internet and its offering of high-speed connections. I've put together a series of video streams that I know will not only serve to reaffirm what you're about to learn but that will also affirm the great progress that I know you'll be making in your pursuit of photographic excellence. Whether you struggle with finding the controls for manual or don't know what I mean when I say "I adjusted my shutter speed until a correct exposure was indicated" or are still not quite sure where to focus when shooting storytelling images or don't quite know how to handhold the camera when panning at slow shutter speeds or can't determine where to set the your exposure when shooting a sunset, there are video streams now available that will show you how.

In closing, keep in mind that you're not alone in the confusion or frustration you sometimes experience, and if you ever need someone to talk to, I would encourage you to get online with other like-minded shooters who participate daily in a public forum where just about anything photographic is discussed. Whether you have questions or wish to contribute an answer or simply want to upload photos for some honest feedback, simply go to www.ppsop.com/forum. Just like the video library, the forum is 100 percent free.

TO ACCESS THE VIDEO STREAMS

Access Bryan Peterson's *Understanding Exposure* video streams exclusive for readers of this book at www.ppsop.com/understandingexposure. After following a few simple prompts, the entire library of video streams on *Understanding Exposure* is yours for the viewing. These video streams are free, and you can view them as many times as you wish.

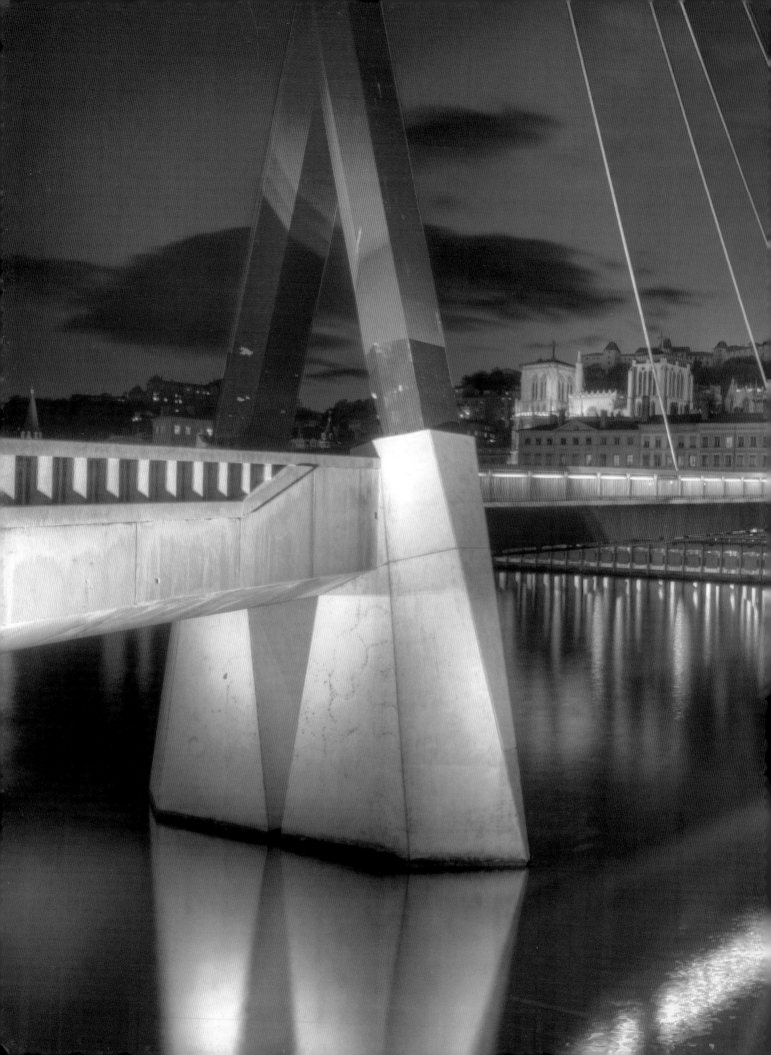

DEFINING EXPOSURE

What Is Meant by "Exposure"?

Just as it was 100 years ago, and just as it was in 1970 when I made my first exposure, today every camera—be it digital or film—is nothing more than a lightproof box with a lens at one end and a digital card or light-sensitive film at the other. The same light enters the lens (the aperture), and after a certain amount of time (determined by shutter speed) an image will be recorded (on digital media or film). This recorded image has been called—since day one—an *exposure*, and it still is.

Sometimes, the word *exposure* refers to a finished image: "Wow, that's a nice exposure!" At other times, it refers to the digital card or film: "I've only got a few exposures left." But more often than not, the word *exposure* refers to the amount, and act, of light falling on photosensitive material (either the digital card or film). And in this context, it comes up most often as part of a question—a question I've heard more often than any other: "Hey, Bryan, what should my exposure be?" (In other words, how much light should hit the digital media/film and for how long?) And my answer is always the same: "Your exposure should be correct!"

Although my answer appears to be flippant, it really is *the* answer. A correct exposure really is what every amateur and professional alike hopes to accomplish with his or her camera.

Up until about 1975, before many autoexposure cameras arrived on the scene, every photographer had to choose both an aperture and shutter speed that, when correct, would record a correct exposure. The choices in aperture and shutter speed were directly influenced by the film's ISO (speed or sensitivity to light). Most photographers' exposures would be based on the available natural light. And when the available light wasn't enough, they'd resort to using flash or a tripod.

Today, most cameras are equipped with so much automation that they promise to do it all for you, allowing photographers to concentrate solely on what they wish to shoot. "Just keep this dial here set to P and fire away! The camera will do everything else," says the enthusiastic salesman at the camera shop. Oh, if only that were true! Most—if not all—of you who bought this book have a do-it-all-for-you camera, yet you still find yourself befuddled, confused, and frustrated by exposure. Why is that? It's because your do-it-all-for-you camera *is not* living up to that promise, and/or you have finally reached the point at which you want to consistently record correct photographic exposures.

SETTING & USING YOUR CAMERA ON MANUAL EXPOSURE

I know of no other way to consistently make correct exposures than to learn how to shoot a fully manual exposure. Once you've learned how to shoot in manual exposure mode (it's really terribly easy), you'll better understand the outcome of your exposures when you choose to shoot in semi- or full autoexposure mode.

With your camera and lens in front of you, set your camera dial to M for manual. (If you're unsure of how to set your camera to manual exposure mode, read the manual!) Get someone to use as your subject and go to a shady part of your yard or a neighborhood park, or if it's an overcast day, anywhere in the yard or park will do. Regardless of your camera, and regardless of what lens you're using, set your lens opening to the number 5.6 (f/5.6). Place your subject up against the house or some six- to eight-foot shrubbery. Now, look through the viewfinder and focus on your subject. Adjust your shutter speed until the camera's light meter indicates a "correct" exposure in your viewfinder and take the photograph. You've just made a manual correct exposure!

Operating in manual exposure mode is empowering, so make a note of this memorable day!

THE DO-IT-ALL CAMERA often falls short of its promise, yielding disappointing results (top). Use your camera's manual settings (bottom), or at the very least, know how light and dark interact on digital media or film so that you can be assured of getting it right even when you're in autoexposure mode. (Note: To determine the successful exposure, I moved in close to the subject and took a meter reading off his face; I then backed up to reframe and make the exposure.)

Both photos: 35–70mm lens at 35mm. Top: f/5.6 for 1/500 sec. in Program mode. Bottom: f/5.6 for 1/90 sec. in manual mode

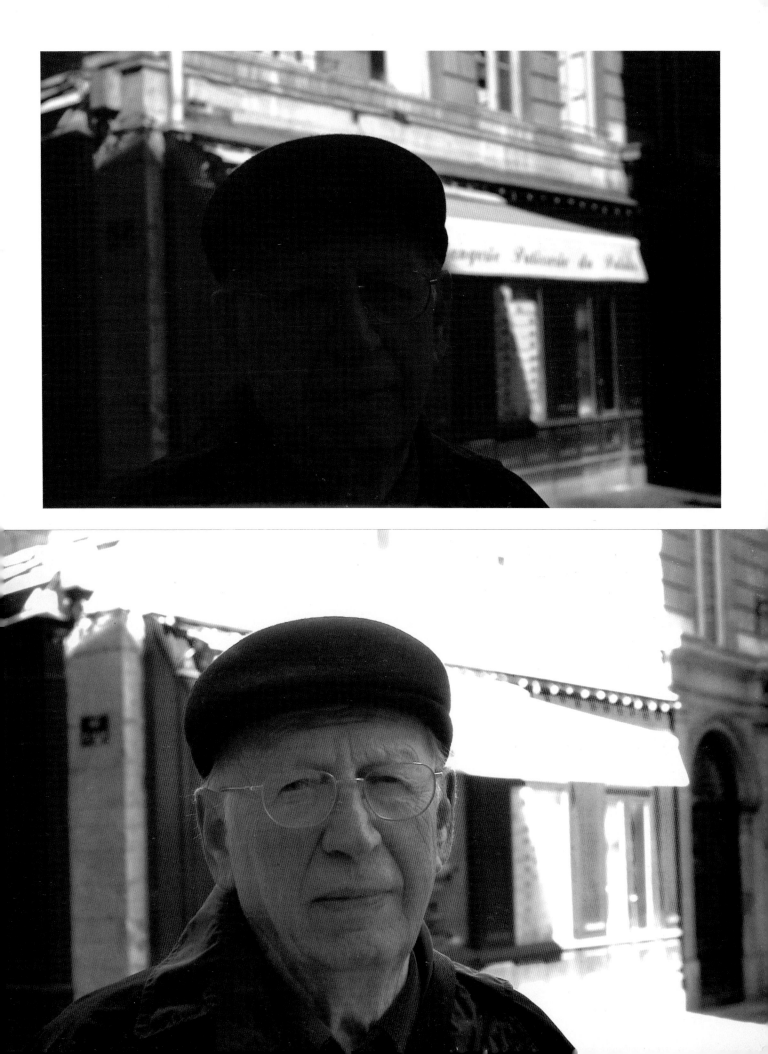

The Photographic Triangle

The last thing I want you to do is forever leave your camera's aperture at *f*/5.6 and simply adjust your shutter speed for the light falling on your subject until the viewfinder indicates a correct exposure. Before you forge ahead with your newfound ease in setting a manual exposure, you need to learn some basic concepts about exposure.

A correct exposure is a simple combination of three important factors: aperture, shutter speed, and ISO. Since the beginning of photography, these same three factors have always been at the heart of every exposure, whether that exposure was correct or not, and they still are today—even with digital cameras. I refer to them as *the photographic triangle*.

Locate the button, wheel, or dial on your camera or lens that controls the aperture. If you're using an older camera and lens, the aperture control is a ring that you turn on the lens itself. Whether you push buttons, turn a wheel, or rotate a ring on the lens, you'll see a series of numbers coming up in the viewfinder or on the lens itself. Of all of the numbers you'll see, take note of 4, 5.6, 8, 11, 16, and maybe even 22. (If you're shooting with a fixed-zoom-lens digital camera, you may find that your apertures don't go past 8 or maybe 11.) Each one of these numbers corresponds to a specific opening in your lens, and these openings are called *f*-stops. So in photographic terms, the 4 is called *f*/4, the 5.6 is *f*/5.6, and so on. The primary function of these lens openings is to control the volume of light that reaches the digital media or film during an exposure. The *smaller* the *f*-stop number, the *larger* the lens opening; the *larger* the *f*-stop number, the *smaller* the lens opening.

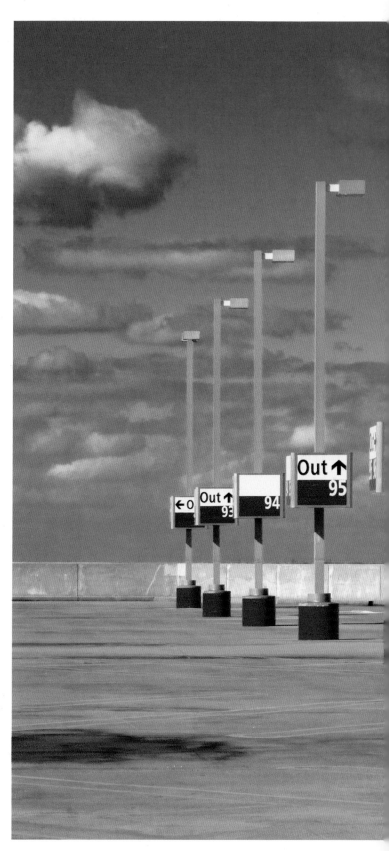

OVER THE YEARS, I'VE SOUGHT OUT *the rooftop levels of parking garages around the world, because they often afford great views of the surrounding areas and streets below. However, it's the parking garage of the Tampa International Airport in Florida that is the only one I've actually photographed. The combination of the bold red-and-white signs and contrasting blue sky and white clouds makes for a surreal landscape.*

I reasoned this empty oasis of color and light would soon be filling up with cars, so I was quick to set up on tripod. With my aperture set to f/22, I focused one-third of the way into the scene (focusing on the Out 97 sign) to ensure the maximum depth of field, and then I simply adjusted my shutter speed until 1/100 sec. indicated a correct exposure and fired away. When composing scenes with my telephoto lens that require front-to-back sharpness, I find the age-old method of focusing one-third of the way into the scene, combined with the smallest aperture (f/22 or f/32), will often provide the necessary front-to-back sharpness, as you see here.

70–200mm lens, ISO 200, f/22 for 1/100 sec.

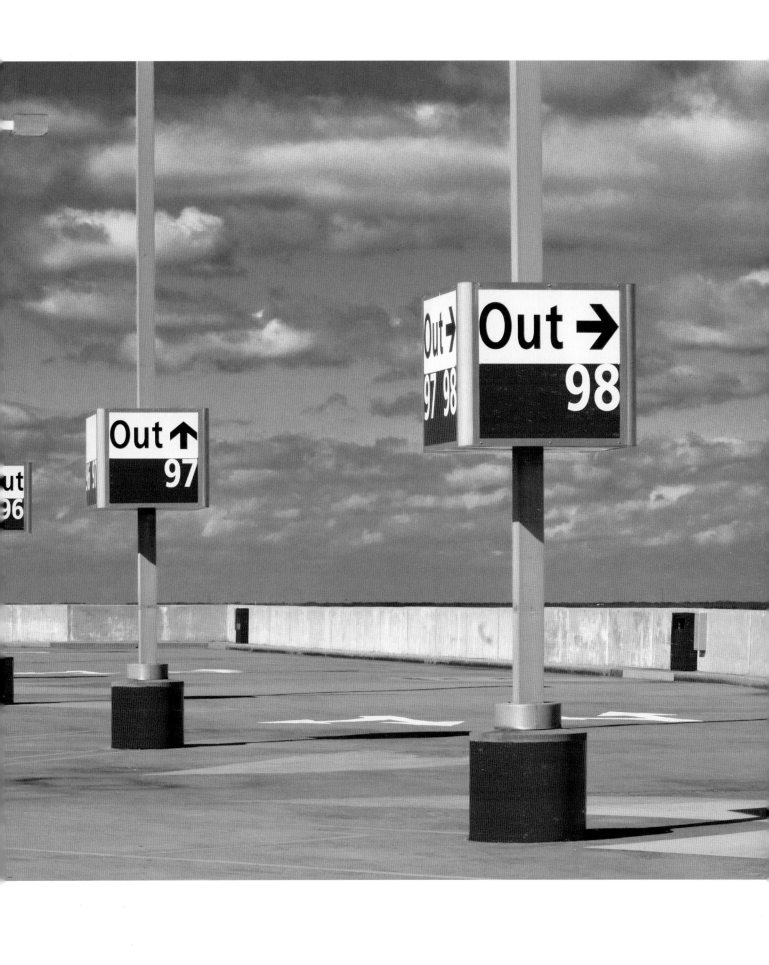

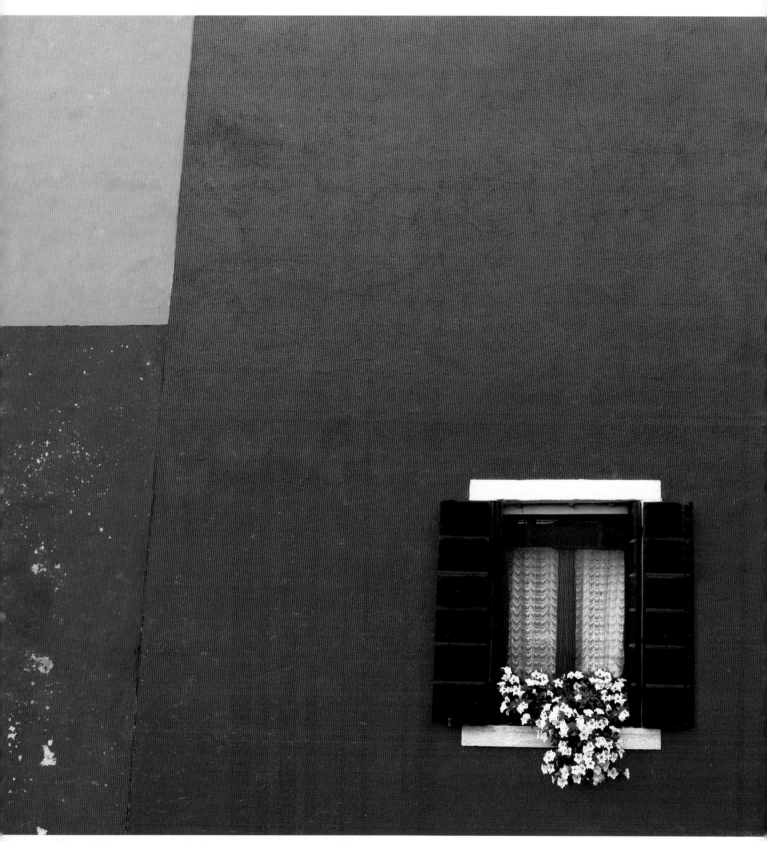

IF YOU TAKE THE FORTY-FIVE-MINUTE FERRY RIDE *east from Venice, Italy, you arrive at Burano—voted by me as the most colorful island in the world. And if color is your thing, Burano will not disappoint. At every turn, a compelling image awaits. Taking one such turn several years ago resulted in one of the most colorful "wall shots" I've ever taken. And it proved to be a simple exposure to be sure, since on this day it was overcast, so the light levels were even throughout the scene. Handholding my Nikon D2X, I set the aperture to f/8, and with the camera in Aperture Priority mode, I simply focused and fired the shutter release, allowing the camera to set the correct exposure for me.*

35-70mm lens, ISO 100, f/8 for 1/15 sec.

For the technical minded out there, an *f*-stop is a fraction that indicates the diameter of the aperture. The *f* stands for the focal length of the lens, the slash (/) means *divided by*, and the number represents the stop in use. For example, if you were shooting with a 50mm lens set at an aperture of *f*/1.4, the diameter of the actual lens opening would be 35.7mm. Here, 50 (lens focal length) divided by 1.4 (stop) equals 35.7 (diameter of lens opening). Whew! It makes my head spin just thinking about all that. Thank goodness this has very little, if anything, to do with achieving a correct exposure.

Interestingly enough, each time you descend from one aperture opening to the next, or *stop down*, such as from *f*/4 to *f*/5.6, the volume of light entering the lens is cut in half. Likewise, if you change from an aperture opening of *f*/11 to *f*/8, the volume of light entering the lens doubles. Each halving or doubling of light is referred to as a full stop. This is important to note, since many cameras today offer not only full stops but also the ability to set the aperture to one-third stops—i.e. *f*/4, *f*/4.5, *f*/5, *f*/5.6, *f*/6.3, *f*/7.1, *f*/8, *f*/9, *f*/10, *f*/11, and so on. (The underlined numbers represent the original, basic stops, while the others are the newer one-third options sometimes available.)

Now let's turn to shutter speed. Depending on the make and model, your camera may offer shutter speeds from a blazingly fast 1/8000 sec. all the way down to 30 seconds. The shutter speed controls the amount of time that the volume of light coming through the lens (determined by the aperture) is allowed to stay on the digital media or film in the camera. The same halving and doubling principle that applies to aperture also applies to shutter speed.

Let me explain. Set the shutter speed control on your camera to 500. This number denotes a fraction—500 represents 1/500 sec. Now change from 500 to 250; again, this represents 1/250 sec. From 1/250 sec. you go to 1/125, 1/60, 1/30, 1/15, and so on. Whether you change from 1/30 sec. to 1/60 sec. (decreasing the time the light stays on the digital media/film) or from 1/60 sec. to 1/30 sec. (increasing the time the light stays on the digital media/film), you've shifted a full stop. Again this is important to note, since many cameras today also offer the ability to set the shutter speed to one-third stops: 1/500 sec., 1/400 sec., 1/320 sec., 1/250 sec., 1/200 sec., 1/160 sec., 1/125 sec., 1/100 sec., 1/80 sec., 1/60 sec., and so on. (Again, the underlined numbers represent the original, basic stops, while the others are the newer one-third options sometimes available.) Cameras that offer one-third stops reflect the camera industry's attempts to make it easier for you to achieve "perfect" exposures. But as you'll learn later on, it's rare that one always wants a perfect exposure.

The final leg of the triangle is ISO. Whether you shoot with a digital or film camera, your choice of ISO has a direct impact on the combination of apertures and shutter speeds you can use. It's so important that it warrants its own discussion and exercise on the following page.

EXERCISE: UNDERSTANDING ISO

To better understand the effect of ISO on exposure, think of the ISO as a worker bee. If my camera is set for ISO 100, I have, in effect, 100 worker bees; and if your camera is set for ISO 200, you have 200 worker bees. The job of these worker bees is to gather the light that comes through the lens and make an image. If both of us set our lenses at the same aperture of f/5.6—meaning that the same volume of light will be coming through our lenses—who will record the image the quickest, you or me? You will, since you have twice as many worker bees at ISO 200 than I do at ISO 100.

How does this relate to shutter speed? Let's assume the scene in question is a lone flower on an overcast day. Remember that your camera is set to ISO 200 and mine to ISO 100, both with an aperture of f/5.6. So, when you adjust your shutter speed for a correct exposure, 1/250 sec. is indicated as "correct," but when I adjust my shutter speed for a correct exposure, 1/125 sec.—a longer exposure—is indicated. This is because your 200 worker bees need only half as much time as my 100 worker bees to make the image.

Since this is such an important part of understanding exposure, I want you to put the book down for a moment and get out your camera, as well as a pen and paper. Set the ISO to 200. (Do this even if you're still using film and have a roll in your camera that's *not* ISO 200; don't forget to set the ISO back to the correct number when we're done here.) Now, set your aperture opening to f/8, and with the camera pointed at something that's well illuminated, adjust your shutter speed until a correct exposure is indicated in the viewfinder by the camera's light meter. (If you want, you can leave the camera in Aperture Priority mode for this exercise, too.) Then, change your ISO again, this time to 400, leaving the aperture at f/8, and once again point the camera at the same subject. Whether you're in manual mode or Aperture Priority mode (indicated by the letter A or Av, depending on your camera), you'll see that your light meter is indicating a different shutter speed for a correct exposure. Once again, write down this shutter speed. And finally, change the ISO to 800, and repeat the steps above.

What have you noticed? When you change from ISO 100 to ISO 200 your shutter speed changed: from 1/125 sec. to 1/250 sec. or perhaps from something like 1/160 sec. to 1/320 sec. These shutter speeds are examples, of course, and not knowing what your subject was, it's difficult at best to determine your actual shutter speeds, but one thing is certain: Each shutter speed is close to, if not exactly half as much as, the one before it.

When you increase the number of worker bees (the ISO) from 100 to 200, you cut the time necessary to get the job done in half. (If only the real world worked like that!) This is what your shutter speed was telling you: Going from 1/125 sec. to 1/250 sec. is half as long an exposure time. When you set the ISO to 400, you went from 1/125 sec.—passing by 1/250 sec.—and ended up at 1/500 sec. Just as each halving of the shutter speed is called 1 stop, each change from ISO 100 to ISO 200 to ISO 400 is considered a *1-stop* increase (an increase of worker bees).

You can do this same exercise just as easily by leaving the shutter speed constant—for instance, at 1/125 sec.—and adjusting the aperture until a correct exposure is indicated in the viewfinder; or, if you choose to stay in autoexposure mode, select Shutter Priority, set a shutter speed of 1/125 sec., and the camera will set the correct aperture for you.

HAVING NOW LIVED IN CHICAGO *for almost one year, I'm aware that my thinking and approach to photography is much like it was when I lived in Oregon during the 1970s and '80s: The calendar does offer up the same twelve months in a year, but due to the Oregon winter rains—and now the Chicago winter snows—my actual shooting time is limited. In late spring into early fall, my daily mantra becomes Do It Now. Marathon days become the norm as I race from one location to another, conscious that soon the "six months of winter" will return and, with that, the many fountains in Chicago will go dry.*

Such was the impetus for this shot. As the light show unfolded before me on this warm summer evening at Chicago's Buckingham Fountain in Grant Park, I set up my Nikon D300 and 12–24mm lens on tripod. With my aperture set to f/11, I raised the camera up toward the dusky blue sky and adjusted my shutter speed until 4 seconds indicated a correct exposure

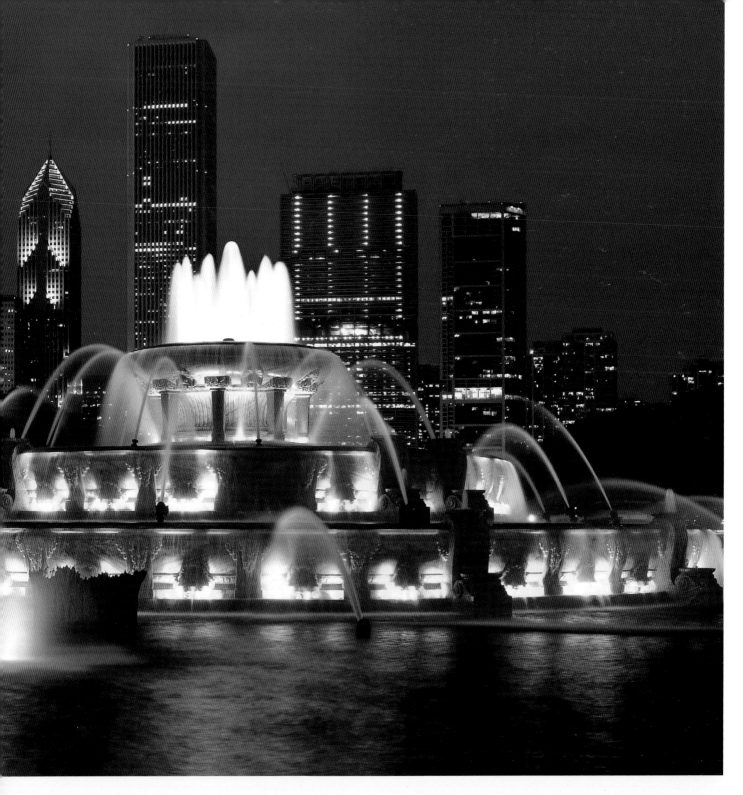

in the viewfinder. I then recomposed, and with the camera's self-timer engaged, fired the shutter release, and recorded the image you see here.

I could have shot this fountain at other correct exposures—f/16 for 8 seconds or f/22 for 16 seconds—but intentionally chose not to. First, fountain motion is much like that of a waterfall: The movement of the falling water does not look any different at 8 or 16 seconds than it does at the 4 seconds you see here. Second, the lights in the fountain were not only changing colors periodically but also changing intensity. With an 8- or 16-second exposure, I ran the risk of catching this change, which could have affected not only the initial exposure but also the overall color. When shooting motion at dusk, ask yourself, "Just how long of an exposure do I need to convey the motion here?" When shooting a busy highway against a backdrop of city skyline, an 8-second exposure makes sense, but when shooting that same skyline with no moving traffic in the

composition, then a 1-second exposure may be sufficient. Additionally, I seldom use those "super-high" ISOs, such as 600, 800, 1600, or that real whopper of an ISO, 3200. Despite claims that these high ISOs have a very low noise factor, they are seldom practical in the world of creative exposures. Here, I was able to get the flowing-water effect I wanted at 4 seconds and f/11 with ISO 200. And f/11 is considered a critical aperture, meaning that optical sharpness reigns supreme at this setting. Had I been using a high ISO such as 1600 and wished to shoot at f/11, my correct exposure would have been 1/2 sec.—and although you'd clearly see the water in motion, the overall color and contrast wouldn't be nearly as vivid. A couple of the main things missing in your exposures when using the higher ISOs are contrast and color.

12–24mm lens at 24mm, ISO 200, f/11 for 4 seconds

The Heart of the Triangle: The Light Meter

Now it's time to introduce you to what I call the heart of the photographic triangle: the light meter. At the heart of every exposure is your camera's light meter, which is a precalibrated device designed to react to any light source no matter how bright or dim that light source may be.

Based on the example on the previous page, the camera's light meter knew that the aperture was set to *f*/11, and it also knew that the ISO was set to 200. As a result, it reacted and directed me to adjust the shutter speed; then it indicated in the viewfinder that I had reached the correct shutter speed. It's the light meter that is ultimately behind the calculations of every correct photographic exposure.

To set this idea in stone, let me offer this final illustration: Imagine your lens opening, again say *f*/11, is the same diameter as your kitchen faucet opening. Now imagine that your faucet handle is your shutter speed dial and that waiting in the sink below are 200 worker bees, each with an empty bucket. The water coming through the faucet will be the light. It's the job of the camera's light meter to indicate how long the faucet stays open to fill up all the buckets of the waiting worker bees below. The light meter knows that there are 200 worker bees and that the opening of the faucet is *f*/11. So with this information, the camera's light meter can now tell you *how long* to leave the faucet open, and assuming you turn on the faucet for this correctly indicated amount of time, you will record a correct exposure. In effect, each worker bee's bucket is filled with the exact amount of water necessary to record a correct photographic exposure.

What happens if the water (the light) is allowed to flow longer than the light meter says? The buckets become overfilled with water (too much light). In photographic terms, this is called an *overexposure*. If you've ever taken an overexposed image, you've undoubtedly commented that the colors look "washed out." Conversely, what happens if the water (the light) coming through the faucet is *not* allowed to flow as long as the light meter says? The buckets get but a few drops (not enough light). In photographic terms, this is an *underexposure*. If you've ever taken an underexposed photo, you've found yourself saying, "It's hard to see what's there, since it's so dark."

Having now learned how simple the basic concept of exposure is, is it safe to say you can record perfect exposures every time? Not quite, but you're closer than you were when you started reading this book. You can certainly say that you understand how an exposure is made. And you now understand the relationship between *f*-stops, shutter speeds, and ISOs. However, most picture-taking opportunities rely on the *one* best aperture choice or the *one* best shutter speed choice. What's *the one* best aperture? *The one* best shutter speed? Learning to "see" the multitude of creative exposures that exist is a giant leap toward photographic maturity.

UNDERSTANDING THE EXPOSURE INFO IN YOUR VIEWFINDER

So, what do I mean when I say, "I then adjusted the shutter speed until a correct exposure was indicated"? And how will *you* know when a correct exposure is indicated? When you look through your camera's viewfinder while you are *in manual exposure mode*, you'll see your light meter indicating either an overexposure (the tracking dot is on the *plus* side) or an underexposure (the tracking dot is on the *minus* side). Your goal is to simply adjust your shutter speed (or, in some cases, your aperture) until the tracking dot is at 0.

Sometimes, you may not be able to get a "dead-center" exposure indication due to various and changing light values in your scene. If you're within 1/3 or even 2/3 of a stop, your exposure will in all likelihood still turn out just fine—*as long as you set the exposure on the minus side* (bottom image). Whenever possible, you want to avoid "blown highlights," and shooting exposures that are a wee bit underexposed is more favorable than shooting exposures that are overexposed.

Note: Shooting in Shutter Priority or Aperture Priority mode eliminates the need to align the tracking dot at 0, because the camera will "automatically" set the correct exposure for you—in theory, at least. Also, the camera make determines which side of 0 is plus (+) and which is minus (-); on Canon, for example, plus (+) is to the right of 0 and minus (-) is to the left. And some cameras (including Canon and Nikon) offer models that display the exposure information on the right side of the viewfinder instead of at the bottom.

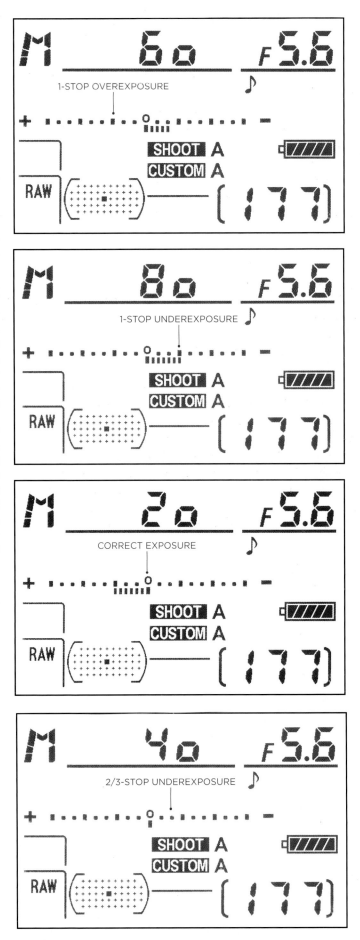

CROSSING THE BRIDGE
leaving the harbor in Hamburg, Germany, I spotted this great shot in my rearview mirror. I immediately pulled off to the side of the highway and set up my tripod. Since I knew I wanted to exploit the motion of the traffic flowing across the bridge, I chose a shutter speed of 8 seconds. With my camera pointed to the sunset sky, I adjusted my aperture until the camera's light meter indicated f/11 as a correct exposure and then recomposed the scene. I was so pleased with the result that I forgot my previous anger at receiving a ticket for "parking along a highway when there clearly was no emergency." The $85 fine was well worth it, since this image has earned more than $4,000 in stock photo sales.

300mm lens, f/11 for 8 seconds

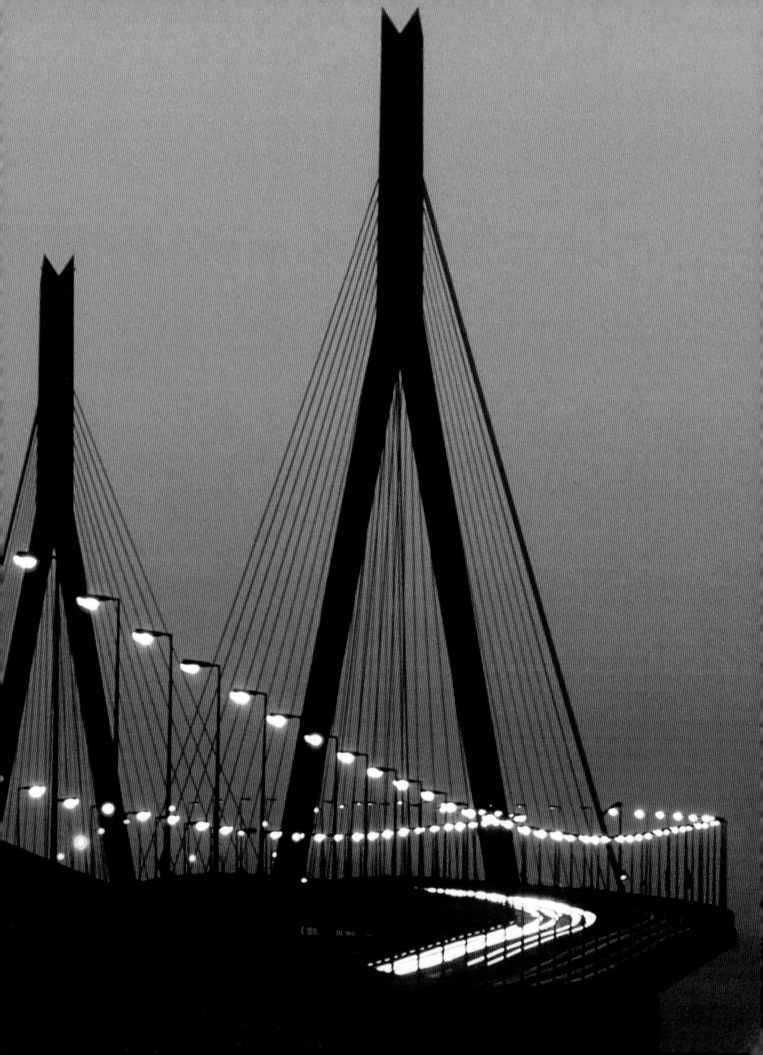

White Balance

Are you confused about white balance? It's my opinion that, next to the histogram, the white balance (WB) setting is one of the most over-rated controls on the digital camera. I have actually seen forums on the Internet discussing white balance, and there are some very strong feelings about the importance of white balance in your photography. But until someone can show me otherwise, I will continue setting my white balance only once and leaving it alone.

Before I get to what, exactly, white balance is and to my one chosen setting, I want to briefly discuss the colors red, green, and blue and color temperature. Every color photograph ever made has some degree of each of these colors in it, but how much will depend on the color temperature of the light. Yes, that's right. Light, just like the human body, has a temperature. Unlike the human body, though, the temperature of light is measured by its color. And this is where it gets kind of funny. Blue light has a higher temperature than red light in photography. If you were red in the face, you'd probably also have sweat coming out of your pores, and anyone who looked at you would say, "You're burning up!"

Not so, with the temperature of light. Color temperature is measured by what is called the Kelvin scale, which is nothing more than an extension of the Celsius scale. On any given day, the color temperature of the light that falls on our world is measured in degrees Kelvin (K), from roughly 2,000 K to 11,000 K. A color temperature of between 7,000 and 11,000 K is considered "cool" (bluer shades would fall in this range), a color temperature of between 2,000 and 4,000 K is considered "warm" (reds would fall in this range), and a color temperature of between 4,000 and 7,000 K is considered "daylight" (or the combination of red, green, and blue).

Cool light is found on cloudy, rainy, foggy, or snowy days or in areas of open shade on sunny days (the north side of your house, for example). Warm light is found on sunny days, beginning a bit before dawn and lasting for about two hours tops and then beginning again about two hours before sunset and lasting for another twenty or thirty minutes after the sun has set.

During my last six years of using film, I made 90 percent of my images with Kodak's E100VS, a highly saturated color slide film. One of the problems I had with digital photography in the beginning was its inability to produce in the raw file these same highly saturated colors—until I stumbled upon the Cloudy white balance setting, that is.

Over the years, I found myself out shooting film in overcast, rainy, snowy, foggy, or open-shade/sunny-day conditions. To eliminate much of the blue light present at those times, I would use my 81-A or 81-B warming filters. These would add red to a scene, in effect knocking down, if not out, the blue light. I prefer my images warm.

And that brings me to my one white balance setting. As is always the case, I leave my white balance set to Cloudy. If—and this is a big if—you feel that the Cloudy white balance setting is a bit too much, you can always change it to Auto, Daylight, Shade, Tungsten, Fluorescent, or Flash in the postprocessing phase, assuming, of course, that you're shooting in raw mode. (This is yet another good reason to shoot raw files.)

Perhaps you're shocked by my white balance choice, but hear me out. I seldom, if ever, shoot interiors, whether they're lit by available daylight, tungsten, fluorescent, sodium, or mercury vapor. If I were shooting interiors that have a great deal of artificial light, then and only then, would I shift my white balance to the appropriate setting—for example, Tungsten (for ordinary household lighting) or Florescent (for ordinary office lighting). I am, for the most part, a natural-light photographer, as probably are most of you reading this book. The only exceptions to this are when I use my mini studio setup at home to photograph objects on white backgrounds and when I'm doing commercial work for which I'm using a number of strobes to light a given interior. In both of these situations, I usually end up using the Flash setting for white balance.

I'm also a "very specific time of day" photographer. On sunny days, I shoot in the early morning or from late afternoon to dusk. Midday light, between 11:00 AM and 3:00 PM, is what I call poolside light, and if there's a pool nearby, that's where you'll find me—sitting by the pool.

So, since I add even more warmth with my white balance set to Cloudy, it's like shooting with Kodak E100VS. And my Cloudy white balance setting seldom changes, whether I shoot on sunny, cloudy, rainy, foggy, or snowy days. And, in case you're convinced that I'm truly an idiot, don't forget that if I determine on those rarest of occasions—and I want to stress rare—that I may have been better off with a different WB setting, I can always change it in postprocessing after downloading my raw images into the computer.

Midday photography is the norm for many shooters, and the added warmth that you'll see in your pictures (that's usually associated with early or late times of day) will surely get your attention. You can fool your friends into thinking you've become a morning person or that you were out shooting in late afternoon light, but watch out for the discerning eye! Morning and late-afternoon light reveals lots of long shadows, while midday light is "shadowless." And if you're thinking of taking on the intricate task of adding shadows later in Photoshop, you might consider volunteering for the Peace Corps instead if you have that much time on your hands.

THE IMAGE AT LEFT *is a classic example of midday overcast light and was made with the camera set to the Auto white balance setting, which not surprisingly did a "great" job of recording accurate color; and since midday light is blue, it looks blue overall. Now compare this to the image below, which I made with the white balance set to Cloudy. Obviously, this image is warmer. The choice is, of course, a personal one, but if you haven't considered shooting with your white balance set to Cloudy, it might be worth a look.*

Both photos: 17–55mm lens at 24mm, ISO 200, f/8 for 1/125 sec.

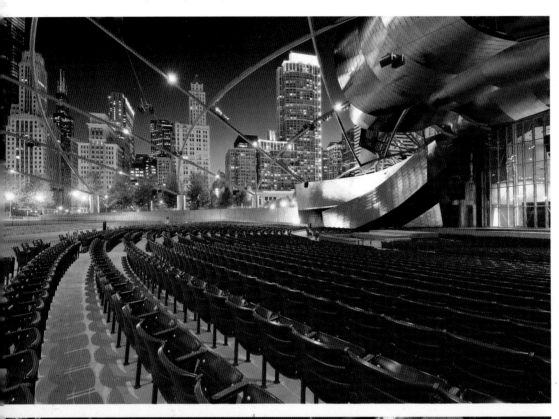

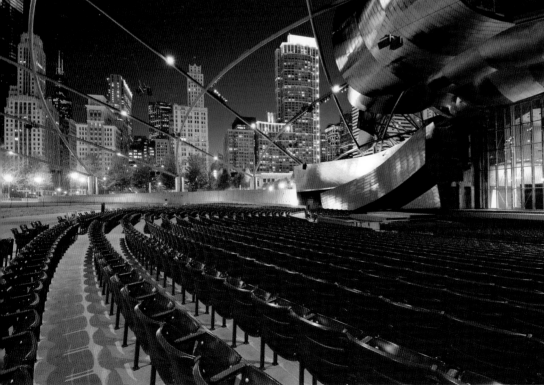

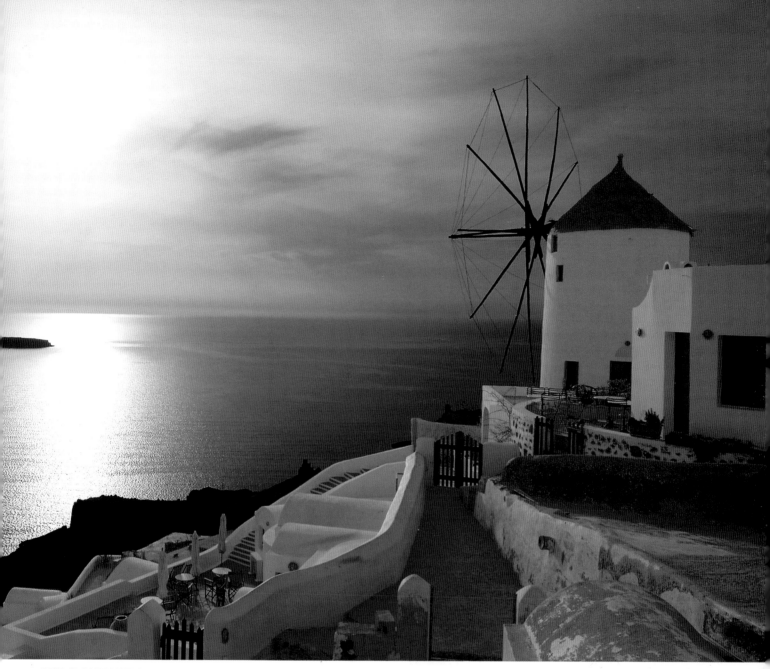

THE CLOUDY WB SETTING *imparts a richer, warmer overall feel to an image, so I shoot 99 percent of my images on Cloudy when outdoors, 24/7, even if it's a sunny day. But when I shoot at dusk, I'll often switch over to the Tungsten WB setting and shoot at least one or two exposures. Then I can compare how the much deeper and richer dusky blue sky I get in Tungsten impacts the overall composition.*

As an example, the only difference in these two photographs of the amphitheater in downtown Chicago's Millennium Park is the white balance setting. Both images were shot at the same exposure with the same lens; but the top one used Cloudy WB and is certainly warmer, while the bottom image shows Tungsten WB.

Granted, if you're shooting in raw format and forget to try out the Tungsten setting, you can always change it in postprocessing, but for those of you shooting only in JPEG format, this is the time to try both Cloudy and Tungsten WB settings. The Tungsten setting is also called Incandescent by some camera manufacturers, and its WB symbol is that lightbulb in your WB menu.

Opposite, both photos: 12-24mm lens at 14mm, ISO 200, f/8 for 5 seconds. Top: Cloudy white balance. Bottom: Tungsten white balance

HERE'S A WHITE BALANCE "TRICK": *On the island of Santorini, a lone windmill sits at the western end. Shooting into the somewhat hazy sunset reminded me of many an equally hazy moonrise I have witnessed. This time, however, I was determined to record a "moonrise" simply by calling on my DSLR's different white balance settings, in this case Tungsten. The Tungsten setting is meant for shooting indoors under tungsten lights (ordinary household lamps), yet when used outside Tungsten WB records very blue, and sometimes this blue (in combination with a slight underexposure) comes close to mimicking dusky blue evening light, as it does here. Handholding my camera, and working in Aperture Priority mode, I set the aperture to f/8 and simply fired the shutter release. Sure looks like a moonlit scene to me! How about you?*

17-55mm lens at 17mm, ISO 100, f/8 for 1/1250 sec.

Six Correct Exposures vs.
One Creatively Correct One

t's not uncommon to hear at least one student in my on-location workshops say to me, "What difference does it make which combination of aperture and shutter speed I use? If my light meter indicates a correct exposure, I'm taking the shot!" Perhaps you are like this, too. Whether you shoot in Program mode, Shutter Priority mode, Aperture Priority mode, or even manual mode, you may think that as long as the light meter indicates that everything's okay, then it must be okay to shoot.

The trouble is that this kind of logic makes about as much sense as deer hunters who fire off their rifles at anything that moves. They may eventually get a deer, but at what cost? If you want to shoot only "correct" exposures of anything and everything, be my guest. Eventually, you might even record a creatively correct exposure. But I'm assuming that most of you who bought this book are tired of the shotgun approach and want to learn how to *consistently record creatively correct exposures every time*.

Most picture-taking situations have at least six possible combinations of f-stops and shutters speeds that will *all* result in a correct exposure. Yet normally, *just one* of these combinations of f-stops and shutter speeds is the creatively correct exposure.

As we've already learned, every correct exposure is nothing more than the quantitative value of an aperture and shutter speed working together within the confines of a predetermined ISO. But a creatively correct exposure *always* relies on *the one f-stop* or *the one shutter speed* that will produce the desired exposure.

Let's pretend for a moment that you're at the beach taking pictures of the powerful surf crashing against the rocks. You're using an ISO of 100 and an aperture of f/4. After adjusting your shutter speed, you get a correct exposure (indicated in the viewfinder) of 1/500 sec. This is just one of your exposure options! There are other combinations of apertures (f-stops) and shutter speeds you can use and still record a correct exposure. If you cut the lens opening in half with an aperture of f/5.6 (f/4 to f/5.6), you'll need to increase the shutter speed a full stop (to 1/250 sec.) to record a correct exposure. If you use an aperture of f/8, again cutting the lens opening in half, you'll need to increase the shutter speed again by a full stop (to 1/125 sec.). Continuing in this manner would also produce the following pairings of apertures and shutter speeds to achieve a correct exposure: f/11 at 1/60 sec., f/16 at 1/30 sec., and finally f/22 at 1/15 sec. That's six possible correct exposures for the scene—six possible combinations of aperture and shutter speed that will all result in exactly the same exposure. And I want to stress that the word *same* here means the same in terms of *quantitative value only*! Clearly, a picture of crashing surf taken using f/4 at 1/500 sec. would capture action-stopping detail of the surf as it hits the rocks; a correct exposure of that surf using f/22 at 1/15 sec., on the other hand, would capture less action-stopping detail and show the surf as a far more fluid and wispy, somewhat angelic element.

This creative approach toward exposure will reap countless rewards *if* you get in the habit of looking at a scene and determining what combination of aperture and shutter speed will render the most dynamic and creative exposure for that subject. The choice in exposure is always yours, so why not make it the most creative exposure possible?

SHOOTING A FERRIS WHEEL
at dusk presents an opportunity to show the vast difference between three quantitatively identical exposures (opposite and on the following two pages)—the difference is in their creative exposure value. I made all three of these photographs on Kodak E100S slide film with my 20mm lens and camera mounted on a tripod. The top image was taken at f/8 for 1/4 sec., the one below was shot at f/11 for 1/2 sec., and the one on page 32 was at f/16 for 1 second.

Top: 20mm lens, f/8 for 1/4 sec.
Bottom: 20mm lens, f/11 for 1/2 sec.

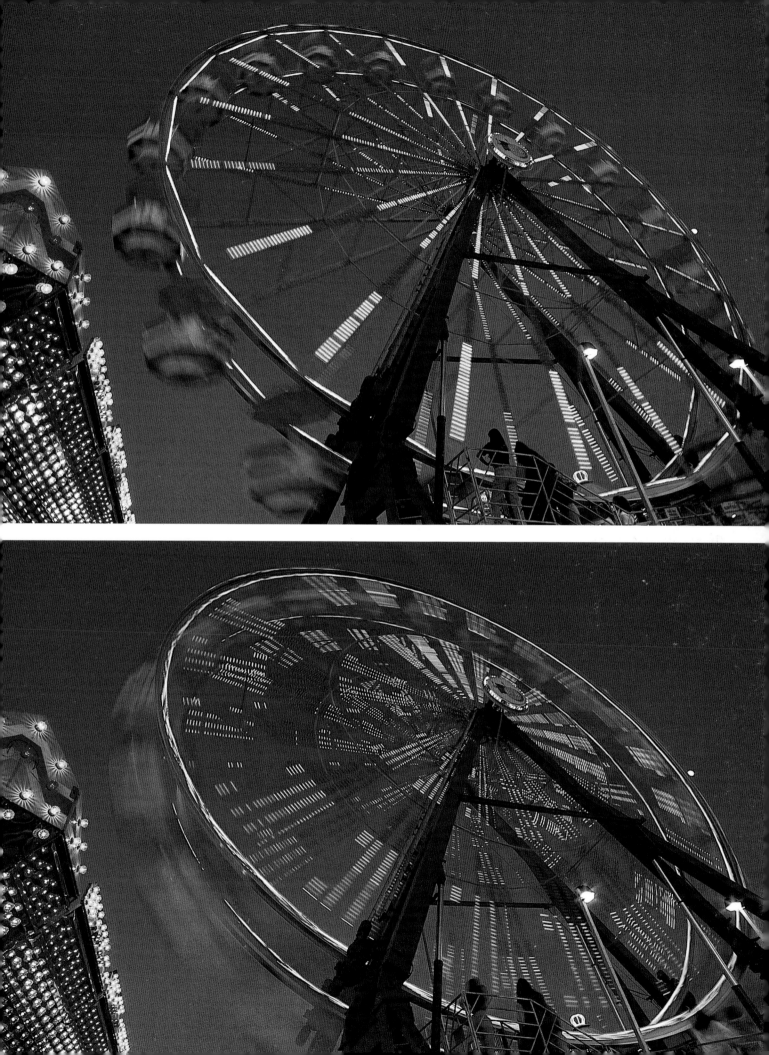

AN EXERCISE SUCH AS THIS
*is truly eye-opening. The next time
you head out to the amusement
park, you probably won't hesitate
to use the slower shutter speeds,
since as this example shows, of the
three "identical" exposures, the one
with the slowest shutter speed is
the most creative and interesting.*

20mm lens, f/16 for 1 second

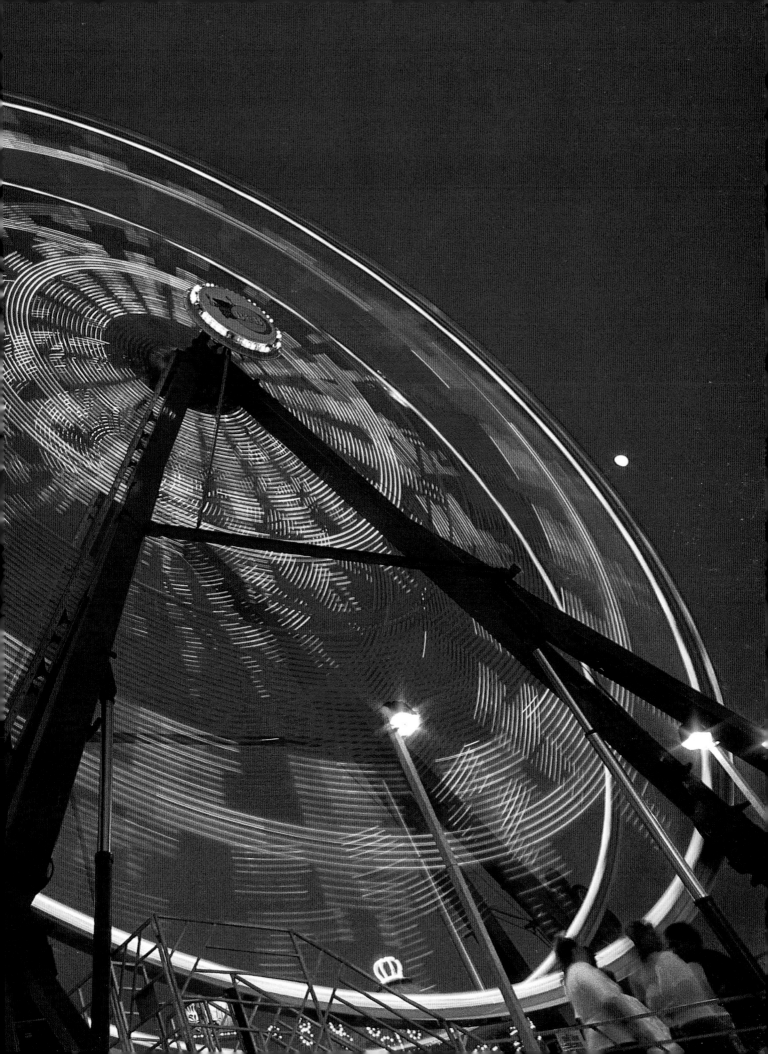

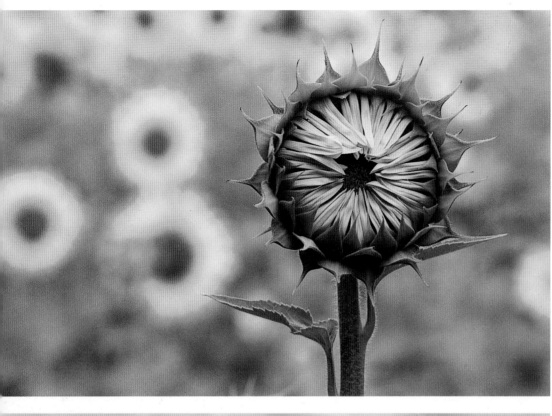

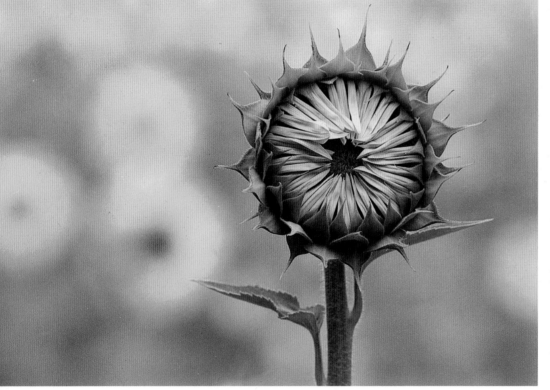

WITH MY CAMERA AND NIKKOR 80–400mm zoom lens mounted on a tripod and the lens set to 300mm, I shot the first image at f/16 for 1/60 sec., the second at f/8 for 1/250 sec., and the third at f/4 for 1/1000 sec. All three exposures are exactly the same in terms of quantitative value but quite different in the arena of "creative" exposure. Note how at the wide-open aperture of f/4, the sunflower is isolated—in effect, it's all alone—but at f/16, due to the increase in depth of field, it has quite a bit of company.

All photos: 80–400mm zoom lens at 300mm. Top: f/16 for 1/60 sec. Bottomt: f/8 for 1/250 sec. Right: f/4 for 1/1000 sec.

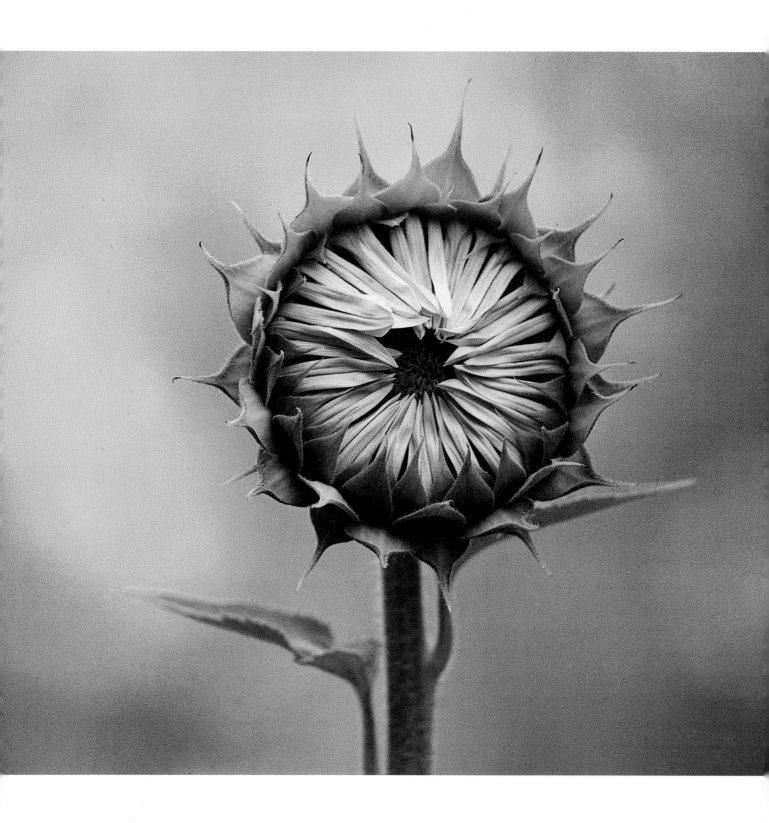

EXERCISE: SEEING THE CREATIVELY CORRECT EXPOSURE

One of the best lessons I know is very revealing. Not surprisingly, it will lead you farther into the world of creatively correct exposures. Choose a stationary subject, such as a flower, or have a friend stand for a portrait. Also choose a moving subject, such as a waterfall or a child on a swing. If possible, photograph on an overcast day and choose compositions that crop out the sky so that it is not part of the scene.

With your camera and lens mounted on a tripod, and your ISO at 200, put your camera in manual exposure mode. Get used to being in manual mode, as this is where you'll now be spending all of your "quality time." Now set your aperture wide open—that will be the smallest number on your lens, such as f/2, f/2.8, f/3.5, or f/4. Do your best to fill the frame with your subject (be it the flower or the portrait), adjust your shutter speed until a correct exposure is indicated (in your camera's viewfinder), and then shoot one frame.

Now change your aperture 1 stop (for example, from f/4 to f/5.6), readjust your shutter speed 1 stop to maintain a correct exposure, and shoot one frame. Then change the aperture from f/5.6 to f/8 and so on, each time remembering to change the

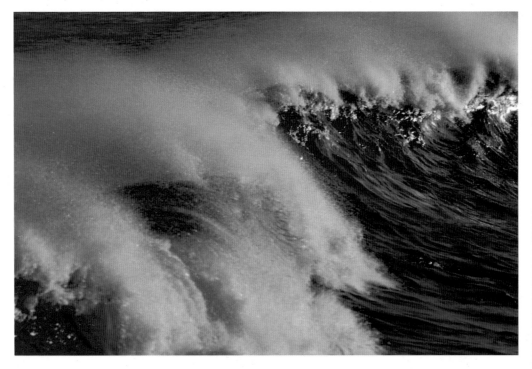

TWO WAVES, DIFFERENT EFFECT—*all because of a change in exposure. The camera and lens were the same for both images, but for the image above, I chose a shutter speed of 1/500 sec. to freeze the action of the wave. In doing so, I knew I'd end up with a large lens opening, namely because I was using ISO 50. Sure enough, as I adjusted my aperture while taking a meter reading off the distant horizon and blue sky, I got f/4 as a correct exposure. I then recomposed and took the shot.*

For the image at right, I wanted the angry surf to have a softer and more surreal quality. So I set the aperture to f/32, knowing that this would force me to use a much slower shutter speed (1/8 sec.) since the aperture opening had been reduced considerably.

Both photos: 80-200mm lens at 200mm. Above: f/4 for 1/500 sec. Right: f/32 for 1/8 sec.

shutter speed in order to keep the exposure correct. For each exposure, write down the aperture and shutter speed used. Depending on your lens, you will have no less than six different aperture/shutter speed combinations, and even though each and every exposure is exactly the same in terms of its quantitative value, you should certainly notice a difference in the overall definition and sharpness of the image! A once-lone flower is really only "alone" in a few frames; it gets lost in a sea of background when you use apertures of f/16 and f/22. (See the images on pages 34 and 35.) A portrait picks up some distracting elements in the background, too, when you use those bigger f-stop numbers.

And what about that waterfall shot, for example? That blurred cotton-candy effect doesn't appear until you use apertures of f/16 or f/22. And isn't that motion-filled photograph of your child on a swing really something? It's funny how at the faster shutter speeds, motion is "frozen," but at the slower shutter speeds, figures in motion look ghostlike. Look at your notes and decide which combination of aperture and shutter speed resulted in the most *creatively correct* exposure for you.

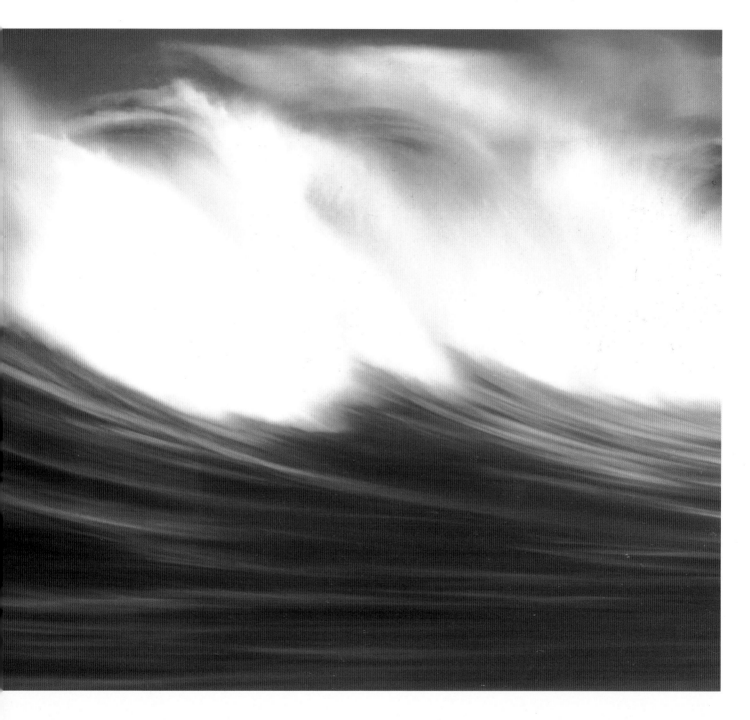

Seven Creative Exposure Options

Since every picture-taking opportunity allows for no less than six possible aperture and shutter speed combinations, how do you determine which combination is the best? You must decide, first and foremost, if you want to simply make an exposure or if you want to make a creative exposure. As we just saw, you can make many different exposures of a given scene, but only one or maybe two are the creative exposures.

You can break down the three components of exposure—ISO, shutter speed, and aperture—to get seven different types of exposures, and since, of these components, it's either the aperture or the shutter speed that's most often behind the success of a creative exposure, I'll start there: Small apertures (*f*/16, *f*/22, and *f*/32) are the creative force behind what I call *storytelling* exposures (this is exposure option 1)—images that show great depth of field (see pages 42–71 for a thorough discussion of depth of field). Large apertures (*f*/2.8, *f*/4, and *f*/5.6) are the creative force behind what I call *singular-theme* or *isolation* exposures (option 2)—images that show shallow depth of field. The middle-of-the-road apertures (*f*/8 and *f*/11) are what I call *"Who cares?"* exposures (option 3)—those in which depth of field is of no concern. Aperture is also the element in *close-up* or *macro* photography that showcases specular highlights, those out-of-focus circular or hexagonal shapes (option 4).

Fast shutter speeds (1/250 sec., 1/500 sec., and 1/1000 sec.) are the creative force behind exposures that *freeze action* (option 5), while slow shutter speeds (1/60 sec., 1/30 sec., and 1/15 sec.) are the creative force behind *panning* (option 6). The superslow shutter speeds (1/4 sec., 1/2 sec., and 1 second) are the creative force behind exposures that *imply motion* (option 7). These factors make up a total of seven creative exposure tools to call upon when reaching for your goal of achieving the one most creative exposure. The next two chapters take a closer look at aperture and shutter speed, respectively, as they pertain to all seven of these situations.

f/2.8 for 1/1000 sec.

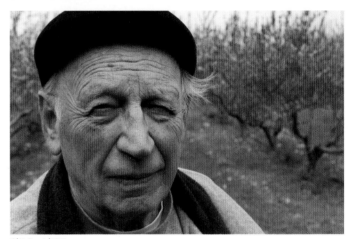

f/8 for 1/125 sec

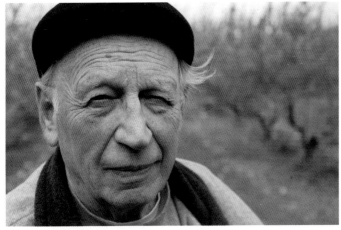

f/4 for 1/500 sec

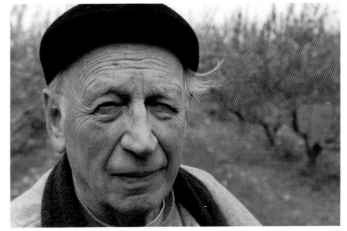

f/5.6 for 1/250 sec.

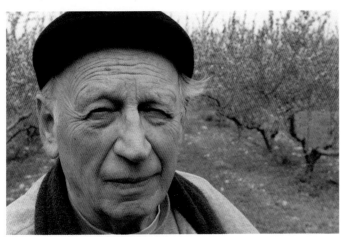

f/11 for 1/60 sec.

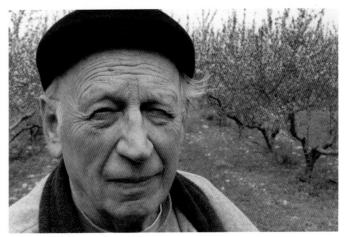

f/16 for 1/30 sec.

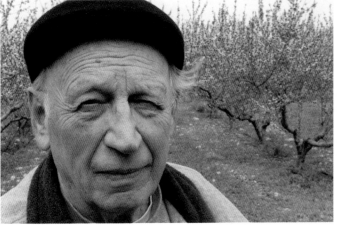

f/22 for 1/15 sec.

GLANCING QUICKLY *at these seven images of my father, it may not register that each is a bit different from the previous one. But note the difference in the background, which becomes gradually more defined in each one—eventually creating a striking difference between the first image and the last one.*

Each of these images is the same in quantitative value, but each one is different in terms of its overall depth of field. The type of background you want—out of focus or clearly defined—will ultimately determine which of these seven images is the "correct" one for you.

All photos: 35–70mm lens at 35mm

APERTURE

Aperture and Depth of Field

The aperture is a "hole" located inside the lens. Also known as the diaphragm, this hole is formed by a series of six overlapping metal blades. Depending on your camera, you either make aperture adjustments on the lens, or you push buttons or turn dials on your camera. As you do this, the size of the hole in the lens either decreases or increases. This, in turn, allows more light or less light to pass through the lens and onto the digital media (or film).

For all lenses, the smallest aperture number—either 1.4, 2, 2.8, or 4, depending on the lens—reflects the widest opening and will always admit the greatest amount of light. Whenever you set a lens at its smallest numbered aperture (or *f*-stop), you are shooting "wide open." When you shift from a small aperture number to a larger one, you are reducing the size of the opening and "stopping the lens down."

The largest aperture numbers are usually 16, 22, or 32 (or 8 or 11 with a fixed-lens digital camera).

Why would you want to be able to change the size of the lens opening? Well, for years, the common school of thought has been that since light levels vary from bright to dark, you will want to control the flow of light reaching the sensor. And, of course, the way to do this is simply by making the hole (the aperture) smaller or larger. This logic suggests that when you're shooting on a sunny day on the white sandy beaches of the Caribbean, you should stop the lens down, making the hole very small. Back in the days of film, doing so would ensure that the brightness of the sand didn't "burn a hole" in your film, and while you would never burn a hole in your digital sensor today, stopping down prevents too much light from getting into the scene. This same logic also implies that when you're in a dimly lit fourteenth-century cathedral, you should set the aperture wide open so that as much light as possible can pass through the lens and onto the digital media/film.

Although these recommendations are well-intentioned, I could not disagree with them more. They set up the unsuspecting photographer for inconsistent results. Why? Because they give no consideration to a far more important function of aperture: its ability to determine depth of field.

So, just what is depth of field? It's the area of sharpness (from near to far) within a photograph. As you've undoubtedly noticed when looking at photographs, some contain a great deal of sharpness. You might be mystified by the "technique" professional photographers use to record extreme sharpness throughout an image—for example, from the flowers in the immediate foreground to the distant mountains beyond. When you try to achieve overall sharpness in a composition like this, you may find that when you focus on the foreground flowers, the background mountains go out of focus; and when you focus on the mountains, the flowers go out of focus. I've had more than one student say to me over the years, "I wish I had one of those 'professional' cameras that would allow me

THE CHOICE *in backgrounds can always be yours, if you know how to control the area of sharpness. This is especially true when using a telephoto lens. I made the image at left at f/32, assuring not only that the branch would be in sharp focus but that the background would also be more defined than it is opposite due to the added depth of field that small lens openings provide. I much prefer the less-defined background.*

Both photos: 80–400mm lens at 400mm. Left: f/32 for 1/30 sec. Opposite: f/5.6 for 1/1000 sec.

to get exacting sharpness from front to back." They can't believe it when I tell them that they already do! They just have to use depth of field to their advantage. Likewise, exposures of a lone flower against a background of out-of-focus colors and shapes (see page 59) are the direct result of creative use of depth of field.

What exactly influences depth of field? Several factors come into play: the focal length of the lens, the distance between you and the subject you want to focus on, and the aperture you select. I feel strongly that of these three elements, aperture is the most important.

In theory, a lens is able to focus on only one object at a time; as for all the other objects in your composition, the farther away they are from the in-focus subject—whether it be in front of or behind it—the more out of focus they will be. Since this theory is based on viewing a given scene through the largest lens opening, it's vital that you appreciate the importance of understanding aperture selection. Of course, the light reflecting off a subject makes an image on digital media (or film), but the chosen aperture dictates how well this image is "formed" on your sensor. Optical law states that the smaller the opening of any given lens (large *f*-stop numbers—16, 22, or 32), the greater the area of sharpness or detail in the photo. When using apertures at or near wide open (smaller *f*-stop numbers—2.8, 4, or 5.6), only the light that falls on the focused subject will be rendered as "sharp"; all the other light in the scene—the out-of-focus light—will "splatter" across the sensor or film. In effect, this unfocused light records as out-of-focus blobs, blurs, and blips.

Conversely, when this same object is photographed at a very small lens opening, such as *f*/22, the blast of light entering the lens is reduced considerably. The resulting image contains a greater area of sharpness and detail because the light didn't "splatter" across the sensor (or film plane) but instead was confined to a smaller opening as it passed through the lens. Imagine using a funnel with a very small opening and pouring a one-gallon can of paint though it into an empty bucket. Compare this process to pouring a one-gallon can of paint into the same empty bucket without the aid of the funnel. Without the funnel, the paint gets into the bucket quicker, but it also splatters up on the bucket sides. With a funnel, the transfer of paint to the bucket is cleaner and more contained.

Keeping this in mind, you can see that when light is allowed to pass through small openings in a lens, a larger area of sharpness and detail always results. Does this mean that you should always strive to shoot "neat" pictures instead of "messy and splattered-filled" ones? Definitely not! The subject matter and the depth of the area of sharpness you want to record will determine which aperture choice to use—and it differs from image to image.

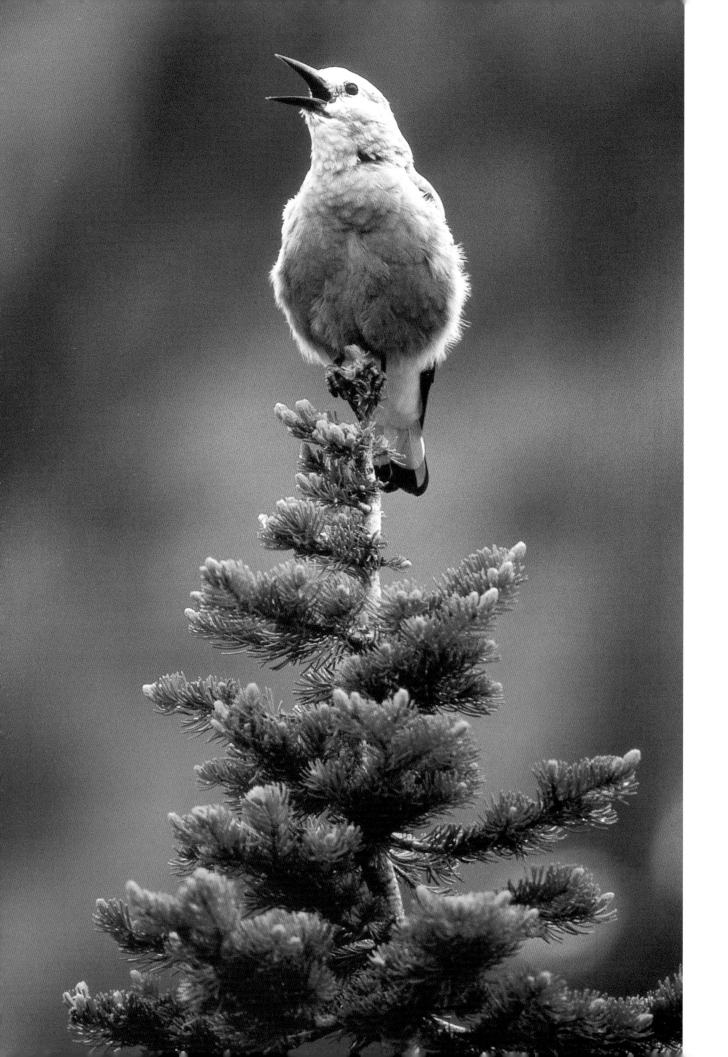

SITTING AT THE CAMPFIRE,
I was visited by a lone Clark's Nutcracker, or "camp robber," as some campers like to call these birds—and for good reason, too, as they're very brave and can carry off small items. Setting my focal length to 300mm, I was able to limit the composition to the top of the tree and the bird. Since my distance to the bird was relatively short and since the background trees were twenty feet or so behind this one, the bird was clearly isolated. An aperture of f/5.6 also helped separate the bird from the background.

75–300mm lens at 300mm, f/5.6 for 1/500 sec.

CAPTURING A SUNSET *along Oregon's coastline in the month of October is like winning the lottery, and it's fair to say that my workshop students and I picked the right lottery numbers on this weekend, as we had nothing but sunshine for three days! Fortunately for me, one of my students was photographing a flock of seagulls to the north just as I was getting into position to shoot the small stream that fed into the ocean surf. Her silhouetted shape not only adds a point of interest but also lends a sense of scale and depth to the overall composition. Unlike the photograph on the opposite page, this image clearly conveys sharpness from the immediate foreground to the infinite background, and this was due in large part to the use of a small aperture opening.*

12–24mm lens at 14mm, ISO 200, f/22 for 1/30 sec., 3-stop graduated ND filter

Storytelling Apertures

There are three picture-taking situations for which your attention to aperture choice is paramount. The first is what I call a *storytelling* composition. This is simply an image that, like the name implies, tells a story. And like any good story, there's a beginning (the foreground subject), a middle (the middle-ground subject), and an end (the background subject). Such an image might contain stalks of wheat (the foreground/ beginning) that serve to introduce a farmhouse fifty to a hundred feet away (the main subject in the middle ground/ middle), which stands against a backdrop of white puffy clouds and blue sky (the background/end).

If using a digital camera with a full-frame sensor, experienced amateurs and professionals call most often upon the wide-angle zoom lenses—such as the 35mm, 28mm, 24mm, and 20mm focal lengths—to shoot their storytelling compositions. If using a digital camera with a non-full-frame sensor, the experienced photographer will call on the 12–18mm range. One of the primary reasons wide-angle zooms have become so popular is that they often encompass 100 percent of the range of focal lengths that a photographer would use when shooting storytelling imagery—i.e., 17–35mm with a full-frame sensor or the commonly used 10–22mm or 12–24mm.

It sometimes happens that a storytelling composition needs to be shot with a moderate telephoto (75–120mm) or with the "normal" focal lengths (45–60mm), but regardless of the lens choice, there is one constant when making a storytelling composition: A small lens opening (the biggest *f*-stop numbers) is the rule!

Once you start focusing your attention on storytelling compositions, you may find yourself asking a perplexing question: "Where the heck do I focus?" When you focus on the foreground stalks of wheat, for example, the red barn and sky go out of focus; and when you focus on the red barn and sky, the foreground wheat stalks go out of focus. The solution to this common dilemma is simple: You don't focus the lens at all but rather preset the focus via the distance settings.

There was a time when most photographers used single-focal-length lenses instead of zooms simply because they were sharper. Additionally, all single-focal-length lenses had—and still do have—what is called a depth-of-field scale. This depth-of-field scale makes it very easy to preset your focus for a given scene, and it offers assurance

that you'll get the area of sharpness that you desire in your image. But with the proliferation of high-quality zoom lenses, most photographers have abandoned single-focal-length lenses in favor of zoom lenses. The trade-off, of course, is that we are then running around with lenses that don't have depth-of-field scales.

But what we do have are *distance settings*. The distance settings are similar to the depth-of-field scale in that they allow you to preset the depth of field *before* you take your shot. And since every storytelling composition relies on the maximum depth of field, you would first choose to set your aperture to *f*/22 and then align the distance above your distance-setting mark on the lens. Your focal length will determine which distance you choose.

FOR A SCENE LIKE THIS, *I
know I need great depth of field
to achieve sharpness throughout.
So here, with my 20–35mm wide-
angle lens, I set my aperture to
f/22 and preset my focus so that
the distance of two feet was
aligned directly above the center
mark near the front of the lens.
Of course when I looked through
the viewfinder, the scene looked
anything but sharp. This is because
the viewfinders of all current
cameras allow for wide-open
viewing, meaning that even when
the aperture is f/22, the image in
the viewfinder is seen at a wide
open aperture (f/2.8). The lens
won't stop down to the picture-
taking aperture of f/22 until the
shutter release is pressed. It's at
that point that the sharpness will
be recorded. I obtained the desired
depth of field not by refocusing the
lens but by combining a wide-angle
lens with a storytelling aperture
and presetting the focus via the
distance scale.*

*Both photos: 20–35mm lens at
20mm, f/22 for 1/30 sec.*

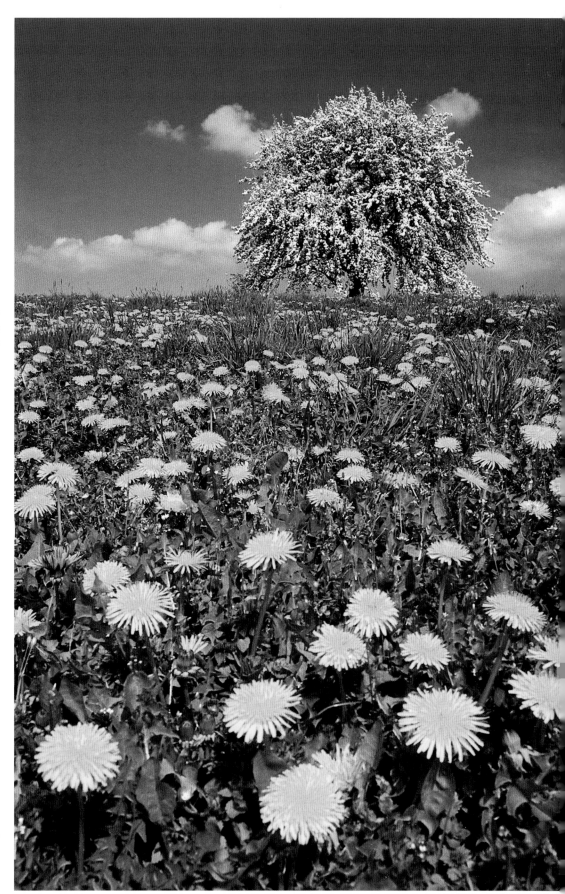

DIFFRACTION VS. SATISFACTION!

Almost weekly, I receive e-mails from students at my online school, as well as from readers of my books, who are "concerned about shooting pictures at apertures of *f*/16 or *f*/22."

Seems a couple of those "big" photography forum Web sites have unleashed some really *old news* that when a lens is set to the smaller apertures, such as *f*/16 or *f*/22, lens diffraction is more noticeable; in laymen's terms, *lens diffraction* means a loss of contrast and sharpness.

So I want to set the record straight about lens diffraction and share what thousands of commercial freelance photographers all over the world know: Shooting at *f*/22 can be a *great idea*, and any worries about loss of sharpness and contrast are just as overblown as the Y2K fears were!

In over thirty-five years of shooting commercially, I can't ever remember a client saying, "Bryan, whatever you do, don't shoot at *f*/22." Nor can I ever remember a single instance when either Getty or Corbis (the two largest stock photo agencies in the world) called me to say, "Bryan, *don't* send us any of your pictures for our stock files if they were shot at *f*/22." And the reason I can't remember is because it has *never happened* and it *never will*.

The aperture of *f*/22 produces a massive depth of field, in particular when combined with a wide-angle lens. When using your wide-angle lens, *if* you have even an ounce of creativity, you'll want to have some foreground interest in your overall composition—since it will be the foreground interest that will create the illusion of depth and the subsequent perspective in your shot. And the only way to record sharpness from front to back when including an immediate foreground is to use *f*/22—the smallest lens opening that, in turn, produces the greatest depth of field (the greatest area of acceptable sharpness).

The long and the short of it is this: The question of using *f*/22 was *never* an issue during the days when we all shot film, and it should *not* be an issue today. Diffraction is a real event, but it should never get in your way of shooting those compositions that demand extreme depth of field. Satisfaction is your reward, so get out there and get creative at *f*/22!

f/22 at 200 percent magnification

f/8 at 200 percent magnification

BOTH OF THESE IMAGES were shot with the same lens at the same focal length, and they are both the same exact exposure in terms of quantitative value, but oh my, is there ever a noticeable difference in their overall sharpness! The first image was shot at the "dreaded" f/22 and the second at the "highly recommended" f/8.

I don't know about you, but I prefer the image taken at f/22 because it shows the overall area of acceptable sharpness that we really need to convey here—front to back. In the image taken at f/8, clearly we don't have front-to-back sharpness. So, with the proof staring at you, what do you think? Will you embrace the use of f/22? You should, if you have any intention of being a creative photographer, because quite simply, you'll never record those great landscape shots unless you choose f/22.

And take a look at the details at 200 percent magnifications, opposite. The difference in the sharpness is almost nil, although I'll be the first to admit that there is a wee bit more contrast in the bark of the tree with the shot taken at f/8 (opposite, right)—but again, this is at 200 percent! This wee bit of contrast loss is something that I, and so many other discerning photographers, can live with.

Both photos: 12–24mm lens at 12mm, ISO 200. Top: f/22 for 1/100 sec. Bottom: f/8 for 1/800 sec.

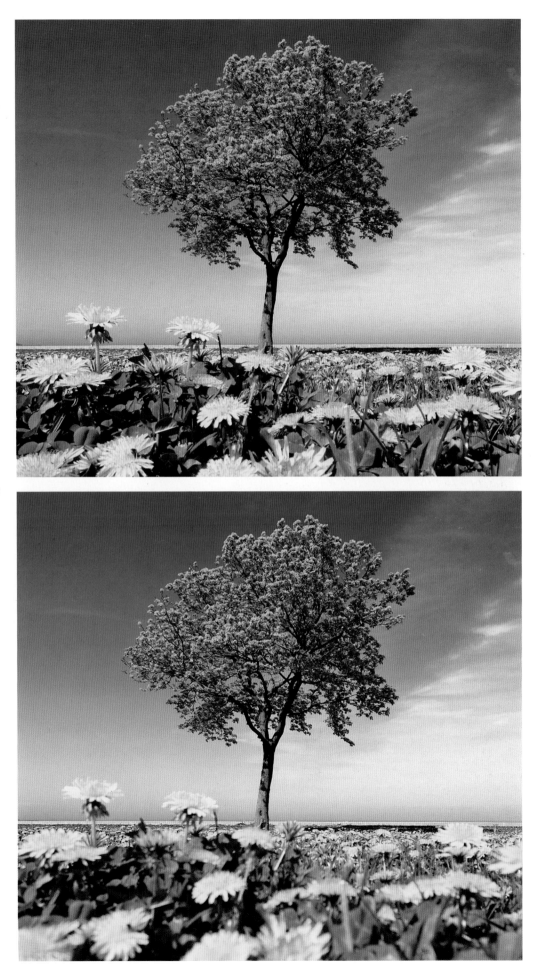

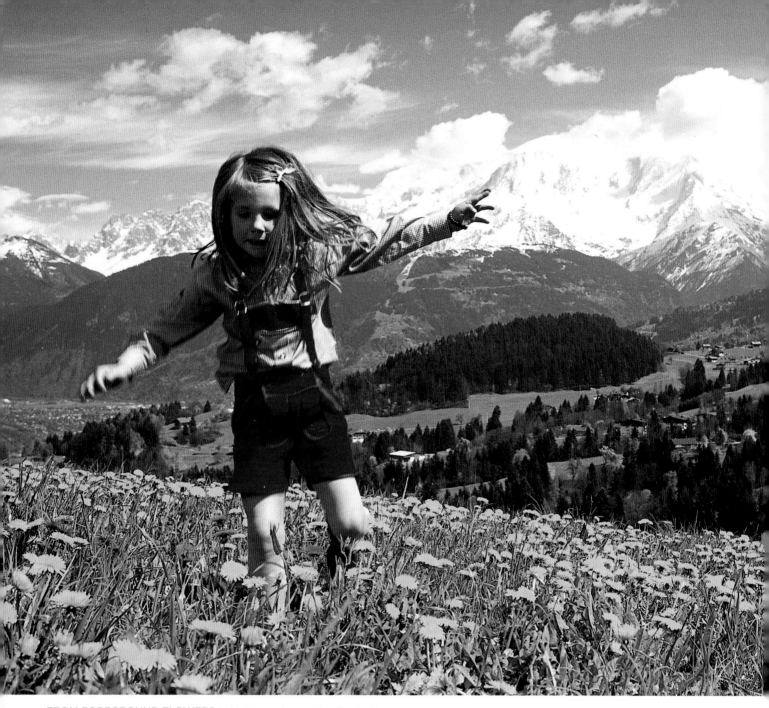

FROM FOREGROUND FLOWERS *to background mountains, the depth of field in this image is extreme. I was setting up my camera and lens to get a storytelling image of flowers and mountains, and had already shot several frames, when my daughter Sophie came running up from the hill below me. It was a photo op I couldn't pass up. With my aperture set to f/16 and my focus already preset for maximum depth of field, I shot this frontlit scene in Aperture Priority mode, firing off several frames. You can get good depth of field at f/16, too, but keep in mind that you should use f/16 only if your foreground doesn't begin closer than four feet from your lens.*

35–70mm lens at 35mm, f/16 for 1/60 sec.

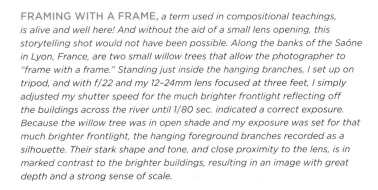

FRAMING WITH A FRAME, *a term used in compositional teachings, is alive and well here! And without the aid of a small lens opening, this storytelling shot would not have been possible. Along the banks of the Saône in Lyon, France, are two small willow trees that allow the photographer to "frame with a frame." Standing just inside the hanging branches, I set up on tripod, and with f/22 and my 12–24mm lens focused at three feet, I simply adjusted my shutter speed for the much brighter frontlight reflecting off the buildings across the river until 1/80 sec. indicated a correct exposure. Because the willow tree was in open shade and my exposure was set for that much brighter frontlight, the hanging foreground branches recorded as a silhouette. Their stark shape and tone, and close proximity to the lens, is in marked contrast to the brighter buildings, resulting in an image with great depth and a strong sense of scale.*

12–24mm lens, f/22 for 1/80 sec.

THE VISION OF THE WIDE-ANGLE LENS

Developing a vision for the wide-angle lens isn't as hard as you might think. Dispelling the "rumor" that a wide-angle lens "makes everything small and distant" is one of the keys to understanding why you should call on the wide-angle lens most often, when you wish to do the most effective storytelling.

The wide-angle lens *does* push everything in a scene to the background, so to speak, and it does so because it is expecting *you* to place something of great importance in that now-empty and immediate foreground—and I can't stress *immediate fore-ground* enough, since therein lies the key to the vision of the wide-angle lens.

Imagine for a moment that you're preparing for a party that will find everyone dancing on your living room floor. What do you do with all of the furniture? You might find yourself push-ing it all to the back wall, which, in turn, opens up the floor so that there is lots of room for dancing. It is initially an empty floor, and I'll be the first to admit it looks wrong: The empty floor calls attention to the fact that no one is dancing. But here comes one couple, followed by another and another, and before you know it, the floor is filled with dancing feet—and now the floor looks like a fun place to be! So, with your dance party in mind, I want you start thinking of using your wide-angle lens in the same way. Do understand that the "vision" of this lens will push everything back time and time again, and it does so solely because you're planning on having a dance party in what is ini-tially an empty foreground—but not for long, of course!

ARE YOU LIMITED TO WIDE-ANGLE LENSES *when making storytelling compositions? Absolutely not, but the wide-angle focal lengths are most often called upon for their ability to encompass the wide and sweeping landscapes—and, of course, for their ability to render great depth of field. There are certainly other compositions for which you use your telephoto lens and also want to make the entire composition sharp. In these cases, I often tell my students to simply focus one-third of the way into the scene and, of course, set the lens to the smallest lens opening. Then, simply fire away.*

While most shooters aren't inclined to think of the wide-angle lens as a close-up lens, if they did, their images (and especially storytelling shots) would improve tenfold. When shooting wide and sweeping scenes, the tendency is to step back to get more stuff in the picture. From now on, try to get in the habit of stepping closer—closer to foreground flowers, closer to foreground trees, closer to foreground rocks, and so on. This poolside scene is one such occasion to get close with a wide-angle lens. Below, there's a lot of stuff in the scene, and the opportunity to exploit foreground color and shape has been missed. But by simply moving closer (bottom), the result is a much more graphic and color-filled image.

Both photos: 20–35mm lens, f/16 for 1/125 sec.

A ROAD BY ITS VERY NATURE *acts as a powerful line that can lead the eye into a scene. After pulling onto the shoulder of this road, I set up my camera and 75–300mm lens on a tripod. I set my focal length to 130mm and my aperture to f/32, and then focused a third of the way into the scene. With my camera pointed upward to the green leaves, I adjusted the shutter speed until a 2/3-stop underexposure (-2/3) was indicated—1/25 sec. instead of the recommended 1/15 sec. (See pages 23 and 134–135 for more on this.) I then recomposed to get the scene here and fired off several frames. Presto! It's in focus throughout.*

75–300mm lens at 130mm, f/32 for 1/25 sec.

DEPTH-OF-FIELD TIP

When shooting storytelling compositions in which you want as much front-to-back sharpness as possible, I'm often asked by students, "Where should I focus?" So here's my foolproof "formula" that's guaranteed to work each and every time.

If you're using a camera with a *"crop factor"* and a lens with a 75-degree angle of view (18mm on the digital 18–55mm zoom), you'll want to first set the aperture to *f*/22 and then focus on something that's approximately five feet from the lens. And then, if you're in manual exposure mode, adjust your shutter speed until a correct exposure is indicated in the camera meter in your viewfinder and shoot. If you're in Aperture Priority mode, simply shoot, since the camera will set the shutter speed for you. Your resulting depth of field

will be approximately from three feet to infinity.

If you're using a 12–24mm digital wide-angle zoom and focal lengths between 12mm and 16mm, set the lens to *f*/22, focus on something three feet away, and repeat the final step mentioned above. Your resulting depth of field will be approximately two feet to infinity. (You must turn off autofocus, by the way.)

For those of you shooting with a *full-frame digital sensor* when using focal lengths from 14mm to 24mm, you would simply focus at three feet. When combined with *f*/22, the resulting depth of field will be two feet to infinity. If you're shooting with the focal length of 25mm to 28mm, your focus must be set to five feet, and you'll record a depth of field from three feet to infinity.

ZOOM LENS CONVERSIONS FOR FIXED-LENS DIGITAL CAMERAS

Whether you shoot with a Minolta, Olympus, Pentax, Nikon, Sony, or Canon fixed-lens digital camera, you no doubt are aware that the focal length of your zoom lens *does not* correspond to the focal-length numbers for a 35mm SLR camera. Your camera may describe the zoom lens as 7–21mm, 9–72mm, or 9.7–48.5mm.

To aid in following along in this book, when I discuss wide-angle lenses or telephoto lenses, take note of how your lens translates its angle of view into 35mm terms. The 7–21mm lens is equivalent to a 38–155mm zoom lens. The 9–72mm lens is equivalent to a 35–280mm zoom lens. And the 9.7–48.5mm lens is equivalent to a 38–190mm zoom lens.

Notice that most fixed-lens digital cameras *don't* have a focal length that offers a greater angle of view than the 62 degrees of the moderate 35mm wide-angle lens used by SLR camera owners. It's a moderate angle of view that seldom creates powerful storytelling compositions, because it's simply not a wide enough angle. So, when thinking about depth of field, keep in mind that your widest lens choice is 35mm, and that is the number you should keep in mind when presetting your lens for maximum depth of field. (See page 46 for focusing for maximum depth of field.)

Fixed-Lens Digital Cameras and Depth of Field

Your fixed-lens digital camera is hopelessly plagued with an uncanny ability to render a tremendous amount of depth of field, even when you set your lens to $f/2.8$—an aperture of $f/2.8$ is equivalent to an aperture opening of $f/11$ on an SLR camera! And, when you're at $f/4$, you're able to record a depth of field equivalent to $f/16$. At $f/5.6$, you're equivalent to $f/22$. At $f/8$, you're equivalent to $f/32$, and if your lens goes to $f/11$, you're at a whopping $f/64$! Those of us who use SLRs can only dream of the vast depth of field that would result from apertures like $f/64$.

One added benefit of having apertures that render such great depth of field is in the area of exposure times. For example, if I were shooting a storytelling composition with my SLR and 35mm wide-angle lens, I would use $f/22$ for maximum depth of field. Combined with an ISO of 100 and assuming I'm shooting a sidelit scene in late-afternoon light, I'd use a shutter speed of around 1/30 sec. With this slow a shutter speed, I'd more than likely use a tripod. You, on the other hand, could choose to shoot the same scene at an aperture of $f/5.6$ (equivalent in depth of field to my $f/22$), and subsequently, you would be able to use a shutter speed that's *4 stops faster*—a blazing 1/500 sec. Who needs a tripod at that speed?!

Likewise, when shooting close-ups of flowers or of dewdrops on a blade of grass (assuming you have a close-up/macro feature), you can shoot at $f/8$ or $f/11$ (equivalents of $f/32$ or $f/64$) and once again record some amazing sharpness and detail that SLR users can only dream of. And, as every SLR user knows, when photographing with a macro lens at $f/32$, we're always using our tripods, since shutter speeds are often too slow to safely handhold the camera and lens. But here again, with your aperture at $f/8$ (an $f/32$ equivalent) you can photograph the same dewdrop at much faster shutter speeds—more often than not, without the need for a tripod.

So, is there a downside to these fixed-zoom-lens digital cameras, other than the absence of a true wide-angle lens? Yes, there is: You can't be nearly as successful when shooting

NORMALLY A SCENE *like this one in Beaujolais, France, would find me reaching for my Nikon D300 and tripod, but I had chosen to travel light on this particular morning with my Leica D-Lux 4 point-and-shoot. Fortunately, like most digital point-and-shoots, the Leica offers up tremendous depth of field, even at f/8 (the equivalent of f/32 on a DSLR). Needless to say, there was no need for a tripod at f/8, since the corresponding shutter for a correct exposure at my chosen ISO of 100 was at a safely handholdable 1/400 sec. This may beg the question, Why not just use this camera all the time, especially since it seems to eliminate the need for a tripod and is obviously lightweight? There are several reasons, the most important being that the file size, although an impressive 11 megapixels, is still too small for commercial clients as well as for most stock agencies. In addition, there's a limitation on what I can and can't do, due to the effective focal length of 24–60mm.*

I will say that we're getting closer to the day when most of us will be able to travel really light and with a camera that offers it all; my dream is a camera similar to the Leica D-Lux 4 that offers up a 16-megapixel sensor and a zoom with an effective focal length of 20–400mm. At the speed technology continues to develop, we may be, at the most, two to three years away from my dream, and I can't wait (neither can my back)!

Leica D-Lux 4, ISO 100, f/8 for 1/400 sec.

singular-theme/isolation compositions (see page 56) as SLR shooters can. Even with your lens set to the telephoto length and your aperture wide open, you'll struggle with most attempts to render a background that remains muted and out of focus. Remember, even wide open—at $f/2.8$, for example—you still have a depth of field equivalent to $f/11$ on an SLR. There are accessories coming onto the market that can help in times like this (auxiliary lenses, close-up filters, and such), but by the time you add it all up, you realize that you could have spent about the same amount of money for an SLR system.

And finally, most fixed-zoom-lens digital cameras *do not* have any kind of distance markings on the lens, so you won't be able to

manually set the focus for maximum depth of field as I've described for the SLR users. Instead, you'll have to rely on estimating your focused distance when shooting storytelling compositions. To make it as easy as possible, do the following: With your lens set to f/8 or f/11 and at the widest focal length (7–9mm), focus on something in the scene that's five feet from the camera. Then, adjust your shutter speed until a correct exposure is indicated and simply shoot! Even though objects in the viewfinder will appear out of focus when you do this, you'll quickly see on your camera's display screen that those same objects record in sharp focus after you press the shutter release.

Isolation or Singular-Theme Apertures

THE OUT-OF-FOCUS *village places the compositional emphasis on just these two lone morning glory flowers. This is the goal of selective focus. To place the visual weight on the flowers, I first focused close and then made the deliberate choice to use a larger lens opening, which in this case was f/6.3. With my Nikon D300 and 28–70mm lens mounted on tripod and the focal length set to 30mm, I was able to encompass a moderately wide and sweeping vision of the surrounding area while still keeping the emphasis on the flowers. With my aperture set to f/6.3, I simply adjusted my shutter speed until 1/400 sec. indicated a correct exposure and fired off several frames.*

28–70mm lens at 30mm, f/6.3 for 1/400 sec.

The second picture-taking situation for which your attention to aperture choice is paramount is when making what I call *isolation or singular-theme* compositions. Here, sharpness is deliberately limited to a single area in the frame, leaving all other objects—both in front of and behind the focused object—out-of-focus tones and shapes. This effect is a direct result of the aperture choice.

Since the telephoto lens has a narrow angle of view and an inherently shallow depth of field, it's often the lens of choice for these types of photographic situations. When combined with large lens openings (*f*/2.8, *f*/4, or *f*/5.6), a shallow depth of field results. A portrait, either candid or posed, is a good candidate for a telephoto composition, as is a flower and any other subject you'd like to single out from an otherwise busy scene. When you deliberately selectively focus on one subject, the blurry background and/or foreground can call further attention to the in-focus subject. This is a standard "visual law" often referred to as *visual weight*: Whatever is in focus is understood by the eye and brain to be of greatest importance.

THE DEPTH-OF-FIELD PREVIEW BUTTON

Is there any tool on the camera that can help determine the best aperture choice for singular-theme compositions? Yes: the depth-of-field preview button. However, this button isn't found on all cameras. And unfortunately, even when it is present, it's often the most misunderstood feature on the camera.

The purpose of this button is simple: When the button is depressed, the lens stops down to whatever aperture you've selected, offering you a preview of the overall depth of field you can expect in your final image. This enables you to make any necessary aperture adjustments, thereby correcting an instance of "incorrect" or unwanted depth of field before recording the exposure.

EXERCISE: MASTERING THE DEPTH-OF-FIELD PREVIEW BUTTON

As simple as the depth-of-field (DOF) preview button is to use, it initially confuses many photographers. A typical comment I hear from students in my workshops is, "I press it and everything just gets dark." Overcoming this distraction isn't at all difficult; it just takes practice. If your camera does indeed have a depth-of-field preview button, try this exercise: First, set your aperture to the smallest number—*f*/2.8, *f*/3.5, or *f*/4, for example. With a 70mm or longer lens, focus on an object close to you, leaving enough room around the object that an unfocused background is visible in the composition. Then, depress the DOF preview button while looking through the viewfinder. Nothing will happen. But now change the aperture from wide open to *f*/8 and take a look, especially at the out-of-focus background. You no doubt noticed the viewfinder getting darker, but did you also notice how the background became more defined? If not, set the aperture to *f*/16 and depress the button again, paying special attention to the background. Yes, I know the viewfinder got even darker, but that once-blurry background is quite defined, isn't it?

Each time the lens opening (the aperture) gets smaller, objects in front of and behind whatever you focus on will become more defined—in other words, the area of sharpness (the depth of field) is extended.

Now, head outside with a telephoto lens—say, a 200mm—and set your aperture to *f*/16. Frame up a flower or a portrait. Once you focus on your subject, depress the DOF preview button. Things will become quite a bit darker in your viewfinder since you've stopped down the aperture, but more important, take note of how much more defined the areas both in front of and behind the subject become. If you want to tone down all that busy stuff around the subject, set the aperture to *f*/5.6. The background will be less defined. Overly busy compositions that are meant to convey a singular theme can easily be fixed with the aid of the depth-of-field preview button.

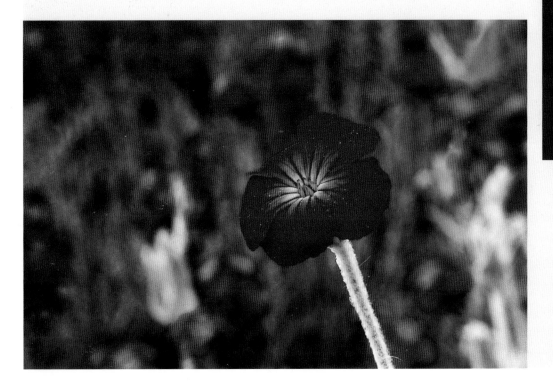

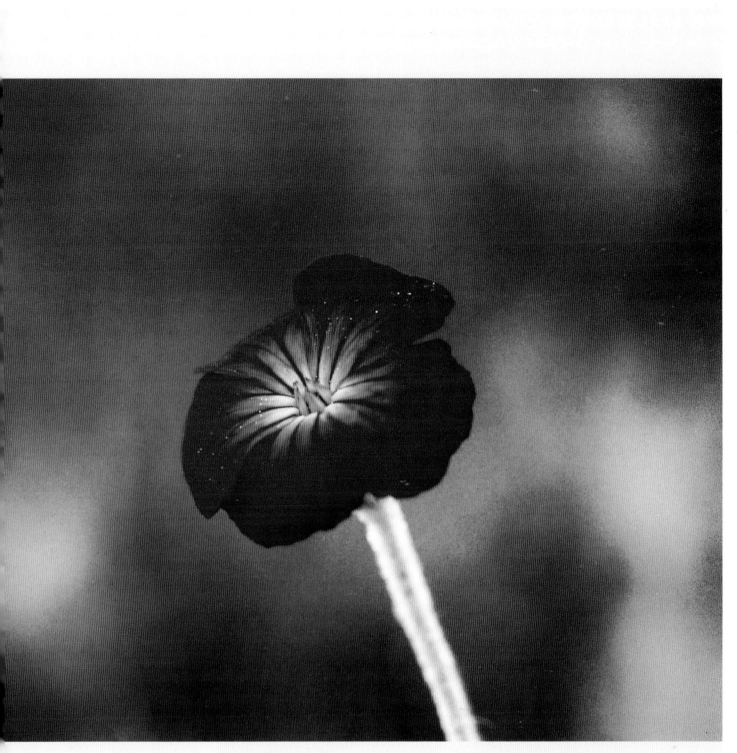

IN THE FIRST EXAMPLE *at f/22 (opposite), note how busy the image is and how the main flower is not alone. Fortunately, I was able to see this when I depressed my depth-of-field preview button and, at that point, moved down toward the smaller aperture numbers—all the while looking through the viewfinder while keeping the DOF preview button depressed. This allowed me to see the once-busy background slowly fade to blurry tones, resulting in a lone-flower composition (above) at an aperture of f/5.6. The soft and muted colors of the out-of-focus background serve to emphasize the importance of the single flower in the photograph. Clearly, I wanted all the attention on this lone flower, and the one sure way to achieve this is to use a large lens opening. A large lens opening, especially when combined with a telephoto lens, renders shallow depth of field.*

Both photos: 75–300mm lens at 280mm. Opposite: f/22 for 1/30 sec. Above: f/5.6 for 1/500 sec.

THE POOR MAN'S DOF PREVIEW BUTTON

Those of you without a depth-of-field preview button may feel you're missing out on a valuable tool. Well, you are, but there are two solutions: If you insist on having a DOF preview button, you can buy a new camera (hopefully, the same make as your current one so that you don't have to buy all new lenses, too). Or, there's the less-expensive approach: Before shooting a singular-theme or isolation image and while still looking through the viewfinder, turn your lens one-quarter of a turn or so (as if you were going to remove it from the camera body, but don't actually remove it). When you do this, you'll see the actual depth of field that the chosen aperture will render. (The viewfinder will also become darker in the same way it does when pressing an actual depth-of-field preview button.)

This is the poor man's depth-of-field preview button. At this point, take note of how much stuff comes into play behind and in front of the subject you're trying to isolate. If you're satisfied with the way the background is being rendered, click the lens back on and fire away. If not, and you want a less-defined background, open up the lens to the next *f*-stop (for example, from *f*/5.6 to *f*/4), and then execute the quarter lens turn again and take another look.

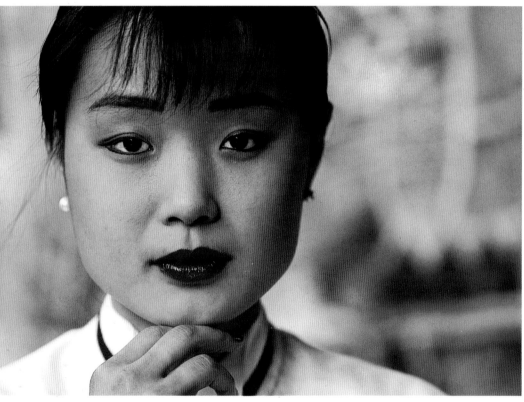

RENDERING COLORFUL BACKGROUNDS *is an easy proposition, if you combine the use of a telephoto lens, a large lens opening, and a colorful background subject. Take a look at this portrait. I used a telephoto lens and shallow depth of field to render the background an area of colorful muted tones. The woman was about ten feet from the background, which was a large, colorful piece of fabric that I had my assistant hold behind her. I made the shot in Aperture Priority mode, letting the camera's light meter set the exposure for me.*

75–300mm lens at 200mm, f/5.6

ALTHOUGH NOT OFTEN CALLED UPON *to create singular-theme images, the wide-angle lens can also be a useful tool for isolating subjects—if you combine the close-focusing abilities of the lens with an isolating aperture, such as f/2.8 or f/4. Here, due to a large lens opening, the depth of field is severely limited, keeping the visual weight of the image where I wanted it—on the freshly picked bouquet.*

35–70mm lens at 35mm, f/2.8 for 1/1000 sec.

"Who Cares?" Apertures

If it's not a storytelling opportunity and it's not a singular-theme/isolation opportunity, does it really matter what aperture you use? Yes and no. Let me explain. The world is filled with *"Who cares?"* compositions: "Who cares what aperture I use when shooting a portrait against a stone wall?" "Who cares what aperture I use when shooting autumn leaves on the forest floor?" Or, put another way, "Who cares what aperture I use when everything in my frame is at the same focused distance?"

In the storytelling and singular-theme/isolation sections, not one of the images was made with an aperture of *f*/8 or *f*/11. That's certainly not because I don't ever use these apertures; I use them a lot, actually, but *only* when depth of field is not a concern. Both *f*/8 and *f*/11 are what I refer to as middle-of-the-road apertures; they rarely tell a story (rendering all the visual information within a great depth in sharp focus), and they rarely isolate (rendering only a limited, selective amount of visual information in sharp focus).

Pretend for a moment that you find yourself walking along a beach. You come upon a lone seashell washed up on the smooth sand. You raise your camera and 28–80mm lens to your eye, set the focal length to 50mm, look straight down, and then simply set the aperture to *f*/8 or *f*/11. In this instance, both the lone seashell and the sand are at the same focused distance, so you could photograph this scene at any aperture. This approach of "not caring" about what aperture you use applies to any composition where the subjects are at the same focal distance. However, rather than randomly choose an aperture, as some shooters do,

I recommend that you use *critical aperture*. This is, simply, whichever aperture yields the optimum image sharpness and contrast. Apertures from *f*/8 to *f*/11 are often the sharpest and offer the greatest contrast in exposure.

To understand why apertures between *f*/8 and *f*/11 are so sharp, you need to know a little bit about lens construction and the way light enters a lens. Most lenses are constructed of elliptically shaped glass elements. Imagine for a moment that within the central area of these elliptical elements is a magnet—which is often called the "sweet

WHO CARES WHAT APERTURE *I use for this resident of Burano, Italy, doing the day's laundry? It's clear that the laundry, the woman, the blue wall, and the green shutters are all at the same focused distance, so concerns about the right depth of field were nonexistent. And with a "Who cares?" opportunity, it's time for f/8 or f/11. Handholding my camera, I set my aperture to f/8, pointed my camera at* only *the blue wall to the left of the woman, and adjusted my shutter speed until 1/400 sec. indicated a correct exposure. I then recomposed the scene with the woman and her laundry. (I'll address where to take meter readings from on page 130.)*

With a scene like this, there's only one thing to do: Shoot now and ask questions later! Who knows how much longer she'll be hanging out her laundry? And so you may be wondering if I got a model release. Yes, but only a "limited release." Just before the woman turned away from the window, I shouted, "Buon giorno," pointed to my camera, said, "Bella foto!" and motioned back to her. That was clear enough, and she met me outside. I carry cards in various languages that explain who I am, what I'm doing, and finally, that I "just made a photograph of you" and wonder if I can have written permission to perhaps someday publish it. With the help of a friendly neighbor who spoke just enough English, I got her to sign the model release to publish her photo only in editorial publications, such as how-to books. In other words, due to the "limited release," this photo will never be used to advertise a product or a destination.

70–200mm lens, ISO 100, f/8 for 1/400 sec.

spot"—designed to gather a specific amount of light and then funnel it through to the awaiting sensor (or film). The approximate diameter of this sweet spot is equivalent to the diameter $f/8$–$f/11$. So, for example, when the light enters a lens through a wide-open aperture, such as $f/2.8$, the amount of light exceeds the area of the sweet spot and, in turn, scatters across the entire elliptical range and onto the sensor. The effect is similar to pouring milk onto an upside-down bowl: Only a little milk remains on the center, while most of the milk spills off to the sides.

Due to the scattering of the light, a wide-open aperture doesn't provide the kind of edge-to-edge sharpness that apertures of $f/8$ to $f/11$ can. When light passes through apertures of $f/8$ to $f/11$, it is confined to the sweet spot on the elliptical glass.

So, *who cares* what aperture you use when shooting compositions where depth of field concerns are minimal at best? You should! And, ironically, you should use "Who cares?" apertures ($f/8$–$f/11$) if you want critical sharpness and great contrast.

THE DEAFENING SOUND *of sirens from passing fire trucks seemed, at first, to be emanating from inside my loft studio. Smelling smoke, I jumped out of bed in record time and frantically looked for the fire. Out my large loft window, I could see a huge warehouse, a mere half block to the left, engulfed in flames. Within seconds, I got to the street and was quickly shooting the firestorm taking place.*

One image that really caught my eye showed thick smoke seemingly engulfing a lone fireman against the backdrop of an even hotter sunrise. Handholding my camera and 105mm lens, I was quick to feel the irony of choosing the "Who cares?" aperture of f/8 in photographing an obviously caring fireman who was valiantly doing his part to put out a warehouse fire.

105mm lens, f/8

I'VE OFTEN SAID TO MY STUDENTS *that every picture we take is merely a "self-portrait of our inner psyche," and it was no surprise to me that my vision was being influenced on this particular early morning that found my family conflicted about our desire to stay another year in Lyon, France, or move back to America. There were many good reasons to stay in France but just as many good reasons to move back to the United States. And in a twist of irony, the song on the radio as I drove toward downtown Tampa this particular morning was "Should I Stay or Should I Go" by the Clash. So was it really a surprise that I found myself pulling off to the side of the road to shoot this "Who cares?" composition of a traffic light that said both stop and go?*

70–200mm lens, ISO 200, f/8 for 1/30 sec.

Aperture and Macro Photography

Close-up, or macro, photography continues to enjoy great popularity with both amateurs and professionals. While such obvious subjects as flowers and butterflies and other insects are ideal for beautiful close-up images, don't overlook the many other close-up opportunities that await in junkyards and parking lots. In my courses, I've noticed more and more that my students are turning their macro gear toward the abstract and industrial world, and coming away with some truly compelling close-ups.

When it comes to working at such close proximity to your subject, you'll soon discover that many of the same principles about aperture in the "big world" apply equally to the small world of the close-up. For instance, although the world is smaller—much, much smaller in some cases—you still must decide if you want great depth of field (one to two inches of sharpness in the macro world) or limited depth of field (one-quarter of an inch). Or, maybe your subject is a close-up that falls into the "Who cares?" aperture category.

There are differences between regular and macro photography, however. When you shoot close-ups, it's not at all uncommon to find yourself on your belly, supporting your camera and lens with a steady pair of elbows, a small beanbag, or a tripod with legs level to the ground. The slightest shift in point of view can change the focus point dramatically. And since the close-up world is magnified, even the slightest breeze will test your patience—what you feel as a 5 mph breeze appears as a 50 mph gust in your viewfinder.

In addition, since depth of field *always* decreases as you focus closer and closer to your subject, the depth of field in macro photography is extremely shallow. The depth of field in close-up photography extends one-fourth in front of and one-half beyond the focused subject, while in regular photography the depth of field is distributed one-third in front of and two-thirds beyond the subject. Needless to say, critical focusing and, again, a steady pair of elbows, a beanbag, or a tripod are essential in recording exacting sharpness when shooting close-ups.

HAVE YOU EVER NOTICED *that the macro feature on your zoom lens will oftentimes just stop short of focusing really close? The solution to this dilemma is extension tubes. Normally sold in sets of three, these hollow metal tubes fit between your camera and lens, allowing the lens to focus even closer. As you can see in the first example (above), my 75–300mm lens with macro falls short of offering a true close-up of the butterfly.*

To get closer and attain exacting sharpness (opposite), I did the following: With my camera and lens mounted on tripod, I chose an aperture of f/5.6 to keep depth of field limited and adjusted my shutter speed until 1/100 sec. indicated a correct exposure in the early-morning light. I then added a 12mm extension tube and was able to move in and focus really close, filling the frame with the butterfly and lone flower supporting it. Since depth of field diminishes the closer you focus, I was careful to choose a viewpoint that placed the side of the butterfly parallel to me. I then adjusted the shutter speed until 1/60 sec. indicated a correct exposure.

Above: 75–300mm lens at 75mm, f/5.6 for 1/100 sec. Opposite: 75–300mm lens at 300mm, 12mm extension tube, f/5.6 for 1/60 sec.

MACRO ACCESSORIES & THE ADVANTAGE OF FIXED-LENS DIGITAL

There are various photographic accessories available to make close-up photography possible. For all of the SLR shooters, you have macro lenses or zoom lenses with a macro or close-focus feature, as well as extension tubes, macro converters, and close-up filters, which are all designed to get you "up close and personal."

For those of you using a fixed-lens digital camera, you can also use close-up filters, or in some cases your camera manufacturer may offer a macro/close-up lens that screws into the front of your lens. And of late, there are a handful of digital point-and-shoots that offer up a surprisingly close focusing distance, usually at the wide-angle end of the fixed digital zoom. One of the reasons I fell in love with my Leica D-Lux 4 is that it can focus down to one-third of an inch at the 35mm wide-angle equivalent of the 24mm lens.

For fixed-lens digital shooters, the world of close-up photography offers closeness that 35mm SLR camera users can only dream of. As explained on page 54, $f/11$ on a fixed-lens digital is equivalent to $f/64$ on a 35mm SLR. That's a lot of depth of field! All of us 35mm SLR camera users are envious of you and your fixed-lens digital for this reason, if for this reason only. Sure, I have a macro lens that can go to $f/32$, but to go 1 stop further to $f/64$. . . oh, that would be so nice. It could make such a difference in much of my close-up work.

Granted, shutter speeds are already slow enough when I shoot at $f/32$, but even so, I would wait hours if necessary for the breeze to stop just so that I could use $f/64$. And here's another bit of good fortune for those fixed-lens digital shooters who have an $f/11$ aperture: Not only do you get to record some amazing depth of field, but you can do so at relatively fast shutter speeds, since your aperture remains at $f/11$ even though it renders depth of field equivalent to $f/64$! If you've ever wanted an excuse to shoot some amazing close-ups, this is certainly a good one. All that remains is to determine whether your lens offers a close-focus feature or a close-up lens attachment. I sure hope so!

BY PLACING THIS LONE *feather on a rock (opposite), I created a composition that offered a great excuse to break out my macro lens for some really-close-up photography. With my aperture set to f/22, I adjusted the shutter speed until 1/15 sec. indicated a correct exposure in the camera viewfinder, and with the camera's self-timer engaged, I then fired off several shots.*

Micro-Nikkor 70–180mm lens at 180mm, f/22 for 1/15 sec.

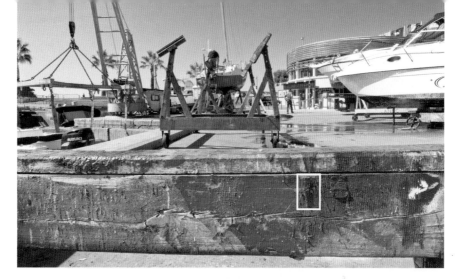

WHILE SHOOTING *in the seaside resort town of Cassis in the south of France, I came upon this boat dolly. Small boats in need of some touch-up paint are placed on the dolly, and as you can see, the painters leave behind painting "remnants"—an abstract close-up opportunity, for sure. And with an ISO of 100, I simply handheld my Leica D-Lux 4 and shot in Aperture Priority mode at f/8, getting a correct exposure with 1/500 sec.*

Leica D-Lux 4, ISO 100, f/8 for 1/500 sec.

JUST HOW CLOSE *can you get to your subjects? With the aid of a small extension tube on a wide-angle lens, you can get really close. This is actually a rose. I used a 35–70mm lens, a tripod, and a small 12mm extension tube, and was soon lost in a world of sensuality, curvilinear lines, and tones. Since I wanted to render the softer shapes and hues of the rose in a highly charged, sensual way, it was critical that I use a large lens opening—in this case, f/4—not a small one.*

35–70mm lens at 35mm, 12mm extension tube, f/4 for 1/60 sec.

DO YOU NEED AN EXCUSE *to wake up early? Here it is: Early morning is the best time to get lost in fields and meadows covered with dew. With my 35–70mm lens in 35mm macro/close-focus mode, I came upon a blade of grass with not one but two dewdrops hanging on it. To give these dewdrops a sense of place, I set my aperture to f/22 and was able to render them in sharp detail while at the same time including the out-of-focus shape of a distant tree in the background. For a different macro look—the two drops all by themselves—I switched to my Micro-Nikkor 70–180mm lens. With my camera resting on a small beanbag support, I was able to sharply render the two lone dewdrops and the upside-down fish-eye reflections (of the tree and field beyond) that were within each drop. I used a cable release to trip the shutter and shot a few exposures in between the very light breeze blowing through the meadow. Crawling around this field in my rain pants proved to be a good idea.*

Above: 35–70mm lens at 35mm, macro/close-up mode, f/22 for 1/8 sec.
Opposite: Micro-Nikkor 70–180mm lens at 180mm, f/32 for 1/4 sec.

OIL & WATER *DO MIX*

We offer up a monthly photo contest at my online school, ppsop. com, and none has ever created the onslaught of e-mails like the one in February 2009. The theme was *pattern*, and as usual, the contest enforced our rule that the image be made *in camera* and not manufactured in Photoshop. Most of the e-mails expressed an interest in the story behind the photograph taken by our second-place winner, Angie Wright. Her simple yet striking image of oil and water had most everyone shaking their heads with disbelief and, of course, asking the question *"How* did she do it?" Having discovered her technique myself some years ago, I went out onto my back deck a few days later with fresh inspiration and shot a few new images of oil and water. It's an easy thing. The "trick" is to decide what kind of colored background you want *and* to be patient! Hunching over this setup with your camera and lens on tripod while waiting for the right arrangement of oil and water to form will test your patience, but it's truly worth it!

THIS IS NOT A DIFFICULT SETUP. *I've used a glass bread pan here, placed atop two large drinking glasses. For my background, I placed one of my "wild and crazy colorful shirts" underneath the pan. I filled the pan about two-thirds full with water and then simply poured a number of small drops of cooking oil into it.*

I made this close-up image with my Nikkor 200mm macro. You don't need a macro lens to do this, but you will need a set of extension tubes. When placed between a lens that offers up a 60–100mm focal length, the extension tube(s) will get you in really close, and soon you'll be enjoying some unbelievable images! And let me reiterate, this technique is not done in Photoshop!

200mm macro lens, ISO 200, f/11 for 1/60 sec.

Aperture and Specular Highlights

You've undoubtedly seen your share of movies that contain night scenes shot on well-illuminated streets. Did you notice that when the camera focused in close on the characters, the background lights appear as out-of-focus circles or hexagons of color? Like the idea of visual weight, this is another optical phenomenon: In close-up photography, any out-of-focus spots of light appearing inside the viewfinder will record on digital media or film in the shape of the aperture in use. Additionally, the distance between the main subject and the background lights determines just how large and diffused the out-of-focus spots will be. The spots are called *specular highlights*.

To produce a background of out-of-focus circles, you must use a wide-open aperture. This is the only aperture that is 100 percent circular in shape. All other apertures are hexagonal. So whether you're using a macro lens (for which a wide-open aperture may be $f/2.5$ or $f/4$) or a telephoto zoom with the "macro" setting or extension tubes on your 35–70mm zoom (when wide open is $f/3.5$ or $f/5.6$), you must physically set the aperture to the wide-open setting if you want to record circular shapes.

If you have a fondness for hexagonal shapes, simply use any aperture *except* wide open. The sooner you put yourself in positions to explore and exploit these out-of-focus shapes, the sooner you can begin to record compositions of great graphic symbolism.

Finally, don't forget to photograph the sun. I've arrived in countless meadows at dawn or just before sunset and focused my close-up equipment on a single of blade of grass or seed head, framing it against a large and looming out-of-focus "ball" of light. What I recorded was, of course, not the actual sun itself but rather a circular record of its distant rays of light.

EXERCISE: CHRISTMAS LIGHTS— NOT JUST FOR THE HOLIDAYS

Grab a string of Christmas tree lights and, in a dark room, plug them in. From across the room, look at the lights through your close-up lens (either an actual macro lens, a zoom lens with a macro/close-focus setting, or a short telephoto lens with an extension tube). Now place your hand out in front of the lights and focus your camera on your hand until it's sharp. You should see a host of out-of-focus shapes of light behind your hand.

Again, to record these out-of-focus shapes as circles, you must use a wide-open aperture (the smallest aperture number). To record these shapes as hexagons, consider shooting at $f/8$ or $f/11$. If your camera has a depth-of-field preview button, press it once you've set the aperture to $f/8$ or $f/11$, and note how the shapes change from circles to hexagons.

Now that you've practiced on Christmas tree lights, consider putting this technique to work at any time of year. Theater marquees, building lights, and even car head- and taillights can be rendered as out-of-focus spots of light. Simply look at any of these subjects with your close-up equipment from a distance of ten to twenty feet and enjoy the light show. For those with film cameras, these specular highlights can be great elements in double exposures of city scenes at dusk or nighttime. Shoot a version of the scene in focus and then another out of focus.

MY BROTHER JIM *promised me but one day off, slave driver that he is, if I would help him build his home in Kodiak, Alaska. When my day off arrived, I bolted out the door at dawn and into the arctic cold. I didn't have far to go before I was immersed in the world of close-ups, framing a lone seed head against a backdrop of out-of-focus and colorful specular highlights. With a wide-open aperture of f/4, I was assured of recording round shapes. Due to the strong backlight, I set my exposure for the light falling on the grass near my feet, adjusted the shutter speed to 1/125 sec., and then recomposed.*

70–180mm micro lens at 180mm, f/4 for 1/125 sec.

EXERCISE: THAT PERFECT CIRCLE

Even if there's only one light source or area of light in the distance of your composition, if you're shooting a close-up image with your macro lens or your Canon 500D close-up filter or extension tubes, that light source will assume the shape of the aperture and record as one out-of-focus spot of light. And again, if you wish to render it a perfect circle, you must use the largest lens opening. Depending your lens, that may be f/4, f/3.5, or f/2.8.

I know I don't have to twist your arm to shoot a sunset, and if you get in the habit of also shooting simple yet effective compositions of a subject set against an out-of-focus spot of light (a single shaft of the sun's light), you will soon double your production of winning images. It's during the first minutes of sunrise or the last few minutes of sunset when you have the opportunity to shoot directly into the sunrise or sunset light and do just that—record that single out-of-focus ball colorful of light.

This idea is *not* limited to the sun. Any out-of-focus light source will perform in the same manner: flashlights, matches, porch lights, headlights, taillights, bright sunlight reflecting off rivers and streams, Christmas lights, and even streetlamps (opposite).

Try this yourself to see exactly what I mean: Dim the lights in the dining room or kitchen, and grab a flashlight. Turn it on, and lay it down on one end of a table, pointing it toward you where you have your camera set up with a macro or zoom lens in combination with a Canon 500D close-up filter or an extension tube. Now grab a fork or straw—or heck, even a toothbrush—and place it in a glass. Focus on the fork tines, the straw, or the toothbrush bristles, and what do you see? An out-of-focus ball of light directly behind your focused subject! And again, to record that perfectly circular shape, you *must* set your aperture wide open.

FOR THIS SHOT, THE SUN *was starting to rise, and so I picked my three stalks of wheat, holding them in my left hand. With my camera and Micro-Nikkor 60mm lens on tripod (and an FLW filter, for a deep magenta color that I often favor for sunrises and sunsets), I began to focus on the three stalks of wheat that I held directly in line with the sunrise. Immediately, I could see an out-of-focus ball of yellow light (a shaft of light from the distant sunset) that was a welcomed contrast to the three silhouetted stalks of wheat. To ensure that I recorded a circular—and not hexagonal—shape, I set my aperture wide open (f/2.8). All that remained was to adjust my shutter speed and shoot.*

Micro-Nikkor 60mm lens, f/2.8

PROOF THAT THIS *technique will work with any number of light sources is the exercise I recently did with one of my students, Eugene Almazan, in my on-location Chicago workshop. We were shooting the Chicago skyline from North Beach when I suggested he turn around and take note of the parking lot streetlamp that had just come on.*

I grabbed a nearby dandelion seed head and suggested that he mount his Nikon D300 and Micro-Nikkor 105mm lens onto his tripod and set his aperture to the wide-open setting (f/2.8, in this case). I then had him hold the dandelion at roughly arm's length and focus on it while also including the streetlamp in his composition. His response: "Wow! It looks like there's a sunset behind the seed head!" And sure enough, as you can see here in his photograph, it does indeed look like a big ball of setting sun is going down behind the dandelion seed head.

Micro-Nikkor 105mm lens, f/2.8

The Importance of Shutter Speed

The function of the shutter mechanism is to admit light into the camera—and onto the digital media or film—for a specific length of time. All SLR cameras, digital or film, and most digital point-and-shoot cameras, offer a selection of shutter speed choices. Shutter speed controls the effects of motion in your pictures, whether that motion results from you deliberately moving the camera while making an image or from your subjects moving within your composition. Fast shutter speeds freeze action, while slow ones can record the action as a blur.

Up until now, our discussion has been about the critical role aperture plays in making a truly creative exposure. That's all about to change as shutter speed takes center stage over the next several pages. There are two situations in which you should make the shutter speed your first priority: when the scene offers motion or action opportunities, or when you find yourself shooting in low light without a tripod. The world is one action-packed, motion-filled opportunity, and choosing the right shutter speed first and then adjusting the aperture is the order of the day for capturing motion in your images.

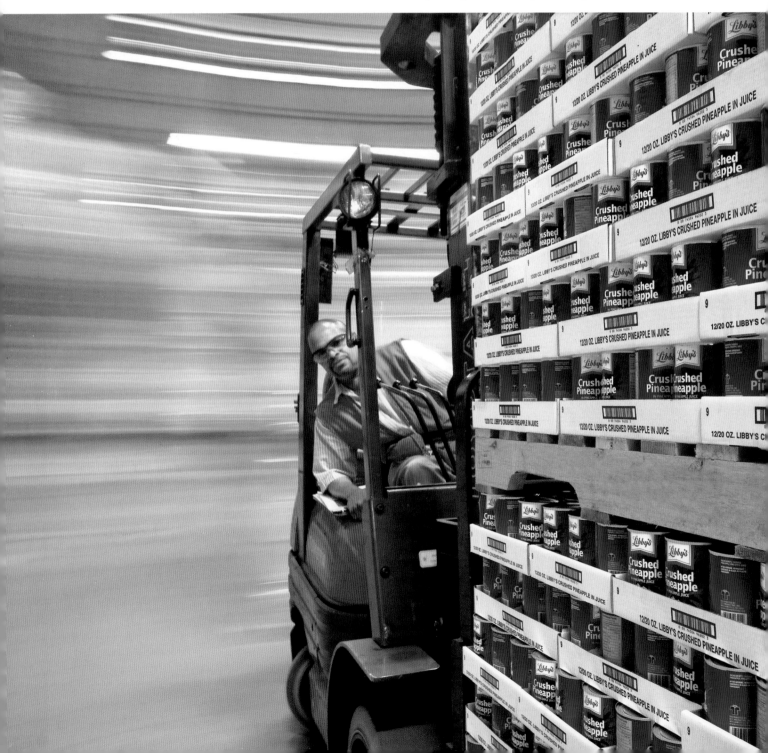

I WAS RECENTLY HIRED TO SHOOT *a series of images for a company called Flex Solutions in Orange County, California. An industry leader in the area of third-party logistics, Flex Solutions' aim was to convey its speed and efficiency to clients. Motion-filled images were the ultimate goal, and the obvious photo solutions involved some rather precarious camera positions.*

Among the 1,520 images I shot over the course of two days, about 30 percent of them required attaching the camera to several of the many lift trucks operating in Flex's 200,000-square-foot warehouse. Ask any commercial photographer what one vital tool of the trade is and the answer will be duct tape, and on this particular shoot, duct tape was king! With my tripod at full extension, I was able to jam the lower eighteen inches of the legs in between the central pallet, and after wrapping the legs and portions of the pallet in duct tape, I was "off to the races."

With my camera and lens mounted securely to the tripod head, as the lift truck driver drove between the many rows of products, I walked in a hurried pace, firing the camera with the attached cable release. With the camera in Aperture Priority mode and my aperture set to f/22, my exposure times varied between 1/4 sec. and 1 full second (the light values would vary as the trucks ventured down different aisles). In addition, due to the overhead tungsten ceiling lighting, I set my white balance to Tungsten. A number of exposures turned out quite well, and if I could offer just one piece of advice, using duct tape would be it!

12–24mm at 12mm, ISO 200, f/22 for 1/2 sec.

The Right Shutter Speed for the Subject

HEARING THE SOUND OF AN ONCOMING TRAIN, *I hurriedly turned my attention away from the sunflower close-up I was making and zoomed my lens from 70mm to 35mm to create a storytelling composition of a sunflower field and moving train. I quickly set my shutter speed to 1/60 sec. and adjusted the aperture until f/22 indicated a correct exposure. With the camera on tripod, I pressed the shutter release as the train made its way across the tracks at a speed of more than 120 mph. The obvious motion that resulted conveys the idea of high-speed trains in France, and the picturesque landscape that surrounds it could entice even the most diehard plane rider into trying the train.*

35–70mm lens at 35mm, 1/60 sec. at f/22

I f ever there was a creative tool in exposure that could "turn up the volume" of a photograph, it would have to be the shutter speed! It is *only* via the shutter speed that photographers can freeze motion, allowing the viewer's eye to study the fine and intricate details of subjects that would otherwise be moving too quickly. And *only* with the aid of the shutter speed can photographers imply motion, emphasizing existing movement in a composition by panning along with it.

As an example, the waterfall is one of the most common motion-filled subjects. In this situation, you can creatively use the shutter speed two ways: You can either freeze the action of the water with a fast shutter speed or make the water look like cotton candy with a much slower shutter speed. Another action-filled scene might be several horses in a pasture on a beautiful autumn day. Here, you can try your hand at panning, following and focusing on the horses with your camera as you shoot at shutter speeds of 1/60 or 1/30 sec. The result will be a streaked background that clearly conveys the action with the horses rendered in focus. Freezing the action of your child's soccer game is another motion subject. Any city street scene at dusk is another. Using shutter speeds as slow as 8 or 15 seconds (with a tripod, of course) will turn the streets into a sea of red and white as the head- and taillights of moving cars pass through your composition.

BASIC SHUTTER SPEEDS

Although standard shutter speeds are indicated on the shutter speed dial or in your viewfinder as whole numbers—such as 60, 125, 250, and 500—they are actually fractions of time (i.e., fractions of 1 second): 1/60 sec., 1/125 sec., 1/250 sec., and 1/500 sec. If you bought your camera recently, you may find that your camera offers shutter speeds that fall between these: for example, going from 1/60 sec. to 1/80 sec. to 1/100 sec. to 1/125 sec. to 1/160 sec. to 1/200 sec. to 1/250 sec. and so on. These additional shutter speeds are useful for fine-tuning your exposure, and I discuss this idea in greater detail on the chapter on light.

In addition to these numbers, most cameras offer a B setting as part of the shutter speed selection. B stands for *bulb*, but it has nothing to do with electronic flash. It's a remnant from the early days of picture-taking, when photographers made an exposure by squeezing a rubber bulb at the end of their cable release, which was attached to the camera shutter release. Squeezing the bulb released air through the cable, thereby locking the shutter in the open position until the pressure on the bulb was released. Today, when photographers want to record exposures that are longer than the slowest shutter speed the camera will allow, they use the B setting, along with a cable release and a tripod or very firm support.

Freezing Motion

The first photograph I ever saw that used the technique of freezing action showed a young woman in a swimming pool throwing back her wet head. All the drops of water and the woman's flying hair were recorded in crisp detail. Since the fast-moving world seldom slows down enough to give us time to study it, pictures that freeze motion are often looked at with wonder and awe.

More often than not, to freeze motion effectively you must use fast shutter speeds. This is particularly critical when the subject is moving parallel to you, such as when a speeding race car zooms past the grandstand. Generally, these subjects require shutter speeds of at least 1/500 or 1/1000 sec. Besides race cars on a track, many other action-stopping opportunities exist. For example, Sea World provides an opportunity to freeze the movement of killer whales as they propel themselves out of the water from the depths below. Similarly, rodeos enable you to freeze the misfortunes of falling riders. And on the ski slopes, snowboarders soar into the crisp, cold air.

When you want to freeze any moving subject, you need to consider three factors: the distance between you and the subject, the direction in which the subject is moving, and your lens choice. First, determine how far you are from the action. Ten feet? One hundred feet? The closer you are to the action, the faster the shutter speed must be. Next, determine if the action is moving toward or away from you. Then decide which lens is the most appropriate one.

For example, if you were photographing a bronco rider at a distance of ten to twenty feet with a wide-angle or normal lens, you'd have to use a shutter speed of at least 1/500 sec. to freeze the action. If you were at a distance of one hundred feet with a wide-angle or normal lens, his size and motion would diminish considerably, so a shutter speed of 1/125 sec. would be sufficient. If you were at a distance of fifty feet and using the frame-filling power of a 200mm telephoto lens, 1/500 sec. would be necessary (just as if you were ten feet from the action). Finally, you'd need a shutter speed of 1/1000 sec. if the bronco rider were moving parallel to you and filled the frame either through your lens choice or your ability to physically move in close.

WHILE BUYING ONE OF THOSE PLASTIC *fish-identifier cards at the dive shop across from our hotel on Maui, I overheard a couple of surfers talking about the promise of "some big swells coming in on the North Shore tomorrow." Rising early the next morning, I found the spot where both big waves and surfers would soon be arriving. After traveling down a somewhat narrow path along a rather steep cliff, I found the perfect shooting spot and waited for some hoped-for surfers. Luckily, within thirty minutes, several surfers had arrived, along with some really large twenty- to thirty-foot waves.*

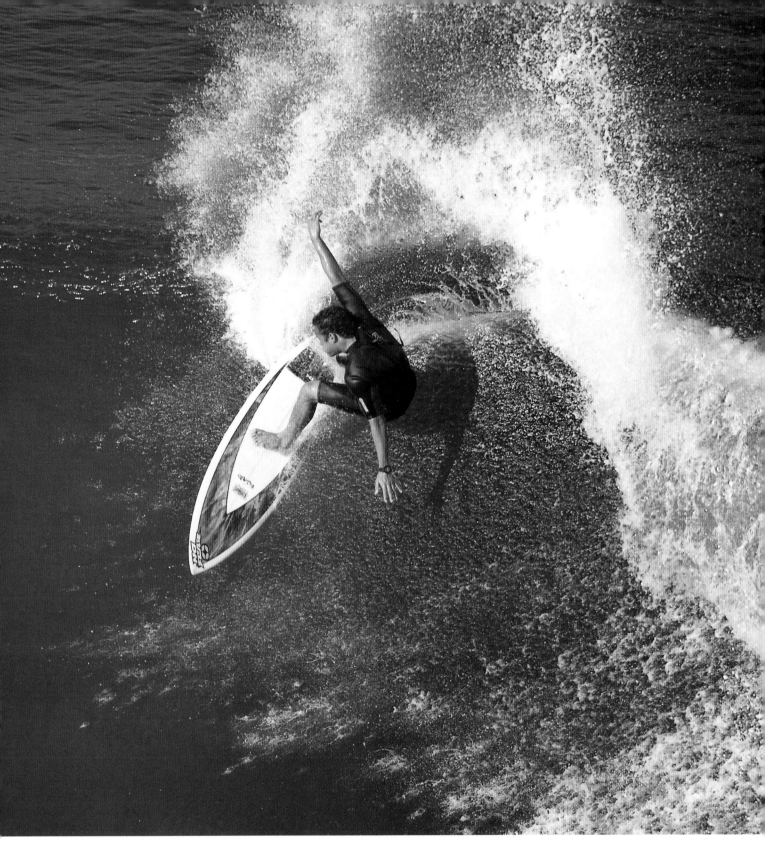

With my camera and zoom mounted on a monopod, I set my shutter speed to 1/1000 sec. and adjusted the aperture until f/5.6 indicated a correct exposure from my good friend overhead, Brother Blue Sky. (Read more about the Sky Brothers on page 130.) I find the clear blue sky a great place to take a meter reading when shooting early-morning or late-afternoon frontlit scenes when those scenes have as much white in them as these waves did. White is a killer when it comes to exposure, as it "reads" far too bright, and often, the end result is an exposure that looks far more gray (underexposed) than white. To avoid this, I almost always will take a reading from the blue sky about 30 degrees above the horizon, since it's "neutral" insofar as it's not too dark or too light.

Although I was only there for less than an hour, I managed to record a number of exciting images. With the action moving at such a frantic pace, and in a rare move (since I'm strong believer in manual focus), I switched my autofocus mode to AF-Servo, which meant that my Nikon continuously kept my subject in focus as I tracked it inside my viewfinder.

200–400mm zoom lens, monopod, ISO 100, 1/1000 sec. at f/5.6

WHEN MY DAUGHTER SOPHIE got a pogo stick for her twelfth birthday, I was as surprised as she was. She wasn't expecting one, and I didn't even know they still made pogo sticks. That's why I'm not in charge of buying the birthday presents!

With any up-and-down motion, 1/500 sec. is all it takes to freeze the action. How you get to 1/500 sec. is another matter, and in this case, due to the very low, dusk light levels, I found myself opting to increase the ISO to 1200—and even at this high ISO, I still found myself using an aperture of f/4. So beyond being an obvious frozen-action shot, this is also a testament to the fine grain/noise reduction that the current crop of DSLRs offer even at the high ISOs. But I must add that the color and contrast were not quite what I wish. Such is the trade-off when using those "low-noise high ISOs" in low light.

70-200mm lens at 200mm, ISO 1200, 1/500 sec. at f/4

KIDS AND PUDDLES go together like peanut butter and jelly. In Place Terreaux in Lyon, France, numerous small fountains dot the marbled pavement—an open invitation to kids to jump over them as if they were puddles. I chose a very low viewpoint—lying on my knees and belly in front of a fountain—and challenged several nearby children to make the jump.

Since the late-afternoon sunlight cast its warm glow on the face of the city hall and since the fountain was in open shade, I knew this would be a very graphic exposure, combining a strong silhouetted shape against a warmly lit background. To accomplish this, I first determined my lens choice: 17–35mm wide-angle set to the 20mm focal length. This wide and sweeping vision would let me capture not only the child in the foreground but also the surrounding plaza and distant city hall. I then chose a shutter speed of 1/500 sec., set my light meter to spot metering, took a meter reading from the warm light falling on the building, and adjusted the aperture until f/9.5 indicated a -2/3 exposure (see pages 23 and 134). I was now ready and motioned to the kids to start jumping. This image was my best from the more than twenty made. Since my exposure was set for the much brighter light falling on the building, the foreground—including the child—recorded as a severe underexposure, seen here as a silhouette.

17-35mm lens at 20mm, 1/500 sec. at f/9.5

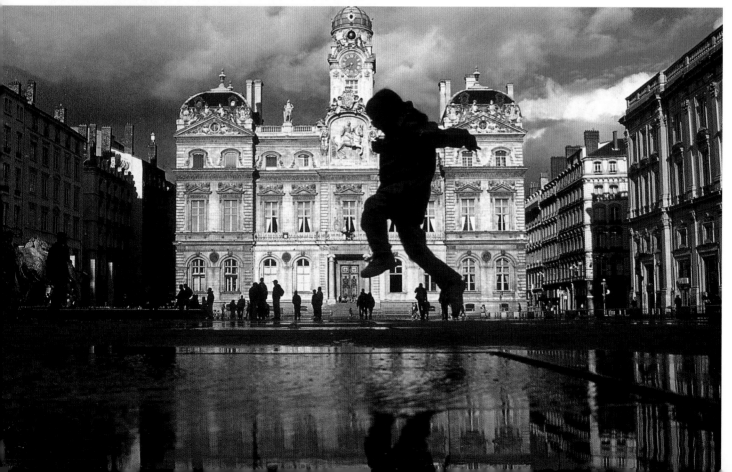

IN MY EARLY YEARS AS A PHOTOGRAPHER, *I spent many hours—from the safety of a makeshift blind that was really just a window in my garage—photographing the birds that came to my bird feeder. Obviously, a bird feeder attracts lots of birds, especially in winter when food is sometimes scarce, and I photographed my share of juncos, chickadees, and finches.*

When I helped my brother build his home in Alaska, however, we both took time out to photograph eagles! And unlike me with my backyard bird feeder of suet, millet, sunflower seeds, and peanut butter, my brother placed large pieces of salmon on several sheets of plywood. Leaving their perch in a nearby tree, the eagles swooped toward the salmon at a fast pace and, with their claws outstretched, snagged the pieces of salmon with grace and ease.

Unlike photographing birds perched in trees, photographing any birds in flight—especially big ones like eagles and especially when they're so close to you—requires the use of a fast shutter speed to freeze the action (flying speeds can reach 30 or 40 mph). With my camera and lens on autofocus, I first set my shutter speed to 1/500 sec. With the sun at my back and the eagles bathed in early-morning frontlight, I simply aimed the camera toward the blue sky above some distant hills and adjusted my aperture until f/9 indicated a correct exposure. I then recomposed and fired away at the many eagles flying nearby.

80–400mm lens at 400mm, 1/500 sec. at f/9

MOTOR DRIVES

Most cameras today come fully equipped with a built-in motor drive or winder, which allows photographers to attain a higher degree of success when recording motion. Without the aid of a motor drive or winder, it's often a hit-and-miss proposition as you try to anticipate the exact right moment to fire the shutter. With the aid of a winder or motor drive, you can begin firing the shutter several seconds ahead of the peak action and continue firing through to a second or two after, and it's a very safe bet that one—if not several—of the exposures will succeed! Depending on your camera, you may have one "continuous shooting mode" speed or several. Some cameras offer a "low" mode, which fires off about two frames per second, while others offer also offer a "high" mode, which can fire off upward of seven frames per second.

Panning

Unlike photographing motion while your camera remains stationary (as described on the previous pages), panning is a technique photographers use in which they deliberately move the camera parallel to—and at the same speed as—the action. Most often, slow shutter speeds are called for when panning, i.e. from 1/60 sec. down to 1/8 sec.

Race cars, for example, are a common panning subject. In this situation, from your spot in the grandstand you would begin to follow a race car's movement with your camera as the car enters your frame. Next, while holding the camera, you would simply move in the same direction as the car, left to right or right to left, keeping the car in the same spot in your viewfinder as best you could and firing

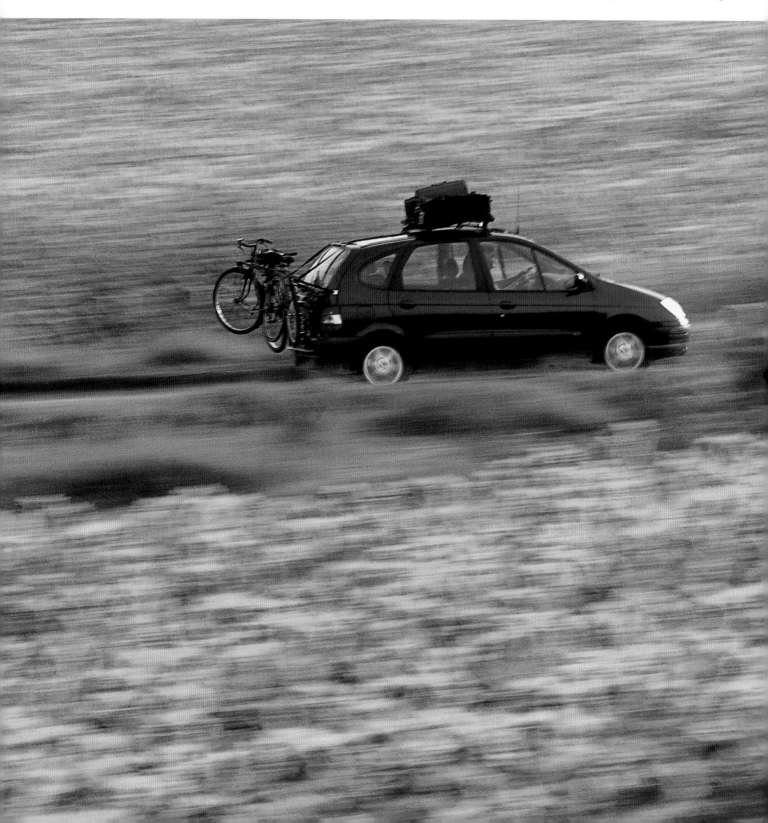

at will. You should make a point to follow through with a smooth motion. (Any sudden stop or jerky movement could adversely alter the panning effect.) The resulting images should show a race car in focus against a background of a streaked, colorful blur.

The importance of the background when panning cannot be overstated. Without an appropriate background, no

blurring can result. I'm reminded of one my first attempts at panning years ago. Two of my brothers were playing Frisbee. With my camera, 50mm lens, and a shutter speed of 1/30 sec., I shot over twenty exposures as the toy streaked across the sky. Twenty pictures of a single subject seemed almost nightmarish to me back then, but I wanted to be sure I got at least one good image. Unfortunately, not a single image turned out! With the Frisbee against only a clear and solid-blue sky, there was nothing behind it to record as a streaked background. Keep this in mind; panning is a good reason to take note of potentially exciting backgrounds.

I use a tripod frequently, but when it comes to panning, a tripod, for some, can be a hindrance. I can hear the roar of thunderous applause at the idea of leaving your tripod at home! But not so fast! The tripod can still help you here, but keep in mind that since you're panning moving subjects, you must be free to move. So do *not lock* down the tripod head but instead keep it loose so that it's free to move from left to right or right to left as the case may be.

I WAS HAVING THE TIME *of my life shooting sunflowers out in the middle of nowhere—where the only noise that breaks the incredible silence is the occasional car passing on the lone country road that runs through this field. It wasn't until I turned my attention away from the sunflowers that it occurred to me that panning on a car as it drove by could prove to be a good stock shot. And, as often happens in cases like this, once I wanted a car, I had to wait and wait and wait for one. Just when I thought about packing it in, I heard a car approaching. I put the camera to my eye and did a quick recheck of my exposure (1/60 sec. at f/16) as I metered the blue sky above the field of flowers. Once the car entered the frame, I began to shoot and pan, following the car and doing my best to keep it in the same point in the frame while moving the camera from left to right. I just kept firing the whole time the car was there (the camera's motor drive fired off five frames per second). And my hunch was right, as this one image has earned thousands of dollars over the years.*

80–200 lens at 200mm, 1/60 sec. at f/16

AMUSEMENT PARKS *are another source of motion-filled opportunities, and here again, you can practice—and, with a bit of luck, succeed at—the art of panning. The Kamikaze is one of those rides that will test even those with iron stomachs, as it zips on by in the same 360-degree fashion as the hands of a clock. The basket where the riders sit is anything but colorful (it's a mere white, rocketlike shape), but on the opposite end, the word Kamikaze is written out in colors and lights. So this bold, hammerlike shape became the focus of my attention, and handholding my Nikon D300, I framed up that end of the ride and fired away as it went zipping past in its downward motion.*

28–70mm lens, ISO 200, 1/30 sec. at f/22

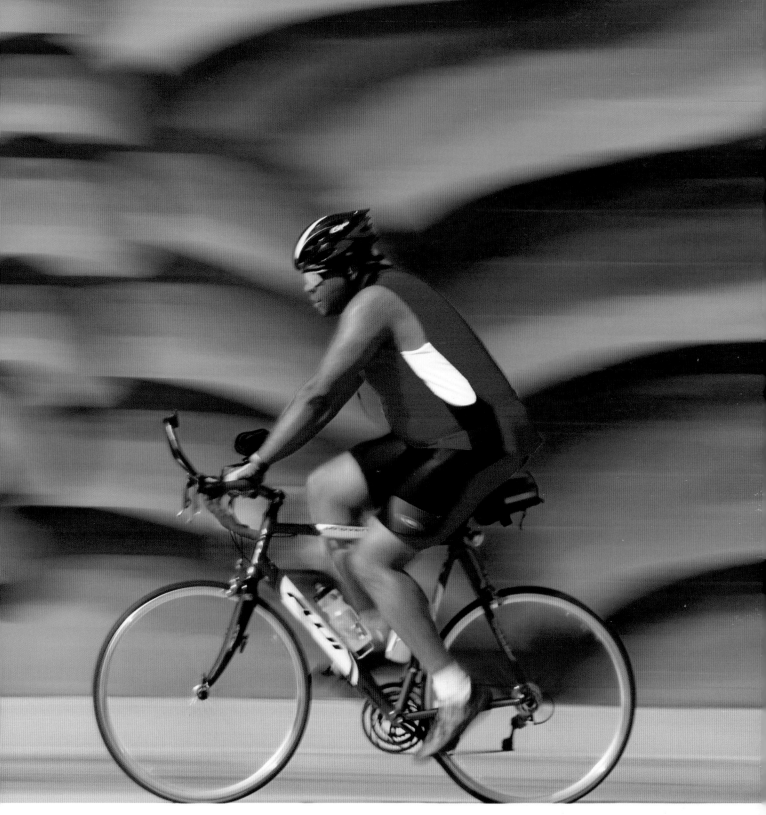

EAST OF DOWNTOWN SAN DIEGO, *near the shipyards, several long murals line the side of the busy four-lane highway. For reasons unknown to me, this road is a popular with cyclists on the weekends. (Heck, maybe they're headed for Tijuana, Mexico!) Nonetheless, it's those long murals that provide a colorful backdrop perfect for panning at slow shutter speeds, such as 1/60 sec., 1/30 sec., or even slower. Since this is such an active bike path, you don't have to hurry the shot for fear of never seeing another cyclist, so I set up my tripod with my telephoto lens but I did not tighten the swivel/pan part of the tripod head; this let me be fluid and smooth in my side-to-side movement of the camera, while keeping the camera level. The outcome is a successful panning shot that exudes energy thanks to the streaked effects that result in the background during a slow exposure.*

70–200mm lens at 175mm, ISO 200, 1/25 sec. at f/10

Implying Motion

When the camera remains stationary—usually on a firm support such as a tripod—and there are moving subjects, the photographer has the opportunity to imply motion. The resulting image will show the moving subject as a blur, while stationary objects are recorded in sharp detail. Waterfalls, streams, crashing surf, airplanes, trains, automobiles, pedestrians, and joggers are but a few of the more obvious subjects that will work. Some of the not-so-obvious include a hammer striking a nail, toast popping out of the toaster, hands knitting a sweater, coffee being poured from the pot, a ceiling fan, a merry-go-round, a seesaw, a dog shaking itself dry after a dip in the lake, windblown hair, and even wind blowing through a field of wildflowers.

Choosing the right shutter speed for many of these situations is oftentimes trial and error. If ever there was a time to embrace the digital camera, this would be it, since in years past, the cost of trial and error would almost prove prohibitive due to film processing prices. And digital camera LCD screens offer another advantage, since they instantly show the results of your shutter speed choices.

There are certainly some general guidelines to follow for implying motion, and if nothing else, they can provide a good starting point for many of the motion-filled situations that abound. For example, 1/2 sec. will definitely produce the cotton effect in waterfalls and streams. An 8-second exposure will definitely reduce the headlights and taillights of moving traffic to a sea of red-and-white streaks. A 1/4-sec. exposure will make hands knitting a sweater appear as if moving at a very high rate of speed. A wind of 30 mph moving through a stand of maple trees, coupled with a 1-second exposure, can render stark and sharply focused trunks and branches that contrast with wispy, windblown, overlapping leaves.

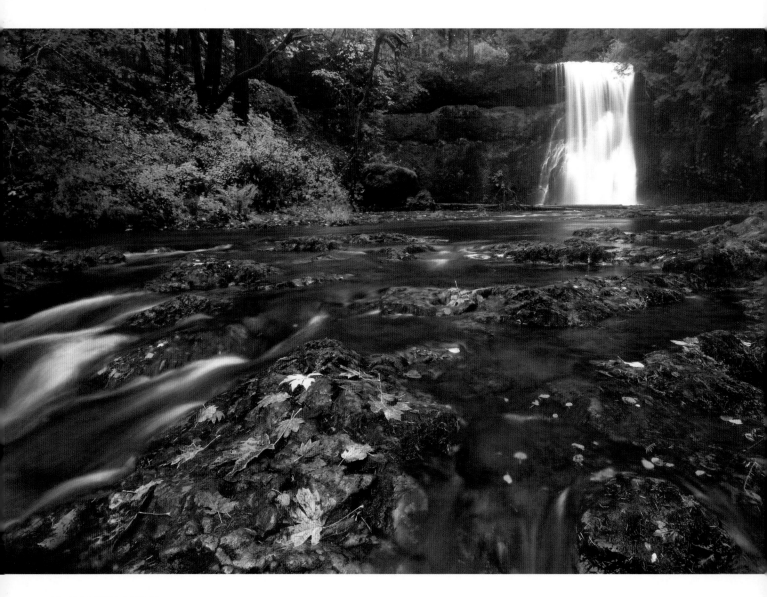

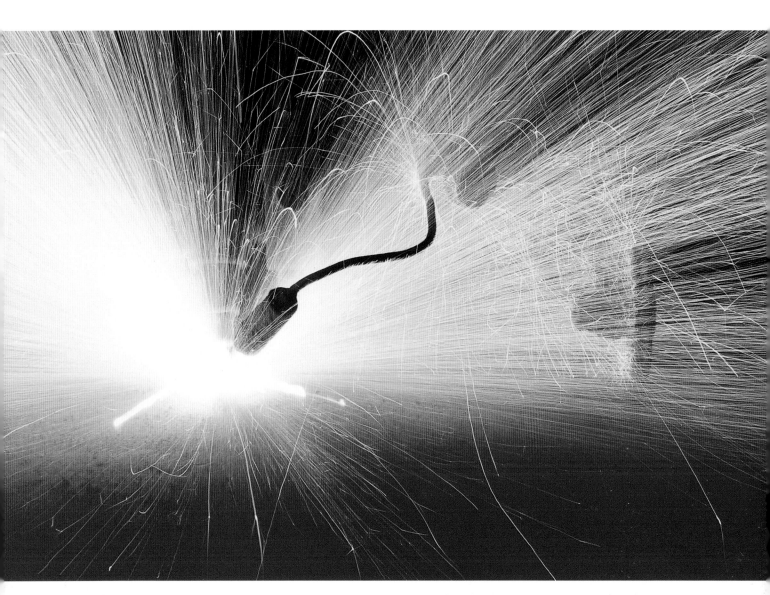

SILVER FALLS STATE PARK IN OREGON *continues to be one of my favorite locations for waterfall shooting, and the two best seasons are late spring and fall. Waterfalls are perhaps the most sought-after motion-filled subject of the amateur photographer. They certainly were for me in my early days, and even today, when I come upon one, I don't hesitate to use an exposure that implies the water's motion. In this image, there are a few things working in my favor to get that slow shutter speed. I set my tripod-mounted camera at a low viewpoint to take advantage of the foreground interest of autumn-colored leaves and flowing water. This means that in addition to using the smallest aperture of f/22, I also preset my focus to three feet to get the maximum depth of field. Interestingly enough, f/22 ensures that I'll record the slowest possible exposure with my setting of ISO 200. Additionally, the heavy overcast conditions, with periods of light rain, meant it would be "dark" in the woods, which further supported my need for slow exposures. And finally, as a big believer in using a polarizing filter on overcast/rainy days (to reduce, if not eliminate, the dull gray glare off the surface of the water and surrounding flora), the 2 stops of light reduction with the filter also force a much slower shutter speed. The resulting long exposure accounts for the cotton-candy water, and f/22 accounts for the front-to-back storytelling sharpness.*

12–24mm lens, ISO 200, f/22 for 1 second

IF SLOW SHUTTER SPEEDS CAN WORK FOR WATER, *why not for industrial sparks? In the fall of 2002, I was offered an assignment shooting steel mills. I photographed numerous subjects over the course of five days, including a number of varied compositions of hot steel and flying sparks. At one of the five mills I photographed, thirty-foot lengths of twelve-inch steel pipe were sent down a long track where the end of each was then cut by an automated machine. It was there that I set up my tripod, about ten feet from the pipe itself. Despite this distance, I found myself sweating profusely, as the heat coming off the pipes was well above 2,000 degrees.*

With a focal length of 400mm, I chose a 1/2-sec. shutter speed—the same speed that has worked so well for waterfalls and streams over the years. As the pipe lay on the track, the automated cutter would slice through the steel, all within five seconds. During these five-second periods, I would look through the viewfinder and note how the camera's light meter reacted to the bright hot steel and flying sparks. Determining that the brightest point in the overall composition was the cutter itself and having shot numerous sunrises and sunsets over the years, I chose to ignore this much brighter light and set an exposure for the surrounding glowing steel of the pipe itself—much like choosing to set an exposure from the orange glowing sky to the right or left of the sun.

80–400mm lens at 400mm, 1/2 sec. at f/27

EXERCISE: MOTION WITH A STATIONARY CAMERA

Shooting movement while the camera remains stationary *relative to the subject* offers an array of possibilities. Try your hand at this exercise the next time you visit the local playground or amusement park. I promise it will help you discover many more motion-filled subjects. At a playground, find a swing set with a stand of trees in the background. As you sit in the swing with your camera and wide-angle lens, set your shutter speed to 1/30 sec., and point and focus the camera at your outstretched legs (preferably with bare feet). Then adjust the aperture until a correct exposure is indicated by the camera's meter. All set? Start swinging (keeping both arms carefully wrapped around the chains or ropes of the swing, of course). Once you reach a good swinging action, press the shutter release. Don't hesitate to take a number of exposures. The results will be sharp legs surrounded by a sea of movement—an image that says, "Jump for joy, for spring has sprung!"

Next, move to the seesaw. Place the camera so that its base rests flat on the seesaw about a foot in front of where you'll be sitting. With the child or adult sitting on the other end, focus on your subject with your shutter speed set to 1/8 sec., and adjust your aperture. Then begin the up-and-down motion of the ride—keeping one hand on the camera, of course—and shoot a number of exposures at different intervals while continuing to seesaw. The end result is a sharply focused person against a background of streaked blurs.

At an amusement park, walk over to the merry-go-round and hop on. Wait until the ride gets moving at a good pace, and with your shutter speed set to 1/30 sec., focus on a person opposite you. Adjust your aperture and fire away. The end result is, once again, a sharply focused person against a background of swirling streaks. Would that make a great advertisement for Dramamine, or what?

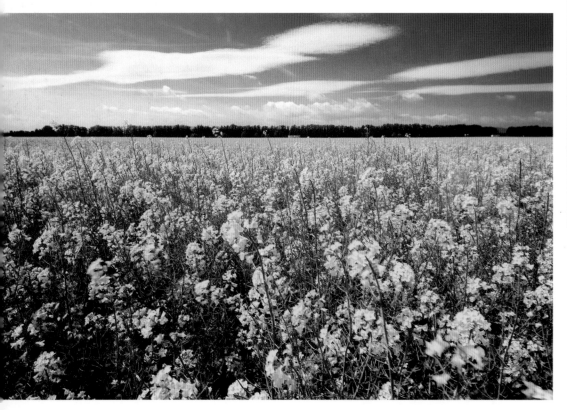

A MUSTARD FIELD NEAR PRAGUE *provided several shooting opportunities. The first (opposite), taken on tripod at f/22 for 1/30 sec., is a classic storytelling image. However, soon after I made this shot, a great deal of wind started to pick up, and the whole field looked like the hands of thousands of symphony conductors, the familiar batons replaced by long yellow spikes of swaying flowers. With the addition of a 4-stop neutral-density (ND) filter, I was able to shoot the scene again at f/22, but at a much slower speed than previously used—4 stops slower, in fact, at 1/2 sec.—while still maintaining a correct exposure.*

Both photos: 12–24mm lens at 14mm, ISO 100. Opposite: 1/30 sec. at f/22. Above: 1/2 sec. at f/22

Implying Motion with Stationary Subjects

How do you make a stationary subject "move"? You zoom it or otherwise move the camera during the exposure! In other words, you press the shutter release *while* zooming your lens from one focal distance to another or *while* moving the camera either upward, downward, from side to side, or in a circle.

Zooming your lens while pressing the shutter release will produce the desired results, *but not without practice*. Don't be disappointed if your first few attempts don't measure up. For those of you using a point-and-shoot digital camera, you may feel your patience being tried. Unless you can figure out a way to override the motorized zooming feature on your camera (and you'd be the first to make this discovery, by the way), you'll be unsuccessful in your attempts. The biggest reason for this is because these cameras won't let you change any settings (and this includes zooming) while the exposure is being made.

WITH MY CAMERA and 35–70mm lens on a tripod, I first composed this lone oak at sunset at a focal length of 35mm with the addition of a Lee sunset filter. With a shutter speed of 1/2 sec., I adjusted my aperture to f/22. As I pressed the shutter release, I zoomed from 35mm to 70mm, and this is one of only a handful of attempts that succeeded from the many exposures I shot of this tree using this technique.

35–70mm lens at 70mm, 1/2 sec. at f/22

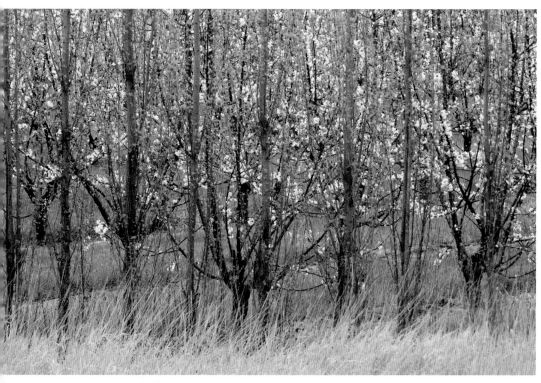

THROW AWAY THE TRIPOD, *call on your polarizing and/or neutral-density filters, and let the fun begin! Bringing "motion" to any scene is a relatively easy proposition, particularly in circumstances where the required shutter speed is really too slow to handhold and maintain sharp focus. You can call your attempts at breaking the "rules" of proper exposure* artistic license, *so anything goes when handholding at slow shutter speeds!*

Case in point: My polarizing filter enabled me to get a slow shutter speed of 1/3 sec. here, but what a difference when I move the camera during that third of a second! The composition at left meets the rules of photographic exposure. It's sharp and correctly exposed—and also very ho-hum. But handholding the camera and simply moving it in an upward direction as I pressed the shutter release produced art (below)!

Both photos: 70–200mm lens at 200mm, ISO 125, 1/3 sec. at f/10

Making "Rain"

Of all the discoveries I've made during my many years of shooting, my favorite is creating "rain"; it has provided me with hours of joy-filled photography. This technique has also resulted in numerous stock photo sales to greeting card and calendar companies, as well as to healthcare-related clients.

The rain effect is easy to achieve. On clear mornings, I set up an oscillating sprinkler so that the water is backlit as it cascades down (low-angled, sunny backlight works best, which is what you find in the early morning or late afternoon). I then gather up some flowers or fruit and arrange them in pots, small cedar boxes, bowls, or vases. To effectively produce the look of falling rain, I use a shutter speed of 1/60 sec. I move in close to the backlit subject and adjust my aperture until the light meter indicates that a correct exposure is set. I then simply back up, compose a pleasing composition, and turn on the sprinkler. I shoot only when the sweeping arc of the oscillating sprinkler begins to fall just behind and then onto the flowers. Also, I almost always choose the 200mm or 300mm focal length for rain shots, not so much because these focal lengths have an inherent shallow depth of field but because they enable me to record pleasing compositions without getting wet.

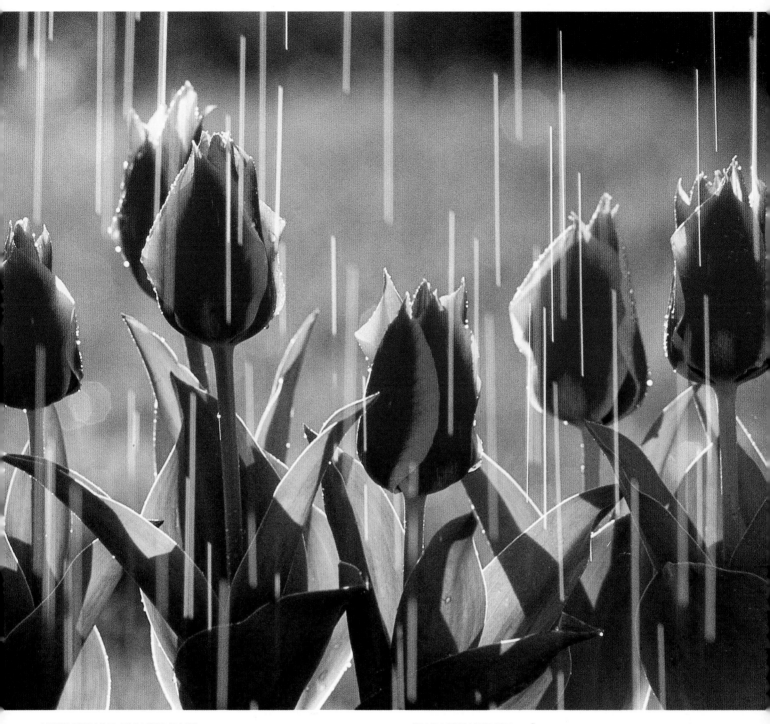

WHY SHOULD FALLING RAIN be limited to flowers? After I'd been using this technique for several years to photograph flowers, I began to place other subjects in my falling "rain," including this vivid blue bowl of fresh strawberries (opposite). With the bowl on a small wooden stool, I took a meter reading from the light falling on the strawberries. Then with my shutter speed set to 1/60 sec., I adjusted the aperture until the light meter indicated a correct exposure, which was at f/19. I backed up, composed the scene you see here, turned on the sprinkler, and fired off several frames each time the droplets fell on the bowl.

80–400mm lens at 300mm, 1/60 sec. at f/19

IF YOU'RE LIKE ME, *you welcome spring with great enthusiasm. The sun has returned and the rains have subsided—at least, the real rain has. I used an oscillating lawn sprinkler to make it "rain" on these backlit tulips, and I metered off the green grass behind them. With my shutter speed at 1/60 sec., I adjusted my aperture until f/10 indicated a -2/3 exposure and fired away. Ah, the joy of spring!*

80–200mm lens at 200mm, 20mm extension tube, 1/60 sec. at f/10

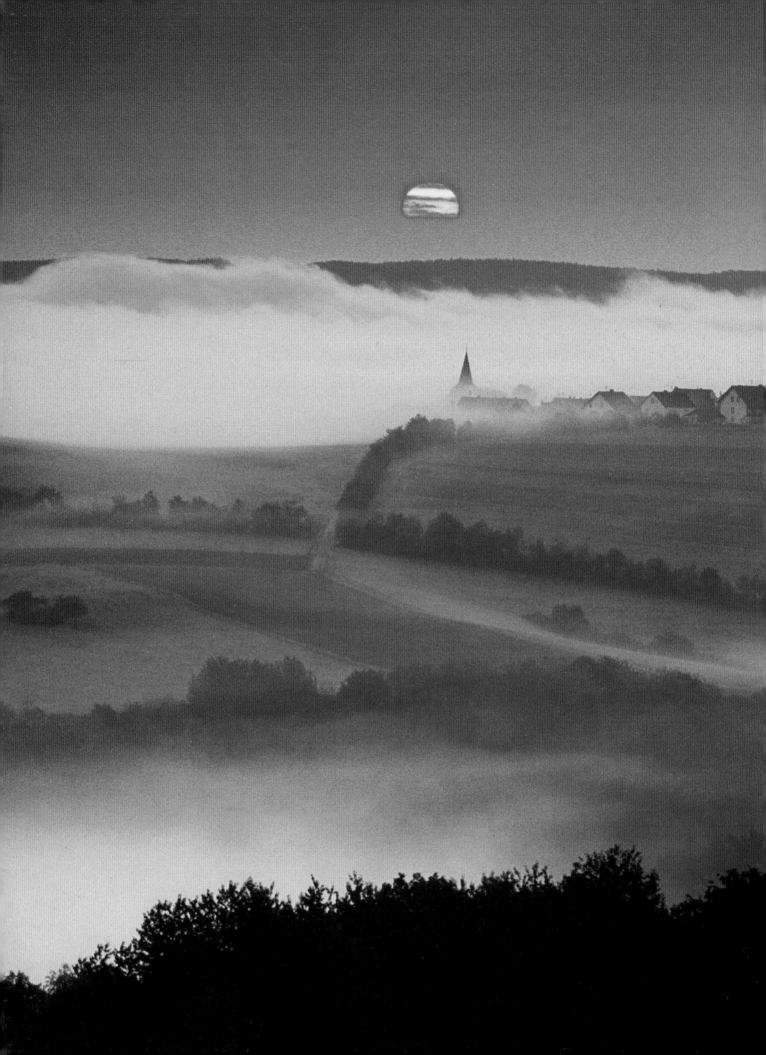

LIGHT

The Importance of Light:
The Importance of Exposure

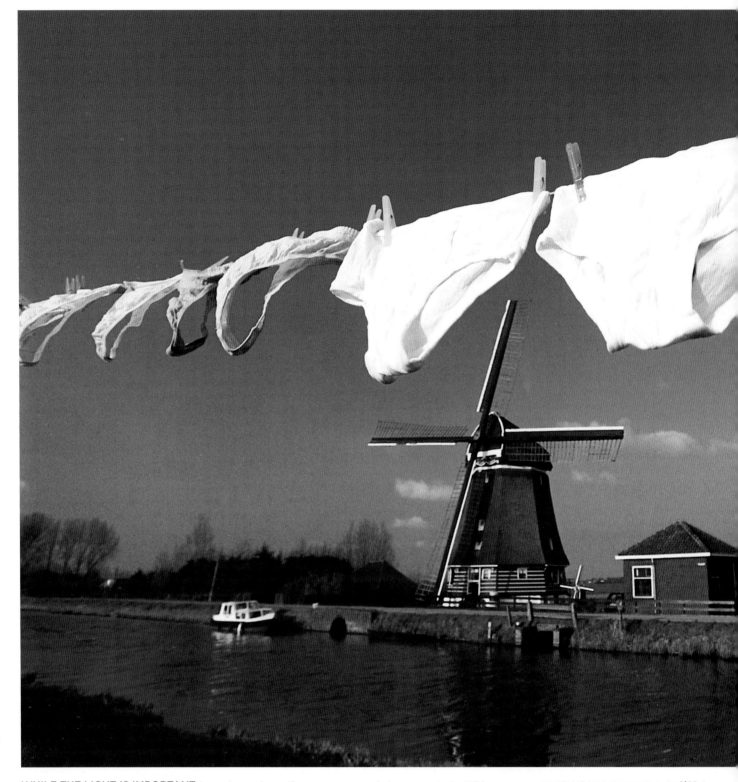

WHILE THE LIGHT IS IMPORTANT *in any image, it was the exposure that was an integral part of making this shot. Getting a true storytelling exposure that rendered everything in this photograph in sharp focus was key to conveying the humor of this scene along one of the many dikes in West Friesland, Holland.*

Windmills abound in this area, and people still live in these "houses." Coming upon the clothesline of one such homeowner, I couldn't resist the obvious opportunity. With my camera on tripod, I set my aperture to f/22. I then prefocused the scene via the distance setting and adjusted my shutter speed for the light reflecting off the blue sky until 1/60 sec. indicated a correct exposure. The scene didn't look in focus in my viewfinder when I shot it, but due to my aperture choice, it was rendered sharp.

20-35mm lens at 20mm, f/22 for 1/60 sec.

W hat should my exposure be?" is, as I've already said, an often-heard question from my students. And, again as I stated earlier, my frequent reply—although it may at first appear flippant—is simply, "Your exposure should be correct—*creatively correct,* that is!" As I've discussed in countless workshops and online photo courses, achieving a creatively correct exposure is paramount to a photographer's ability to be consistent. It's always the first priority of every successful photographer to determine what kind of exposure opportunity he or she is facing: one that requires great depth of field or shallow depth of field, or one that requires freezing the action, implying motion, or panning. Once this has been determined, the real question isn't "What should my exposure be?" but *"From where do I take my meter reading?"*

However, before I answer that question, let's take a look at the foundation upon which every exposure is built: light! Over the years, well-meaning photographers have stressed the importance of light or have even been so bold as to say that "light is everything." This kind of teaching—"See the light and shoot the light!"—has led many aspiring students astray over the years.

Am I antilight? Of course not! I couldn't agree more that the right light can bring importance and drama to a given composition. But more often than not, the stress is on *the light* instead of on the (creatively correct) exposure. Whether you've chosen to tell a story, to isolate, to freeze action, to pan, or to imply motion in your image, the light will be there regardless. I can't tell you how many times I've met students who think an exposure for the light is somehow different than it is for a storytelling image or for a panning image, and so on. But what is so different? What has all of a sudden changed?

Am I to believe that a completely different set of apertures and shutter speeds exists *only for the light*? Of course not! A correct exposure is *still* a combination of aperture, shutter speed, and ISO. And a creatively correct exposure is *still* a combination of the right aperture, the right shutter speed, and the right ISO—with or without the light. As far as I'm concerned, the light is the best possible frosting you can put on the cake, but it has never been—and never will be—*the cake*.

The Best Light

Where do you find the best light for your subjects? Experienced photographers have learned that the best light often occurs at those times of day when you would rather be sleeping (early morning) or sitting down with family or friends for dinner (late afternoon/early evening, especially in summer). In other words, shooting in the best light can be disruptive to your "normal" schedule.

But unless you're willing to take advantage of early-morning or late-afternoon light—both of which reveal textures, shadows, and depth in warm and vivid tones—your exposures will continue to be harsh and contrasty, without any real warmth. Such are the results of shooting under the often harsh and flat light of the midday sun. Additionally, one can argue that the best light occurs during a change in the weather—incoming thunderstorms and rain—that's combined with low-angled early-morning or late-afternoon light.

You should get to know the color of light, as well. Although early-morning light is golden, it's a bit cooler than the much stronger golden-orange light that begins to fall on the landscape an hour before sunset. Weather, especially inclement weather, can also affect both the quality (as mentioned above) and *color* of light. The ominous and threatening sky of an approaching thunderstorm can serve as a great showcase for a front- or sidelit

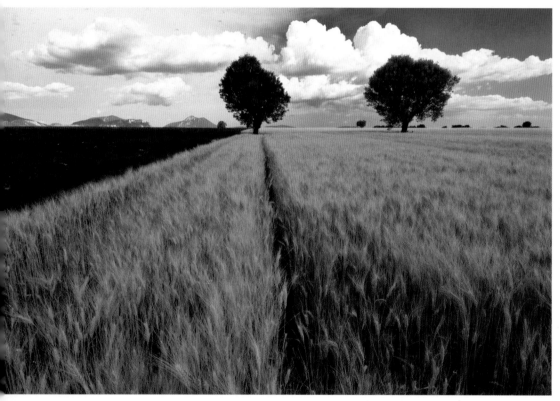

LEARNING TO "SEE" LIGHT *is paramount to the ongoing success of every photographer, and sometimes that means one must often wait for the light. There's a clear difference between these two photographs (both of the Valensole Plain in southern France), and the difference is simply the* light. *Beginning photographers are oftentimes so seduced by a place or subject that they fail to note the subtle changes taking place overhead; a large cloud has passed in front of the sun, for example, yet it will only be about ten minutes before the sun is revealed again. Shooting during the cloud cover results in a pleasant composition, but in the absence of the light to come, it is far from compelling (above). Waiting on the light (again, only ten minutes, in this case) resulted in a much more appealing image. Make a point of seeing the light, knowing where the light is and where it's going, and of course knowing the temperature of that light (i.e., its warmth).*

Both photos: 12–24mm lens at 14mm. Above: f/22 for 1/30 sec.
Right: f/22 for 1/80 sec.

landscape. Then there's the soft, almost shadowless light of a bright overcast day, which can impart a delicate tone to many pastoral scenes, as well as to flower close-ups and portraits.

Since snow and fog are monochromatic, they call attention to subjects such as a lone pedestrian with a bright red umbrella. Make it a point, also, to sense the changes in light through the seasons. The high, harsh, direct midday summer sun differs sharply from the low-angled winter sun. During the spring, the clarity of the light in the countryside results in delicate hues and tones for buds on plants and trees. This same clear light enhances the stark beauty of the autumn landscape.

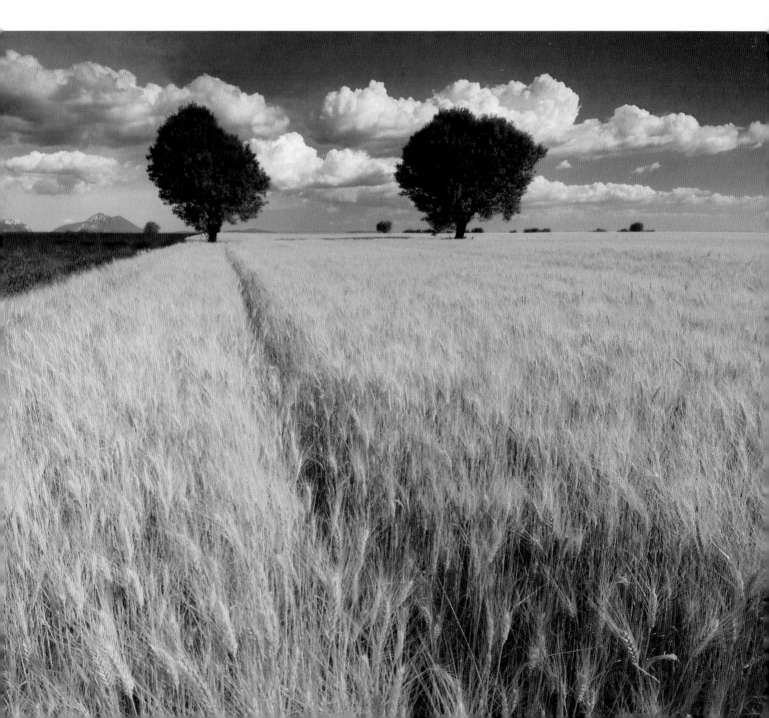

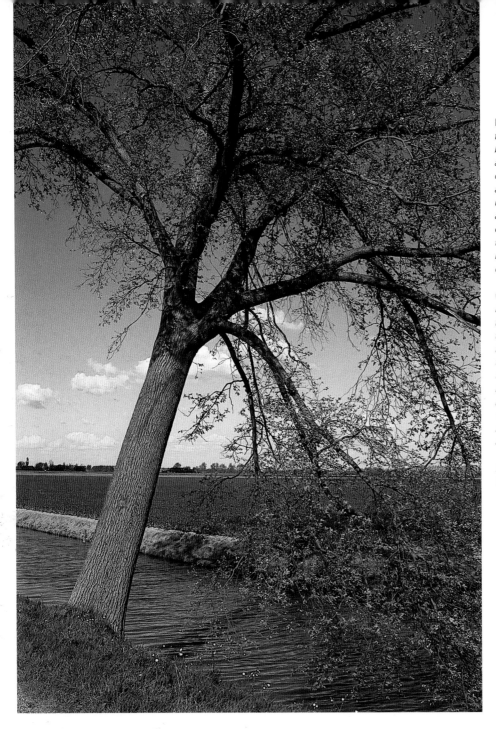

I FELT WONDERFUL AFTER *recording this image at left of a lone Dutch elm on the banks of a small dike in Holland. The low-angled light of late afternoon had begun to cast its warm glow across the landscape, and I was there to catch it all. It was only until I happened upon this same scene again two days later—but under even more dramatic lighting conditions—that I knew the photograph could be improved. I could now capture the scene against a backdrop of a fierce and oncoming storm (opposite).*

I made both images without a tripod and with the same lens settings. In both cases, I used an aperture of f/16 and preset the focus via the distance setting on the front of the lens to ensure maximum depth of field front to back. And in both cases I adjusted the shutter speed for the light falling on the tree. The difference is in the "frosting"—the light—and it is amazing. But it was still necessary to decide what kind of cake I wanted to make: in this case, a cake that relied on the conscious selection of the right aperture first.

Both photos: 20–35mm lens at 20mm, f/16 for 1/125 sec.

EXERCISE: EXPLORING LIGHT

You can do one of the best exercises I know near your home, whether you live in the country or the city, in a house or an apartment. Select any subject—for example, the houses and trees that line your street or the nearby city skyline. If you live in the country, in the mountains, or at the beach, choose a large and expansive composition. Over the course of the next twelve months, document the changing seasons and the continuously shifting angles of the light throughout the year. Take several pictures a week, shooting to the south, north, east, and west and in early-morning, midday, and late-afternoon light. Since this is an exercise, don't concern yourself with making a compelling composition. At the end of the twelve months, with your efforts spread out before you, you'll have amassed a knowledge and insight about light that few professional photographers—and

even fewer amateurs—possess. Photographers who use and exploit light *are not* gifted! They have simply learned about light and have, thereby, become motivated to put themselves in a position to receive the gifts that the "right" light has to offer.

Another good exercise is to explore the changing light on your next vacation. On just one day, rise before dawn and photograph some subjects for one hour following sunrise. Then head out for an afternoon of shooting, beginning several hours before and lasting twenty minutes following sunset. Notice how low-angled frontlight provides even illumination, how sidelight creates a three-dimensional effect, and how strong backlight produces silhouettes. After a day or two of this, you'll soon discover why I always say that the light of the midday sun is reserved for relaxing poolside.

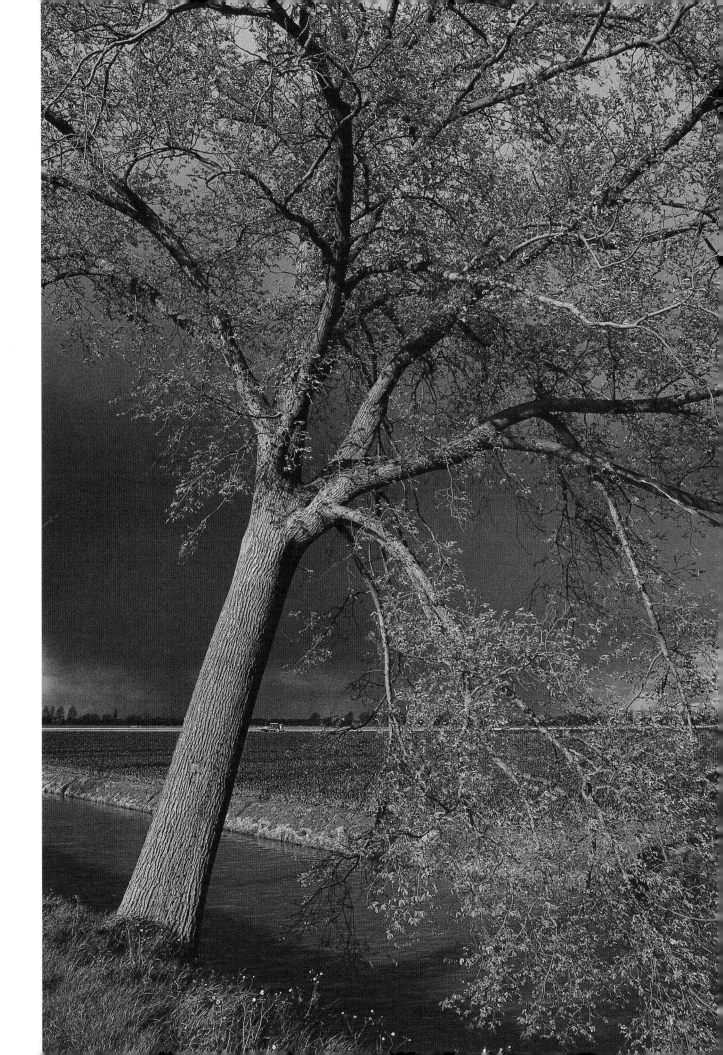

Frontlight

What is meant by frontlight or frontlighting? Imagine for a moment that your camera lens is a giant spotlight. Everywhere you point the lens you would light the subject in front of you. This is frontlighting, and this is what the sun does—on sunny days, of course. Due to frontlighting's ability to, for the most part, evenly illuminate a subject, many photographers consider it to be the easiest kind of lighting to work with in terms of metering, especially when shooting landscapes with blue skies.

So, is it really safe to say that frontlight doesn't pose any great exposure challenges? Maybe it doesn't in terms of metering, but in terms of testing your endurance and devotion, it might. Do you mind getting up early or staying out late, for example? The quality and color of frontlighting are best in the first hour after sunrise and during the last few hours of daylight. The warmth of this golden-orange light will invariably elicit an equally warm response from viewers. This frontlighting can make portraits more flattering and enhance the beauty of both landscape and cityscape compositions.

In addition, frontlighting—just like overcast lighting (see page 110)—provides even illumination, making it relatively easy for the photographer to set an exposure; you don't have to be an exposure "expert" to determine the spot in the scene where you should take your meter reading. Even first-time photographers can make successful exposures, whether their cameras are in manual or autoexposure mode.

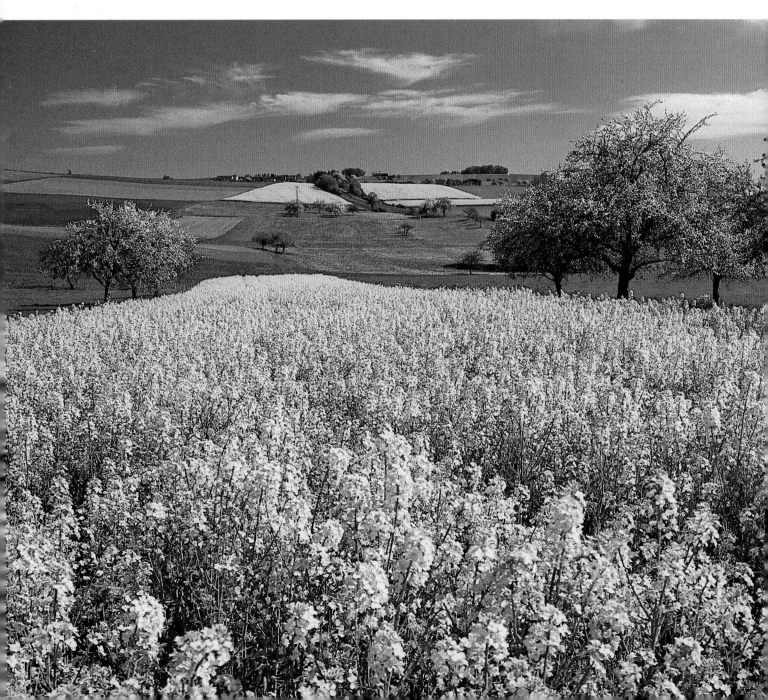

TO PHOTOGRAPH THIS MUSTARD FIELD,
I handheld my camera and set my 20–35mm lens to 24mm. I then set the aperture to f/22 and preset the focus via the distance settings on the front of the lens, which assured me that everything would be sharp from two feet to infinity. With the camera in manual exposure mode, I raised it to the sky above, adjusted my shutter speed to 1/60 sec., and then recomposed the shot.

20–35mm lens at 24mm, f/22 for 1/60 sec.

AS THE LATE-AFTERNOON FRONTLIGHT
cast its glow across the face of this lavender farmer in Provence, I didn't hesitate. With my camera set to Aperture Priority mode, I chose f/5.6 to soften the background and keep the visual weight on him and then simply fired away, allowing the camera to set the exposure for me with a shutter speed of 1/500 sec.

80–200mm lens at 200mm, f/5.6 for 1/500 sec.

Overcast Frontlight

Of all the different lighting conditions that photographers face, overcast frontlighting is the one that many consider to be the safest. This is because overcast frontlight illuminates most subjects evenly, making meter reading simple. (This assumes, of course, that the subject isn't a landscape under a dull gray sky; that subject and light combination needs some extra care, as I explain on page 152.)

Overcast frontlight also gets autoexposure to perform well, since overall illumination is balanced. The softness of this light results in more natural-looking portraits and richer flower colors, and it also eliminates the contrast problems that a sunny day creates in wooded areas. Overcast conditions are ones in which I often shoot in auto-exposure mode: either Aperture Priority, if my exposure concerns are about depth of field or the absence thereof, or Shutter Priority, if my concern is about motion (i.e., freezing action or panning).

JUST AS PHOTOGRAPHING *in the woods on sunny days is problematic—yielding images that are too contrasty—shooting in outdoor markets under sunny conditions creates the same problems. Wait for overcast days; correct exposures will be much easier to record, and you can certainly shoot in Aperture Priority mode without fear. In this classic "Who cares?" situation at right, I held my camera and stood on tiptoe to shoot down on these small spice sacks. Exposure wasn't a concern, since the light levels throughout the scene were even.*

35-70mm lens at 35mm, f/11 for 1/60 sec.

ONE OF MY STUDENTS HAD HEARD *about the house covered in license plates in Vermont. While on a workshop there, we were elated to find it and weren't the least bit disappointed. It was a subject that lent itself perfectly to the soft and even illumination that only a cloudy day can provide. Since this house was surrounded by a lot of deciduous trees, a sunny day would have cast numerous shadows on the roof and sides of the house, resulting in a composition of sharp contrasts. With my camera on a tripod, I framed up one wall of the house with two windows and chose a "Who cares?" aperture of f/11. Due to the even illumination, I had no worries about using Aperture Priority mode and letting the camera pick the exposure for me.*

80-200mm lens at 120mm, f/11 for 1/30 sec.

PORTRAITS ARE ANOTHER FINE SUBJECT *for overcast lighting. The soft and even illumination of a cloudy day makes getting an exposure easy. Posed candids that offer direct eye contact are pleasing to viewers. Here, I first asked my subject to sit about ten feet in front of a background of blue barrels. I then placed my camera on a tripod, and because I wanted to render the background as out-of-focus shapes and tones, I set my aperture to f/5.6. Since I was using Aperture Priority automatic exposure, I had only to focus on my subject's pleasant demeanor and shoot.*

80-200mm lens at 200mm, f/5.6 for 1/125 sec.

I MET THIS ELDERLY GERMAN WOMAN by accident. While driving around the countryside, I ran out of gas in front of her farm, and she generously offered me several liters of gas to get me going again. But before I knew it, I'd spent more than five hours with the woman and her daughter talking about life on the farm. Of the many photographs I made that day, this is one of my favorites. Since the bench she was on was against a wall, depth of field was of no great concern. I put my lens to Aperture Priority mode, set a "Who cares?" aperture of f/11, and let the camera choose the shutter speed for me.

80–200mm lens at 100mm, f/11 for 1/60 sec.

Sidelight

Frontlit subjects and compositions photographed under an overcast sky often appear two-dimensional, even though your eyes tell you the subject has depth. To create the illusion of three-dimensionality, you need highlights and shadows—in other words, you need sidelight. For several hours after sunrise and several hours before sunset, you'll find that sidelit subjects abound when you shoot toward the north or south.

Sidelighting has proven to be the most challenging of exposures for many photographers because of the combination of light and shadow. But it also provides the most rewarding picture-taking opportunities. As many professional photographers would agree, a sidelit subject—rather than a frontlit or backlit one—is sure to elicit a much stronger response from viewers, because it better simulates the three-dimensional world they see with their own eyes.

SINCE I COULDN'T GET *as close to this bee as I wanted with my 70–210mm zoom lens, I added a small extension tube, which enabled me to fill the frame with the subject without having to be within a cat's whisker of the bee. I also decided to exploit the early-morning sidelight, using the background shadows to get some wonderful contrast against which to showcase the bee. With my camera and lens on a tripod, I set my aperture to f/11 and adjusted the shutter speed until 1/250 sec. indicated a correct exposure.*

70–210mm lens at 210mm, 36mm extension tube, f/11 for 1/250 sec.

THE SPACES IN WHICH *I work are sometimes cramped. When this occurs, I often opt for a wide-angle lens, and this is exactly what happened when I entered this teahouse in China years ago. Since I wanted to shoot a full-length portrait of this intriguing man and found myself in a very small room, I crouched down with my camera and 35mm lens. Through the opening at the right of the frame, soft and diffused sidelight from the much brighter midday sun filled the room. With an aperture of f/8, I adjusted the shutter speed until 1/30 sec. was indicated as a correct exposure for the light reflecting off the green wall. I then recomposed the scene and made several exposures.*

35mm lens, f/8 for 1/30 sec.

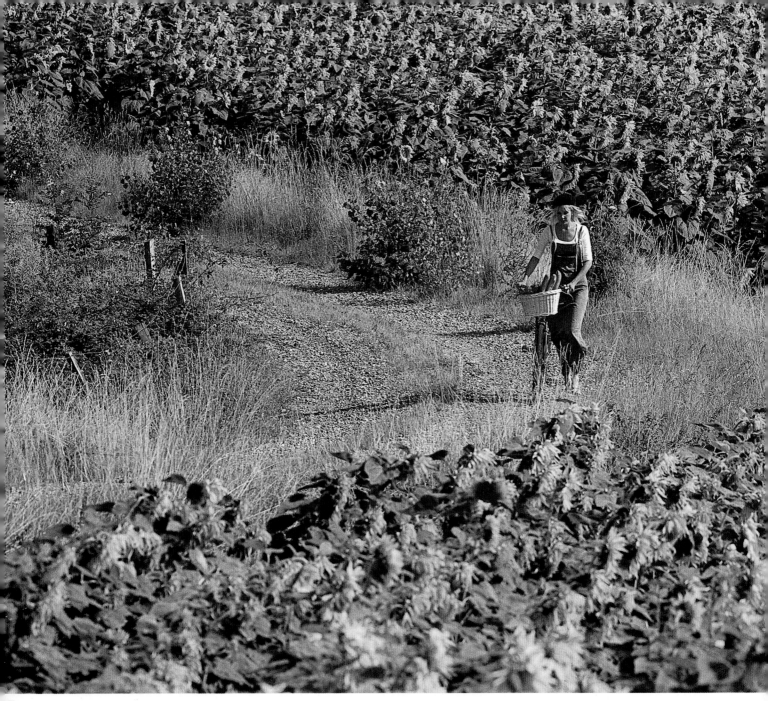

THIS IS CLASSIC STORYTELLING STUFF
—and one of those shots that "comes to you," rather than you going to it. With my camera and 300mm lens on a tripod, I framed a section of the dirt road with sunflowers from front to back. Then, with my aperture set to f/32, I raised the camera quickly to the blue sky above, adjusted the shutter speed, and recomposed.

300mm lens, f/32 for 1/30 sec.

WHILE WORKING ON A PROJECT *that featured women in industry, I came upon a female welder working on the docks of the Portland, Oregon, shipyards. She was taking a brief break from making countless welds on the large anchor chain that lay before her. Bathed in the low-angled sunlight of late afternoon, I wasted no time in quickly introducing myself and setting up my camera and tripod. With my aperture set to f/22—so that I could record as much depth of field in the foreground chains as possible—I framed the scene before me and, with the camera's built-in light meter set to spot metering, metered the light falling on her face, adjusting the shutter speed accordingly until a correct exposure was indicated. Directly behind the subject, and lasting for some time, a large and looming shadow had fallen. Since the exposure was set for the much stronger sidelight, the shadow areas recorded on film as severe underexposures, providing a nice contrast between light and dark, as well as imparting a feeling of three-dimensionality to the image.*

105mm lens, f/22 for 1/60 sec.

Backlight

SUNRISE IN SONOMA VALLEY *is a welcomed experience every spring. Coming upon a grove of oak trees shortly after sunrise, I was quick to grab my camera and focus on one large tree, framing the sun in such a way that only a piece of it was visible behind the trunk. Where did I take my meter reading from? I pointed the camera in the direction of the light that was cascading down on the ground behind the oak.*

20-35mm lens at 20mm, f/16 for 1/250 sec.

acklight can be confusing. Some beginning photographers assume that backlighting means the light source (usually the sun if you're outdoors) is behind the photographer, hitting the front of the subject; however, the opposite is true: The light is *behind the subject*, hitting the front of the photographer and the back of the subject. Of the three primary lighting conditions—frontlighting, sidelighting, and backlighting—backlight continues to be the biggest source of both surprise and disappointment.

One of the most striking effects achieved with backlight is silhouetting. Do you remember making your first silhouette? If you're like most other photographers, you probably achieved it by accident. Although silhouettes are perhaps the most popular type of image, many photographers fail

DURING THE SPRING, *the area of West Friesland, Holland, is one of those places where it's hard not to make a photograph of strong, graphic design and bold color. The many meandering dikes, perfect rows of tulips, and the "walls" of trees lend themselves to exciting compositions at almost every turn. And almost without fail, as the sun begins its descent toward the direction of the North Sea, the thick salt air diffuses the intensity of the sun's light so that, for almost the last forty-five minutes of daylight, a thick orange-yellow ball hangs in the western sky.*

Having witnessed this scene many times, I had an idea to shoot a lone runner on one of the many tree-lined dikes. A quick phone call to my friend Ron confirmed that I'd have my runner the following evening. Armed with walkie-talkies so that I could tell him exactly where I needed him to run, I gave the cue to start. At a distance of about three-quarters of a mile from me, Ron ran back and forth between the five trees you see here for the next few minutes.

With my camera and 800mm lens securely mounted on tripod and with my aperture set to f/11, I focused on the distance—trees and infinite sky. When shooting backlight photos with any telephoto lens when the focal length is 100mm or more, I will always set my exposure from the sky to the right or left of the setting sun. With f/11 and my camera pointed to the sky to the right of the setting sun, I simply adjusted my shutter speed until 1/250 sec. indicated a correct exposure and then recomposed the shot you see here.

800mm lens, f/11 for 1/250 sec.

to get the exposure correct. This inconsistency is usually a result of lens choice and metering location. For example, when you use a telephoto lens, such as a 200mm lens, you must know where to take your meter reading. Since telephoto lenses increase the image magnification of very bright background sunrises and sunsets, the light meter sees this magnified brightness and suggests an exposure accordingly. If you were to shoot at that exposure, you'd end up with a picture of a dark orange or red ball of sunlight while the rest of the frame fades to dark. And whatever subject is in front of this strong backlight may merge into this surrounding darkness. To avoid this, *always* point a telephoto lens at the bright sky to the right or left of the sun (or above or below it), and then manually set the exposure or press the exposure-lock button if you're in autoexposure mode.

When photographing a backlit subject that you don't want to silhouette, you can certainly use your electronic flash to make a correct exposure; however, there's a much easier way to get a proper exposure without using flash. Let's assume your subject is sitting on a park bench in front of the setting sun. If you shoot an exposure for this strong backlight, your subject will be a silhouette; but if you want a pleasing and identifiable portrait, move in close to the subject, fill the frame with the face (it doesn't have to be in focus), and then set an exposure for the light reflecting off the face. Either manually set this exposure or, if shooting in autoexposure mode, press the exposure-lock button and return to your original shooting position to take the photo. The resulting image will be a wonderful exposure of a radiant subject.

Backlight is favored by experienced landscape shooters, as they seek out subjects that by their very nature are somewhat transparent: leaves, seed heads, and dew-covered spiderwebs, to name but a few. Backlight always provides a few exposure options: You can either silhouette the subject against the strong backlight, meter for the light that's usually on the opposite side of the backlight (to make a portrait), or meter for the light that's illuminating the somewhat transparent subject. Although all three choices require special care and attention to metering, the results are always rewarding. Like so many other exposure options, successful backlit scenes result from a conscious and deliberate metering decision.

WHEN BACKLIT, *many solid objects (such as people, trees, and buildings) will render as dark silhouetted shapes. Not so with many transparent objects, such as feathers or flowers. When transparent objects are backlit, they seem to glow. Such was the case when shooting these mule's ears in a small pine forest in eastern Oregon. I chose a low viewpoint so that I could showcase the backlit flowers against the solid, silhouetted trees. Although this may appear to be a difficult exposure, it really isn't. Holding my camera and 20–35mm lens, I set the focal length to 20mm. With an aperture of f/22, I moved in close to the flowers, adjusting my position so that one of the flowers blocked the sun. I then adjusted my shutter speed until 1/125 sec. indicated a correct exposure in the viewfinder. But before I took the shot, I moved just enough to let a small piece of the sun out from behind the flower to be part of the overall composition. With this exposure, I was able to record a dynamic backlit scene that showcases both transparent and solid objects.*

20–35mm lens at 20mm, f/22 for 1/125 sec.

FROST-COVERED *spiderwebs can produce dynamic compositions when they are backlit. Crawling on my knees and belly in this meadow with my camera and 24mm lens allowed me to showcase one against the early-morning backlight. This particular web was one of the largest I'd seen that morning—almost two feet across! Choosing an aperture of f/16, I raised the camera up toward the sky (so as not to include the sun in the photograph) and adjusted my shutter speed until 1/250 sec. indicated a correct exposure in the viewfinder. I then recomposed the scene you see here, making certain to block the sun behind a piece of the frost-covered web.*

24mm lens, f/16 for 1/250 sec.

Exposure Meters

As discussed in the first chapter, at the center of the photographic triangle (aperture, shutter speed, and ISO) is the exposure meter (light meter). It's the "eye" of creative exposure. Without the vital information the exposure meter supplies, many picture-taking attempts would be akin to playing pin the tail on the donkey—hit-and-miss! This doesn't mean that you can't take a photograph without the aid of an exposure meter. After all, a hundred years ago photographers were able to record exposures without one, and even thirty years ago I was able to record exposures without one. They had a good excuse, though: There were no light meters available to use one hundred years ago. I, on the other hand, simply failed—on more than one occasion—to pack a spare battery for my Nikkormat FTN, and once the battery died, so did my light meter.

Just like the pioneers of photography, I, too, was then left having to rely on the same formulas for exposure offered by Kodak, the easiest being the Sunny f/16 Rule. This rule simply states: When shooting frontlit subjects on sunny days, set your aperture to f/16 and your shutter speed to the closest corresponding number of the ISO in use. (See page 125 for digital shooting and ISOs.) In my early years, when film was the only option and if I were using Kodachrome 25, I knew that at f/16 the shutter speed should be 1/30 sec. If I were using Kodachrome 64, the shutter speed should be 1/60 sec. Needless to say, this bit of information was valuable stuff when the battery went dead—but only when I was out shooting on sunny days! One of the great advances in photography today is the auto-everything camera; trouble is, when the batteries in these auto-everything cameras die, the *whole camera* dies, not just the light meter! Make it a point to *always* carry an extra battery or two.

Despite my feelings about this obvious shortcoming in auto-everything cameras, it cannot be ignored that the light meters of today are highly sensitive tools. It wasn't that long ago that many photographers would head for home once the sun went down, since the sensitivity of their light meters was such that they couldn't record an exposure at night. Today, photographers are able to continue shooting well past sundown with the assurance of achieving a correct exposure. If ever there was a tool most often built in to the camera that eliminates any excuse for not shooting twenty-four hours a day, it would be the light meter.

Exposure meters come in two forms. They're either separate units not built in to the camera, or as with most of today's cameras, they're built into the body of the camera. Handheld light meters require you to physically point the meter at the subject, or at the light falling on the subject, and to take a reading of the light. Once you do this, you set the shutter speed and aperture at an exposure based on this reading. Conversely, cameras with built-in exposure meters enable you to point the camera and lens at the subjects while continuously monitoring any changes in exposure. This metering system is called through-the-lens (TTL) metering. These light meters measure the intensity of the light that reflects off the metered subject, meaning they are *reflected-light meters*. Like lenses, reflected-light meters have a wide or very narrow angle of view.

Many cameras today offer up two if not three types of light-metering capabilities. One of those is *center-weighted metering*. Center-weighted meters measure reflected light throughout the entire scene but are biased toward the center portion of the viewing area. To use a center-weighted light meter successfully, you must center the subject in the frame when you take the light reading. Once you set a manual exposure, you can then recompose the scene for the best composition. On the other hand, if you want to use your camera's autoexposure mode (assuming that your camera has one) but don't want to center the subject in the composition, you can press the exposure-lock button and then recompose the scene so that the subject is now off-center; when you fire the shutter release, you'll still record a correct exposure.

Another type of reflected-light meter that many digital cameras are equipped with is the *spot meter*. Up until about four years ago, spot meters were only available as handheld light meters, but today it is not at all uncommon to see camera bodies that are equipped with them, as well. The spot meter measures light at an extremely narrow angle of view, usually limited to 1 to 5 degrees. As a result, the spot meter can take a meter reading from a very small area of an overall scene and get an accurate reading from that one very specific area despite how large an area of light and/or dark surrounds it in the scene. My feelings about using spot meters haven't changed that much since I first learned of them over thirty years ago: They have a limited but important use in my daily picture-taking efforts.

And finally, there is Nikon's matrix metering or Canon's evaluative metering mode. Matrix (or evaluative) metering came on the market about fifteen years ago and has since

EARLY ONE SUMMER MORNING, *I arrived at Millennium Park in downtown Chicago to discover a small maintenance crew scrubbing the Bean. An easy exposure, for sure, since it was "simple, early-morning frontlight." I set the aperture to f/13, and with my camera and lens on tripod, I allowed the camera's Aperture Priority mode to select the correct exposure for me.*

70–200mm lens at 170mm, ISO 200, f/13 for 1/125 sec.

down from atop a large coal storage facility, the lone yellow Caterpillar pushing around mounds of coal caught my eye. All of that black coal would have played havoc with center-weighted or even matrix/evaluative metering, which would have rendered it 18% gray (see pages 126 and 128). Trouble is, coal is black, and my client wouldn't have been thrilled with me if I turned in pictures of gray coal. So, with my camera's meter set to spot metering, and with my 80–200mm lens at 200mm, I pointed the lens at the Caterpillar. With an aperture of f/11, I adjusted the shutter speed until 1/60 sec. indicated a correct exposure. I then zoomed back out to 80mm, showing the expansive field of coal, and shot several frames. Sure enough, when I did this, the light meter indicated to me that I was way off! It was telling me that I should shoot the scene at f/11 for 1/15 sec. Had I shot at this exposure, I would have recorded an overexposure—or in other words, gray coal!

80–200mm lens at 80mm, f/11 for 1/60 sec.

been revised and improved. It's rare that you'll find a camera on the market today that doesn't offer a kind of metering system built on the original idea of matrix metering. This holds true for the Pentax, Minolta, Panasonic, Sony, and Olympus brands of digital SLRs. Matrix metering relies on a microchip that has been programmed to "see" thousands of picture-taking subjects, from bright white snow-capped peaks to the darkest canyons and everything in between. As you point your camera toward your subject, matrix metering recognizes the subject ("Hey, I know this scene! It's Mt. Everest on a sunny day!") and sets the exposure accordingly. Yet, as good as matrix metering is, it still will come upon a scene it can't recognize, and when this happens, it will *hopefully* find an image in its database that comes close to matching what's in the viewfinder.

The type of camera determines which light meter or meters you have built in to the camera's body. If you're relatively new to photography and have a camera with

surprising, they were often unsure of which exposure to believe, so they took one of each. This is analogous to having two spouses: Those who have a spouse would certainly agree that dealing with the quirks and peculiarities of one spouse is at times too much, let alone two? But since I was raised on center-weighted metering, I'll stay with it for life. If it ain't broke, don't fix it.

Just how good are today's light meters? Both center-weighted and matrix metering provide accurate exposures 90 percent of the time. That's an astounding, and hopefully confidence-building, number. Nine out of ten pictures will be correctly exposed, whether one uses manual exposure mode (still my favorite) or semi-autoexposure mode (Aperture Priority when shooting storytelling or isolation themes, or Shutter Priority when freezing action, panning, or implying motion). In either metering mode and when your subject is frontlit, sidelit, or under an overcast sky, you can simply choose your subject, aim, meter, compose, and shoot.

In addition, I do recommend taking another exposure at -2/3 stop when shooting most any subject, since this often improves contrast and the overall color saturation of a given scene. This extra shot will allow you a comparison example so that you can decide later which of the two you prefer. Don't be surprised if you often pick the -2/3 exposure. Oftentimes, this slight change in exposure from what the meter indicates is just the right amount of contrast needed to make the picture that much more appealing. With the sophistication of today's built-in metering systems, it's often unnecessary to bracket like crazy.

Finally, there isn't a single light meter on the market today that can do any measuring, calculating, or metering until it has been "fed" one piece of data vital to the success of every exposure you take: the ISO. In the past, photographers (using film) had to manually set the ISO every time they would switch from one type of film to another.

Digital shooters, despite all the technology advances, must resort to setting the ISO for each and every exposure, in effect, telling the meter what ISO to use. (On some DSLRs there is an auto ISO feature. When this is activated, the camera will determine which ISO to use based on the light. I *do not* recommend this approach at all, since the camera will often get it wrong, and it doesn't know that you desire to be a "creative photographer"—and part of your creativity stems, of course, from having full control over what ISO you use.) Since digital shooters can switch ISO from one scene to the next, as well as shift from shooting color to black and white at the push of a button, so much for the old adage that you can't change horses midstream.

The photo industry has come a long way since I first started. With today's automatic cameras and their built-in exposure meters, much of what you shoot will be a correct exposure. However, keep in mind that the job of recording *creatively correct exposures* is still yours.

several light-meter options (matrix/evaluative, as well as center-weighted), I would strongly recommend using matrix 100 percent of the time. It has proven to be the most reliable and has fewer quirks than center-weighted metering. On countless field trips, I've witnessed some of my students switching from center-weighted metering to matrix metering repeatedly. Not surprisingly, due to each light meter's unique way of metering the light, they would often come up with slightly different readings. Also not

18% Reflectance

Now for what may be surprising news: Your camera's light meter (whether center-weighted, matrix/evaluative, or spot) *does not* "see" the world in either living color or black and white but rather as a *neutral gray*. In addition, your reflected-light meter is also calibrated to assume that all those neutral-gray subjects will reflect back approximately 18% of the light that hits them.

This sounds simple enough, but more often than not, it's the reflectance of light off a given subject that creates a bad exposure, not the light that strikes the subject. Imagine that you came across a black cat asleep against a white wall, bathed in full sunlight. If you were to move in close and let the meter read the light reflecting off the cat, the meter would indicate a specific reading. If you were to then point the camera at only the white wall, the exposure meter would render a separate, distinct reading. This variation would occur because, although the subjects are evenly illuminated, their reflective qualities radically differ. For example, the white wall would reflect approximately 36% of the light, while the black cat would absorb most of the light, reflecting back only about 9%.

When presented with either white or black, the light meter freaks ("Holy smokes, sound the alarm! We've got a problem!"). White and black especially violate everything the meter was "taught" at the factory. White is no more neutral gray than black; they're both miles away from the middle of the scale. In response, the meter renders these extremes onto your digital sensor just like it does everything else: as a neutral gray. If you follow the light meter's reading—and fail to take charge and meter the right light source—white and black will record as dull gray versions of themselves.

To successfully meter white and black subjects, treat them as if they were neutral gray, even though their reflectance indicates otherwise. In other words, meter a white wall that reflects 36% of the light falling on it as if it reflected the normal 18%. Similarly, meter a black cat or dog that reflects only 9% of the light falling on it as if it reflected 18%.

IF THE LIGHT METER *is confused by white and black separately, can you imagine how confused it must get when aimed at a zebra? Actually, this is one of the easiest exposures. Why? Because the light meter averages the two tones and comes back with a correct 18% gray reflectance. It's like putting equal parts white and black paint into a bucket, mixing them together, and getting medium gray. With my camera and 200mm lens set to f/11 ("Who cares" what aperture I use here?), I simply adjusted my shutter speed until 1/125 sec. indicated a correct exposure.*

200mm lens, f/11 for 1/125 sec.

THE GRAY CARD

When I first learned about 18% reflectance, it took me a while to catch on. One tool that enabled me to understand it was a gray card. Sold by most camera stores, gray cards come in handy when you shoot bright and dark subjects, such as white sandy beaches, snow-covered fields, black animals, or black shiny cars. Rather than pointing your camera at the subject, simply hold a gray card in front of your lens—making sure that the light falling on the card is the same light that falls on the subject—and meter the light reflecting off the card.

If you're shooting in an autoexposure, Program, Shutter Priority mode, or Aperture Priority mode, you must take one extra step before putting the gray card away. After you take the reading from the gray card, note the exposure. Let's say the meter indicated *f*/16 at 1/100 sec. for a bright snow scene in front of you. Then look at the scene in one of these modes. Chances are that in Aperture Priority mode, the meter may read *f*/16 at 1/200 sec.; and in Shutter Priority mode, the meter may read *f*/22 at 1/100 sec. In either case, the meter is now "off" 1 stop from the correct meter reading from the gray card. You need to recover that 1 stop by using your autoexposure overrides.

These overrides are designated as follows: +2, +1, 0, -1, and -2; or 2X, 1X, 0, 1/2X, and 1/4X. So, for example, to provide an additional stop of exposure when shooting a snowy scene in the autoexposure mode, you would set the autoexposure override to +1 (or 1X, depending on your camera's make and model). Conversely, when shooting a black cat or dog, you'd set the autoexposure override to -1(1/2X).

Hot Gray Card Tip!: After you've purchased your gray card, you only need it once, since you've already got something on your body that works just as well—but you'll need the gray card to help you initially. If you're ever in doubt about any exposure situation, meter off the palm of your hand. I know your palm isn't gray, but you then simply use your gray card to "calibrate" your palm—and once you've done that, you can leave the gray card at home.

To calibrate your palm, take your gray card and camera into full sun, and set your aperture to *f*/8. While filling the frame with the gray card (it doesn't have to be in focus), adjust your shutter speed until a correct exposure is indicated by the camera's light meter. Now hold the palm of your hand out in front of your lens. The camera's meter should read that you are about +2/3 to 1 stop overexposed. Make a note of this. Then take the gray card once again into open shade with an aperture of *f*/8, and again adjust the shutter speed until a correct exposure is indicated. Again, meter your palm, and you should see that the meter now reads +2/3 to 1 stop overexposed. No matter what lighting conditions you do this under, your palm will consistently read about +2/3 to 1 stop overexposed from the reading of a gray card.

So the next time you're out shooting and you have that uneasy feeling about your meter reading, take a reading from the palm of your hand and when the meter reads +2/3 to 1 stop overexposed, you know your exposure will be correct.

(**Note:** For obvious reasons, if the palm of your hand meters a 2-, 3-, or 4-stop difference from the scene in front of you, you're either [a] taking a reading off the palm of your hand in sunlight, having forgotten to take into account that your subject is in open shade, or [b] you forgot to take off your white gloves.)

FOLLOWING A HEAVY SNOWFALL *in eastern Oregon's high desert country, I headed out at first light and was soon finding a number of excuses to bring my Jeep to a halt and take a picture or two. Within an hour of my outing, I came upon a lone owl perched on a small scrub, and with my 200–400mm lens and my camera in Aperture Priority mode, I was able to frame up a pleasing "portrait" at the aperture of f/8. But as this first image shows (above), this exposure proved too dark (underexposed). Why is this so, when my light meter told me it was correct? Although white subjects reflect roughly 36% of the light, they must be metered as if they reflect the normal 18% gray. When the light meter sees white, it interprets this excessive brightness/reflectance to mean that less exposure time is needed, and subsequently, it renders an underexposed image.*

When I held my gray card up to the front of the lens, however, I noticed that the light meter now indicated a correct exposure at 1/15 sec. And when I put the gray card down, the light meter, not surprisingly, jumped back to 1/30 sec. as the indicated correct exposure. It was then that I chose to switch from Aperture Priority mode to manual mode and set the shutter speed to 1/15 sec. As you can see in the second example, this exposure did, indeed, prove to be correct.

Both photos: 200–400mm lens, f/8. Above: 1/30 sec. Opposite: 1/15 sec.

The Sky Brothers

The world is filled with color, and in fairness, the light meter does a pretty darn good job of seeing the differences in the many shades and tones that are reflected by all of this color. But in addition to being confused by white and black, the meter can also be confused by backlight and contrast. So are we back to the hit-and-miss, hope-and-pray formula of exposure? Not at all! There are some very effective and easy solutions for these sometimes pesky and difficult exposures: They're what I call *the Sky Brothers*.

Oftentimes when shooting under difficult lighting situations (sidelight and backlight being the two primary examples), an internal dispute may take place as you wrestle over just where exactly you should point your camera to take a meter reading. I know of "no one" more qualified to mediate these disputes between you and your light meter than the Sky Brothers. They're not biased. They want only to offer the one solution that works each and every time. So on sunny days, *Brother Blue Sky* is the go-to guy for those winter landscapes (see page 132), black Labrador

I'M A STRONG BELIEVER in morning light. To meter this scene, I used Brother Reflecting Sky, pointing my camera below the horizon line. The reason I didn't use Brother Backlit Sky is that a reflection absorbs at least a full stop of light, sometimes more. Thus, if I'd taken the meter reading off the sky, I would have ended up with an image that was at least 1 stop underexposed, if not more. If you want to show detail, color, and texture in the reflection, this would be disastrous. Granted, the sky is now 1 stop overexposed, but it's a welcome trade-off, since I was able to get both detail and color in the reflection below.

20-35mm lens at 20mm, f/22 for 1/8 sec.

CHAOS IS PERHAPS the best way to describe the result of a traffic light that seems to indicate anything is possible—considering that red, yellow, and blue-green are all lit at the same time. Over the course of an 8-second exposure— which I chose so that I could interpret the traffic as colorful streaks—I was able to record all three lights, since my exposure began just several seconds before the light changed from blue-green to yellow to red. I, of course, used a tripod for such a long exposure, and I used Brother Dusky Blue Sky, metering off the distant dusky blue sky.

80-200mm lens at 135mm, f/11 for 8 seconds

portraits, bright yellow flower close-ups, and fields of deep purple lavender. This means you take a meter reading of the sunny blue sky and use that exposure to make your image. When shooting backlit sunrise and sunset landscapes, *Brother Backlit Sky* is your go-to guy. This means you take a meter reading to the side of the sun in these scenes and use that reading to make your image. When shooting city or country scenes at dusk, *Brother Dusky Blue Sky* gets the call, meaning you take your meter reading from the dusk sky. And when faced with coastal scenes or lake reflections at sunrise or sunset, call on *Brother Reflecting Sky*, meaning you take your meter reading from the light reflecting off the surface of the water.

Warning: Once you've called upon the Sky Brothers, your camera's light meter will let you have it. You'll notice that once you've used Brother Blue Sky and set the exposure, your light meter will go into a tirade when you recompose that frontlit winter landscape ("Are you nuts?! I've got eyes of my own and I know what I'm seeing, and all that white snow is nowhere near the same exposure value of Brother Blue Sky!") Trust me on this one. If you listen to your light meter's advice and, subsequently, readjust your exposure, you'll end up right back where you started—a photograph with gray snow! So, once you have metered the sky using the Sky Brothers, set the exposure manually, or "lock" the exposure if you are staying in automatic before you return to the original scene. Then shoot away with the knowledge that *you are right* no matter how much the meter says you're wrong!

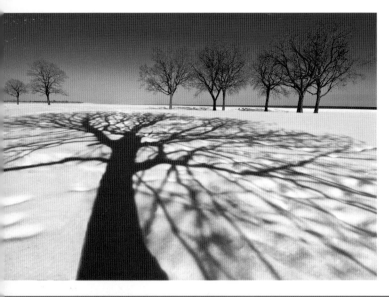

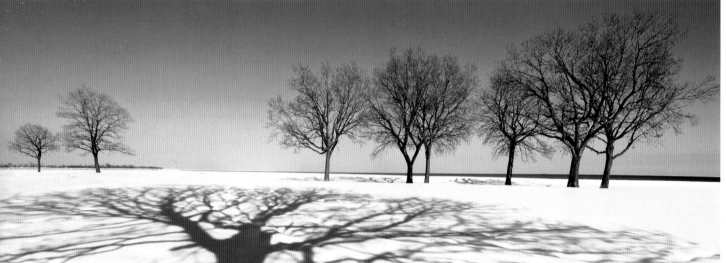

HANDHOLDING MY CAMERA *and using manual exposure mode, I simply framed up this winter scene just off Chicago's Lakeshore Drive and adjusted my meter until a correct exposure was indicated—and, not surprisingly, I got gray snow (top, left)! This same exposure would have happened even in Aperture Priority mode, and why not? The light meter is simply doing its job—making excessively bright subjects gray, since after all, it's programmed to think that the world is one shade of gray. But we all know snow is white, so if you have any intention of recording pure white snow, you need to perform an "intervention" and use Brother Blue Sky.*

With a focal length of 14mm and a storytelling aperture of f/22, I simply pointed the camera to the blue sky above (top, right) and adjusted my shutter speed until a correct exposure was indicated at 1/60 sec. I then recomposed to my original composition, and voilà, I got my white snow. Of course, after I metered the blue sky and recomposed the snow scene before me, my light meter told me I was wrong, but sometimes, just like when a two-year-old throws a tantrum, you have to simply ignore it!

12–24mm lens at 14mm, f/22 for 1/60 sec.

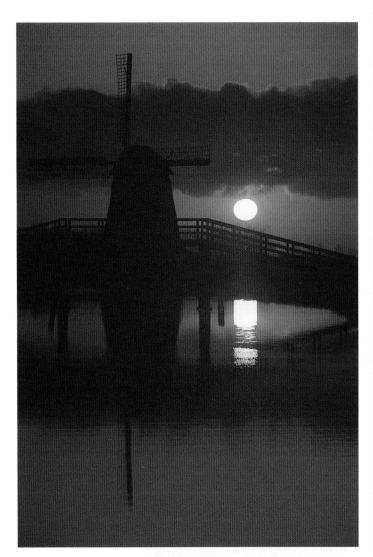

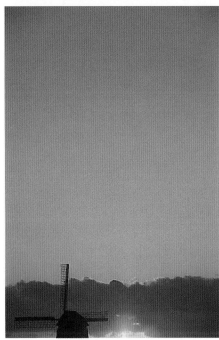

WHEN SHOOTING BACKLIGHTING,
*sunrises, or sunsets—and especially with a
telephoto lens—call on* Brother Backlit Sky. *In
the first exposure, the windmill gets lost in a
cloud and also is a bit too dark. This was the
result of listening to the meter. But when I
took the exposure using Brother Backlit Sky—
always to the left or right of the sun, or above
or below it (left)—I was able to record a much
better exposure.*

80–200mm lens at 200mm, f/22 for 1/125 sec.

Mr. Green Jeans (the Sky Brothers' Cousin)

Mr. Green Jeans is the cousin of the Sky Brothers. He comes in handy when exposing compositions that have a lot of green in them (you take the meter reading off the green area in your composition). Mr. Green Jeans prefers to be exposed at -2/3. In other words, whether you bring the exposure to a close by choosing either the aperture or the shutter speed last, you determine the exposure reading to be "correct" when you see a -2/3 stop indication (which means you adjust the exposure to be -2/3 stops from what the meter tells you it should be.) If there's one thing I've learned about Mr. Green Jeans, it's that he's as reliable as the Sky Brothers, but you must always remember to meter him at -2/3.

WHILE ON ASSIGNMENT for a large Dutch flower company, I made what has become one of my all-time favorite images. I had never before been so mesmerized by a pair of eyes as I was by those of Ijadet. She was one of several hundred employees working on the flower plantation near Burjumbura, Burundi. She was intensely camera shy, and although it took three days, I did finally manage to get her to look at me for a grand total of just one minute.

Again, the lighting challenge here is that the light meter "freaks" when presented with black or white subjects and does everything it can to render them as gray. Due to Ijadet's dark skin color, the light meter interpreted her much lower reflected-light value to mean that the exposure time should be much longer than the "norm." So I put Mr. Green Jeans to use and pointed the light meter toward the bouquet of carnations she was holding. I'd already determined this was a "Who cares?" composition, and so I chose an f/8 aperture. Then with my camera pointed at the flowers, I adjusted my shutter speed until a -2/3 stop exposure was indicated and simply recomposed and took the shot.

105mm lens, f/8 for 1/125 sec.

SINCE THE METER SEES THE WORLD *as neutral gray, it's often a good idea to call on Mr. Green Jeans when shooting waterfalls—to ensure bright, white water. You can see that when you don't, the meter "sees" the waterfall more as a gray tone when left to its own devices. In addition, the surrounding foliage records excessively dark. In its desire to see that waterfall as gray, the meter has in fact rendered an underexposed image, and this affects not only the water but the surrounding forest of green.*

The solution is an easy one, if you set a manual exposure or use your exposure-lock feature. In manual mode, decide on your shutter speed. (Here, I wanted that cotton-candy effect in the water, so I chose 1/4 sec.) Then you merely swing the camera to the right or left of the water to meter off the green (left), and set the exposure at -2/3 of what the meter indicates a correct exposure to be. (See page 23 for meter reading guidance.) If you prefer to shoot in Shutter Priority mode, follow the same procedures, and then set an autoexposure override to -2/3, press and hold the exposure-lock button, recompose the scene, and shoot. Setting a manual exposure seems like less of a hassle to me, so this is just one more reason to get comfortable working in manual mode.

The reason this works is because green's reflected value is a bit shy of neutral gray (or 18% reflectance), and green—when metered at -2/3— records as perfect 18% reflectance. So when I used f/22, this made the waterfall gray. When I used Mr. Green Jeans in manual mode, I saw that at f/16 my meter was now indicating a -2/3 underexposure, so I simply recomposed and fired away. Note that when I recomposed, the meter no longer showed the -2/3 exposure, since I had reintroduced the white waterfall into the scene, but I just ignored the meter and made the shot at the exposure I had set.

Both photos: 12–24mm lens, 1/4 sec. Top, left: f/22. Above: f/16

Night and Low-Light Photography

There seems to be this unwritten rule that it's not really possible to get any good pictures before the sun comes up or after it goes down. After all, if "there's no light," then why bother? However, nothing could be farther from the truth.

Low-light and night photography do pose special challenges, though, not the least of which is the need to use a tripod (assuming, of course, that you want to record exacting sharpness). But it's my feeling that the greatest hindrance to shooting at night or in the low light of predawn is in the area of self-discipline: "It's time for dinner" (pack a sandwich); "I want to go to a movie" (rent it when it comes out on DVD); "I'm not a morning person" (don't go to bed the night before); "I'm all alone and don't feel safe" (join a camera club and go out with a fellow photographer); "I don't have a tripod" (buy one!). If it's your goal to record compelling imagery—and it should be—then night and low-light photography are two areas where compelling imagery abounds. The rewards of night and low-light photography far outweigh the sacrifices.

Once you pick a subject, the only question that remains is how to expose for it. With the sophistication of today's cameras and their highly sensitive light meters, getting a correct exposure is easy, even in the dimmest of light. And yet many photographers get confused: "Where should I take my meter reading? How long should my exposure be? Should I use any filters?" In my years of taking meter readings, I've found there's nothing better—or more consistent—than taking meter readings off the sky. This holds whether I'm shooting backlight, frontlight, sidelight, sunrise, or sunset (the Sky Brothers are your go-to guys, see page 130). If I want great storytelling depth of field, I set the lens (i.e., a wide-angle lens for storytelling) to f/16 or f/22, raise my camera to the sky above the scene, adjust the shutter speed for a correct exposure, recompose, and press the shutter release.

ONE OF THE MANY SUSPENSION BRIDGES *in Lyon, France, has two large, deep red metal struts, one at each end. On the east end, you can look to the west and frame the Fouvrier atop Old Lyon through the struts. I've seen countless tourists make this shot throughout the day, but I have yet to see anyone do it at dusk, which you'd have to agree makes for a better shot.*

With my camera on tripod, I set my aperture to f/22, and with the lens pointed to the dusky blue sky, I adjusted my shutter speed until 3 seconds indicated a correct exposure. I then recomposed the scene you see here, and with the camera's self-timer set, I pressed the shutter release. The reason I use the self-timer with "long" exposures is simply to avoid any contact with the camera during the exposure time. I don't want the risk of any camera shake, since sharpness is paramount most every time I record an exposure.

Note that your camera's default for the self-timer is usually a ten-second delay, but I would strongly recommend that you consider changing this to a two-second delay. Waiting ten seconds in between shots can often mean not getting the shot. (And to be clear, you can also use a cable release, but even here there's the slight risk of camera shake, since you're still "tied" to the camera.)

35–70mm lens, f/22 for 3 seconds

"PAINT THE TOWN RED"
was the campaign for the city of Sydney during my two-week stay there years ago. Even the opera house was covered in red light. Not one to waste an opportunity, I set up my tripod. With my aperture set to f/8 ("Who cares?" since everything is at the same focal distance of infinity), I tilted the camera up to the dusky blue, cloudy sky and adjusted my shutter speed until the meter indicated 2 seconds as a correct exposure. I then recomposed and made several exposures, tripping the shutter with the camera's self-timer.

80–200mm lens, f/8 for 2 seconds

THE ARAVAIS MOUNTAIN
range in the northern French Alps is a skier's paradise, and the village of Grand Bornhand sits in the valley floor of these impressive mountains. It's a town that offers wonderful low-light photo opportunities if you can put off eating dinner for half an hour or so!

With my camera and 35–70mm lens on a tripod, I set the focal length to 35mm and the aperture to f/2.8, and then raised the camera to the dusky blue sky above the mountain range. I adjusted the shutter speed until the meter indicated 1/8 sec. as a correct exposure. I then recomposed, stopped the lens down 5 stops to f/16, and increased my exposure time by 5 stops. With my exposure time now set for f/16 for 4 seconds, I tripped the shutter with my camera's self-timer.

35–70mm lens at 35mm, f/16 for 4 seconds

WITH THE FALL OF COMMUNISM, *tourism to many of the former countries who were locked behind the Iron Curtain increased. Perhaps none has been more visited by travelers the world over than Prague, Czech Republic. It is truly a beautiful city! Your first challenge, however, won't be recording a correct exposure but rather jockeying for a position on the concrete path that hugs the Danube River. When I made this shot, the tour buses had emptied out and the shooters were out in force, just as determined as I to record a great shot of Prague and her illuminated castles. Unfortunately, most of them didn't get the shot. Without a tripod, a night shot of Prague is just not going to happen.*

With my camera on tripod, I first set my aperture to the "Who cares?" choice of f/11 (since everything was at the same focused distance: infinity). I then tilted the camera to the Brother Dusky Blue Sky and adjusted my shutter speed until 4 seconds indicated a correct exposure. After that, it was simply a matter of recomposing the scene, and with the aid of an electronic cable release and the camera set to mirror lock-up, I fired off several frames, one of which also recorded the slow movement of a tour boat that had entered the frame.

17–55mm lens at 32mm, f/11 for 4 seconds

WHEN I MADE THIS LONG EXPOSURE *of St. Peter's basilica in Rome, I started shooting shortly after the streetlights had come on, yet the church itself never lit up! In any event, I used a filter I can't live without (besides the polarizer and Tiffen 3-stop graduated): the FLW. It's a magenta-colored filter not to be confused with the FLD. The magenta color of the FLW is far denser and is far more effective on normally greenish city lights, giving them a much warmer cast. Additionally, this filter imparts its magenta hue onto the sky, which is perfect for those nights when there isn't a strong dusky blue sky.*

With my camera mounted on a tripod, I at first set my aperture to f/4. I pointed the camera to the gray sky and adjusted my shutter speed to 1/2 sec., but since I had already determined that I wanted the longest possible exposure time, I did the math and ended up at f/32 for 30 seconds!

105mm lens, f/32 for 30 seconds

MANY ROCKY SHORELINES *offer opportunities to convey both tranquility and motion. This exposure, although it appears difficult, is really quite easy to make. I first placed my FLW magenta filter on my 24mm lens and then went looking for my meter reading. Using Brother Reflecting Sky and with my aperture at f/4, I metered off the light reflecting on the surface of the water, adjusting my shutter speed until 1 second indicated a correct exposure. I then pointed the lens above the horizon and, with the aperture still at f/4, took a meter reading using Brother Backlit Sky. I got a correct exposure at 1/15 sec., a difference of 4 stops (f/4 for 1 second vs. f/4 for 1/15 sec. is 4 stops—from 1 second to 1/2 sec. to 1/4 sec. to 1/8 sec. to 1/15 sec.). So, which exposure wins? Both, thanks to my trusty 3-stop graduated soft-edge neutral-density filter. The graduated neutral density had effectively slashed 3 stops of exposure from Brother Backlit Sky, so the exposure time had to change from f/4 for 1/15 sec. to f/4 for 1/2 sec. In other words, the brothers would only be separated by 1 stop, and a 1-stop difference in backlit exposures like these is nothing.*

But wait! Since I wanted to shoot a long exposure and use the first exposure I took using Brother Reflecting Sky, I had to do the math. Since f/4 was correct at 1 second, then f/5.6 for 2 seconds would also be good, as would f/8 for 4 seconds and f/11 for 8 seconds and f/16 for 16 seconds. Stop! That's good enough for me! After setting my depth of field via the distance setting on my lens (in this case, setting five feet out ahead of the center focus mark), I was ready to shoot—and presto, here's the result (with the aid of my Lee 3-stop soft-edge neutral-density filter and my Tiffen FLW magenta filter.)

24mm lens, f/16 for 16 seconds

WHILE MANY PHOTOGRAPHERS *watch the moon rise, few photograph it because they aren't sure how to meter the scene. Surprisingly, however, a "moonrise" is easy to expose. It's actually just a frontlit scene—just like the frontlit scenes found in daylight—but now, of course, it's a low-light frontlit scene.*

Since depth of field was not a concern here, I set the aperture on my lens to f/8, metered the sky above the tree, adjusted my shutter speed to 1/8 sec., recomposed the scene, and—using the camera's self-timer—fired the shutter release button.

Note: *In this instance, as well as for other full-moon landscapes, it's best to take the photograph on the day before the calendar indicates a full moon. Why? Because the day before a full moon (when the moon is almost full), the eastern sky and the landscape below are darn near at the same exposure value. (And, truth be told, I could have also taken my meter reading from the wheat field in this scene and it would have been within a cat's whisker of the meter reading for the sky.)*

300mm lens, f/8 for 1/8 sec.

A FIRM AND STEADY TRIPOD enabled me to shoot this classic scene of the San Francisco skyline. With my camera and 35–70mm lens on a tripod, I set the focal length to 50mm and set my aperture wide open at f/2.8. I then pointed the camera to the sky above and adjusted the shutter speed to 1/2 sec. Since I wanted an exposure of at least 8 seconds to capture the flow of traffic on the bridge, I knew that by stopping the lens down 4 stops to f/11 would require me to increase my exposure time by these same 4 stops to 8 seconds. With an 8-second exposure, I tripped the shutter with my cable release.

35–70mm lens at 50mm, f/11 for 8 seconds

THE IMPORTANCE OF THE TRIPOD

When should you use a tripod? When I want exacting sharpness and/or when I'm shooting long exposures and want to convey motion in a scene, I always call upon my tripod.

The following features are a must on any tripod. First, the *tripod head*: This is the most important, because it supports the bulk of the camera and lens weight. When looking at the many different styles of tripod heads, make it a point to mount your heaviest combination of camera and lens on each head as a test. Once you secure the camera and lens, check to see if it tends to flop or sag a bit. If so, you need a much sturdier head. Next, see if the tripod head offers, by a simple turn of the handle, the ability to shift from a horizontal to a vertical format. Also check whether you can lock the tripod head at angles in between horizontal and vertical. Finally, does the tripod head offer a quick release? Some tripods require you to mount the camera and lens directly onto the tripod head by way of a threaded screw. A quick release, on the other hand, is a metal or plastic plate that you attach to the camera body; you then secure the camera and plate to the head via a simple locking mechanism. When you want to remove the camera and lens, you simply flick the locking mechanism and lift the camera and lens off the tripod.

Second, the *base stability*: Before buying any tripod, you should also spread out its legs as wide as possible. The wider the base, the greater the stability. Each leg of the tripod is composed of three individual lengths of aluminum, metal, or graphite. You can lengthen or shorten the legs and then tighten them by a simple twist of hard plastic knobs, metal clamps, or a threaded metal sleeve. The height of a tripod at full extension is another important consideration: Obviously, if you are 6'2", you don't want a tripod with a maximum height of only 5'2"—unless you won't be bothered by stooping over your tripod all the time. All tripods have a center column designed to provide additional height; this can vary from six inches to several feet. Some center columns extend via a cranking mechanism, while others require you to pull them up manually. Keep in mind that you should raise the center column only when it's absolutely necessary, because the higher the center column is raised, the greater the risk of wobble—which defeats the purpose of using a tripod.

Finally, when shooting any subject with your tripod, make it a point to use either the camera's self-timer or a cable release to trip the shutter.

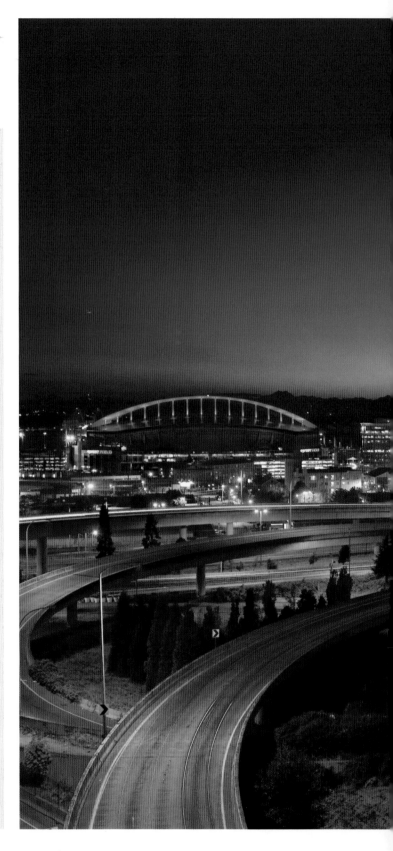

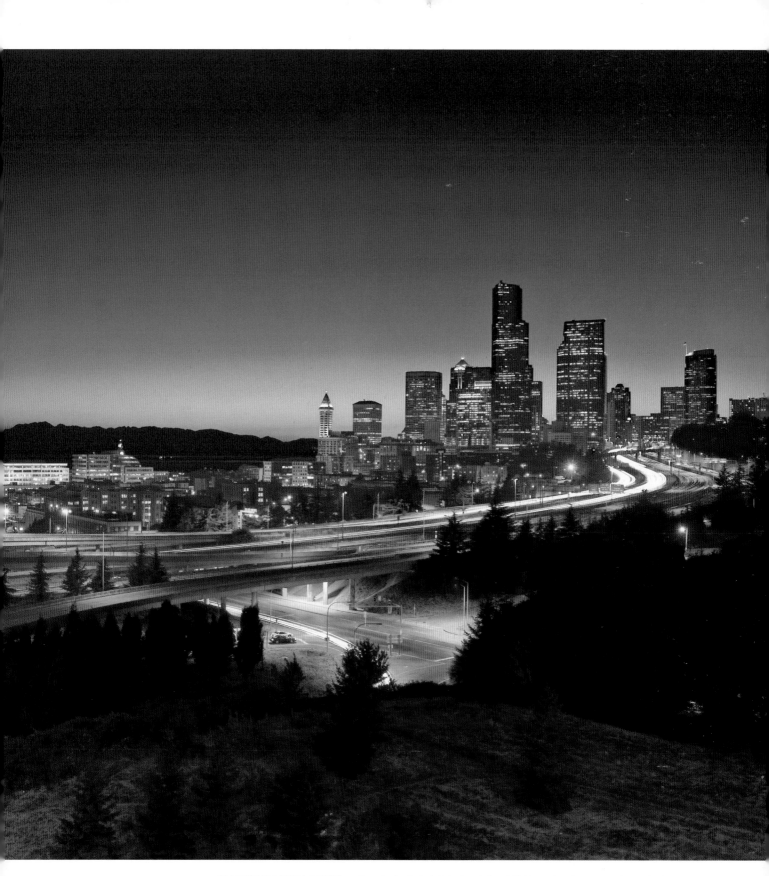

IF THERE'S STILL SOME *of that dusky light left in the sky, and if I have the time, I'm going to find something to shoot! That was the case several years ago in Seattle when my son and I were returning home from a movie. Near the Amazon headquarters is a truly amazing view of the city, so I was quick to pull the car over, take my tripod and camera from the trunk, and set up the composition you see here. With my 28–70mm lens, I set the aperture to f/22, pointed the camera up to the dusky blue sky, and adjusted my shutter speed until 15 seconds indicated a correct exposure. I welcomed this long shutter speed, since this longer exposure would increase my chances of recording headlight and taillight streaks from the many cars that were on the roads below.*

28–70mm lens, f/22 for 15 seconds

FILTERS,
SPECIAL TECHNIQUES
& FLASH

Polarizing Filters

Of the many filters on the market today, a polarizing filter is one that every photographer should have. Its primary purpose is to reduce glare from reflective surfaces, such as glass, metal, and water. On sunny days, a polarizer is most effective when you're shooting at a 90-degree angle to the sun. For this reason, sidelighting (when the sun is hitting your left or right shoulder) is a popular lighting situation for using a polarizing filter. Maximum polarization can only be achieved when you're at a 90-degree angle to the sun; if the sun is at your back or right in front of you, the polarizer will do you no good at all.

Working in bright sunlight at midday isn't a favorite activity for many experienced shooters, since the light is so harsh, but if you need to make images at this time of day, a polarizer will help somewhat. This is because the sun is directly overhead—at a 90-degree angle to you, whether you're facing north, south, east, or west.

If you're working in morning or late-afternoon light, you'll want to use the polarizing filter every time you shoot facing to the north or south. In this situation, you're at a 90-degree angle to the sun, and as you rotate the polarizing filter on your lens, you'll clearly see the transformation: Blue sky and puffy white clouds will "pop" with much deeper color and contrast.

Why is this? Light waves move around in all sorts of directions—up, down, sideways, and all angles in between.

SINCE MY POINT OF VIEW was at a 90-degree angle to the early-morning light coming in from my left, this scene of Neuschwanstein castle in the German Alps offered an obvious opportunity to use my polarizing filter. In the first example (below), I didn't use the filter, and you can see the overall haze, the lack of vivid blue sky and of detail in the distant mountains, and the somewhat flat greens of the valley floor. After placing the polarizing filter on my lens and rotating the outer ring to achieve maximum polarization (right), the difference is clear. Even the once lone and indistinct cloud is now more vivid and has company!

Both photos: 35–70mm lens at 35mm. Below: f/8 for 1/250 sec. Right: f/8 for 1/60 sec.

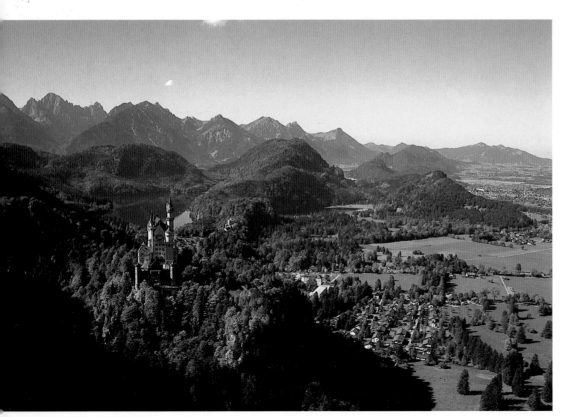

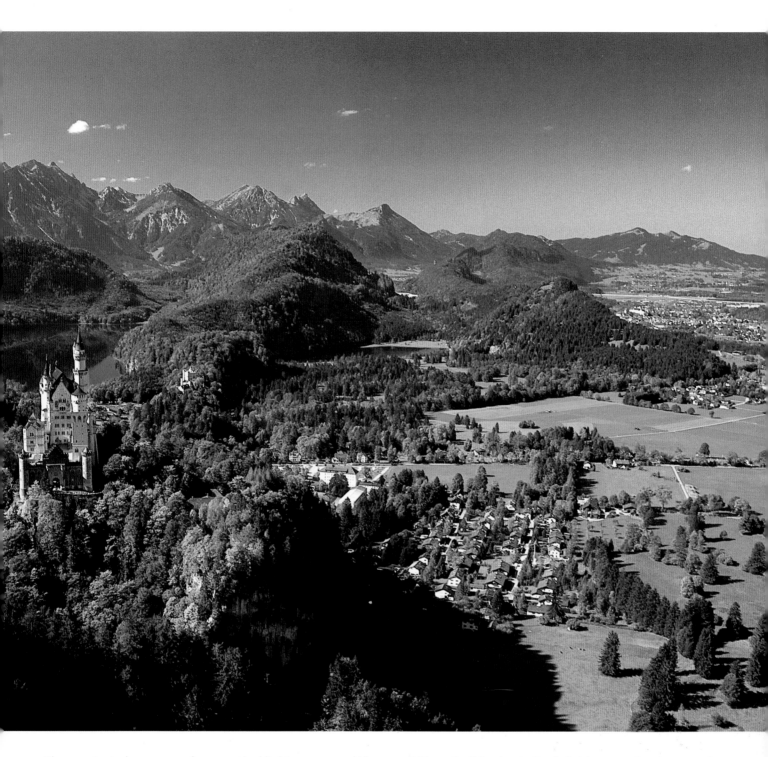

The greatest glare comes from vertical light waves, and the glare is most intense when the sun itself is at a 90-degree angle to you. The polarizing filter is designed to remove this vertical glare and block out vertical light, allowing only the more pleasing and saturated colors created by horizontal light to be recorded. Note that if you shift your location so that you're at a 30- or 45-degree angle to the sun, the polarizing effect of the filter will be seen on only one-half or one-third of the composition, so one-half or one-third of the blue sky is much more saturated in color than the rest of it. Perhaps you've already seen this effect in some of your landscapes. Now you know why.

Although there's vertical light around when you're working with frontlit or backlit subjects, there's no need to use the polarizing filter at these times, since the sun is no longer at a 90-degree angle to you.

Is the use of polarizing filters limited to sunny days? Definitely not! In fact, on cloudy or rainy days, there's just as much vertical light and glare as on sunny days. All this vertical light casts dull reflective glare on wet streets, wet metal and glass surfaces (such as cars and windows), wet foliage, and surfaces of bodies of water (such as streams and rivers). The polarizing filter gets rid of all this dull, gray glare.

I CAN'T LIVE WITHOUT MY POLARIZING FILTER, *more for the rain than for the sunshine. It's the one tool that will save you each and every time when shooting in the woods on rainy days. It alone can remove all the glare from your rainy-day compositions— no amount of Photoshop ever will! Take a look for yourself. Without the polarizing filter (above), note all the glare. The stream, rocks, and leaves are all reflecting the dull, gray, rainy sky overhead. But as you can see at right, with the filter you discover a colorful world that only seconds ago was awash in glare.*

Note that because a polarizing filter cuts the light down by 2 stops, I had to increase my shutter speed by 2 stops (from 1/4 sec. to 1 second) to accommodate this. Since that brought the shutter speed to 1 second, a tripod was a must, and I then used the camera's self-timer to fire the shutter release.

Both photos: 24mm lens. Above: f/22 for 1/4 sec. Right: f/22 for 1 second

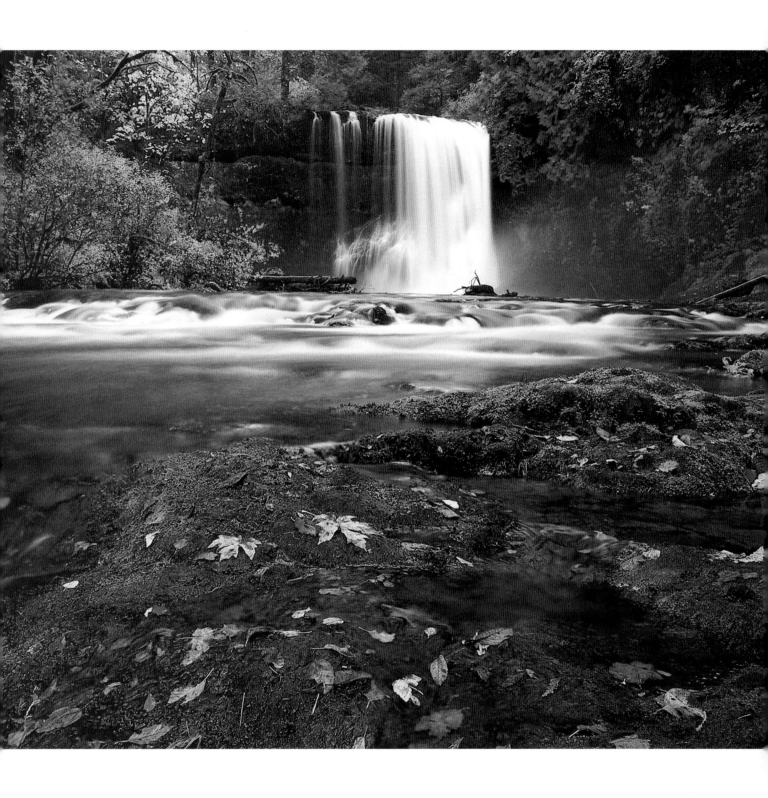

Neutral-Density Filters

s there a filter than can reduce your depth of field? Is there a filter that can help you imply motion (panning) or turn that fast-moving waterfall into a sea of white frothy foam? You bet there is, and it's called a neutral-density filter.

The *sole* purpose of the neutral-density (or ND) filter is to reduce the intensity of the light in any given scene. It acts in much the same way as a pair of sunglasses, knocking down the overall brightness of a scene without interfering with the overall color. Just as sunglass lenses come in varying degrees of darkness, neutral-density filters come in stop increments. So, for example, a 3-stop neutral-density filter knocks down the brightness of the light by 3 stops.

This reduction of light intensity allows you to use larger lens openings (resulting in shallower depth of field) or slower shutter speeds. If, for example, I were using an ISO of 400 and wanted to create a cotton-candy effect in a waterfall, I would first stop the lens down to the smallest lens opening. For argument's sake here, let's say that is $f/22$. I would then adjust my shutter speed until I got a correct exposure, let's say at 1/15 sec. At 1/15 sec., I couldn't record the cotton-candy effect, because the shutter speed is too fast. I would need at least 1/4 sec. to record this effect. If I were to use a 3-stop neutral-density filter, I'd knock the intensity of the light down by 3 stops. My meter would tell me that $f/22$ for 1/15 sec. is 3 stops underexposed, so I would readjust my shutter speed to 1/2 sec. (1/15 sec. to 1/8 sec. to 1/4 sec. to 1/2 sec. is 3 stops), which is slow enough to record the cotton-candy effect I was going for.

And there are other "problems" for which the ND filter is a good solution. Let's say you find yourself shooting a portrait of a vendor at an outdoor flower market. You position your subject about ten feet in front of a "wall" of flower stands. You want all the visual weight on the vendor, with a background of only out-of-focus flower tones and shapes. So you choose, rightly so, a short telephoto lens (say, 135mm) and a large aperture (say, $f/4$) to limit the depth of field to the vendor. As you adjust your shutter speed and notice that you reach the end of the shutter speed dial (say, 1/2000 sec.), your light meter still indicates a 2-stop overexposure. You could stop the lens down to $f/8$, but this would increase the depth of field, revealing too much background detail. By adding a 3-stop ND filter to your lens, $f/4$ for 1/1000 sec. yields a correct exposure—and gives the depth of field you want.

Although you can buy ND filters that reduce the intensity of light from 1 to 4 stops, my personal preference is the 3-stop filter. As you'll see over time, this is all you need when you want to use slower shutter speeds or larger lens openings without the worry of overexposure.

WITH MY CAMERA AND 80–200MM LENS *on a tripod, I set my aperture to f/22, knowing full well that a lens opening this small would necessitate the slowest possible shutter speed—and to "explode" this meadow of flowers with my zoom lens, I would need a slow shutter speed. How slow? Normally, at least 1/4 sec., if not 1/2 sec. As I adjusted my shutter speed, I noticed that my light meter was indicating 1/30 sec. as a correct exposure. Good thing I had my 3-stop Tiffen neutral-density filter with me. I threaded it onto the lens, and just like that, I had a correct exposure indication of f/22 for 1/4 sec. As I fired off several exposures, I was quick to zoom the lens from 80mm to 200mm during the 1/4-sec. period. Some of my attempts fell a bit short, but this and a few others turned out beautifully.*

80–200mm lens, f/22 for 1/4 sec

Graduated Neutral-Density Filters

nlike a neutral-density filter, a graduated neutral-density filter contains an area of density that merges with an area of no density. In effect, it is like a pair of sunglasses with lenses that are only tinted in certain areas and not others. Rather than reducing the light transmission throughout the entire scene, as an ND filter does, a graduated ND filter reduces light only in certain areas of the scene.

Suppose you were at the beach just after sunset and want to use your wide-angle lens to get a composition that included the bright, color-filled, postsunset sky; several small foreground boulders surrounded by wet sand; and the incoming waves. Since this would be a storytelling image, you'd choose the right aperture first, in this case *f*/22 for maximum depth of field. Then you'd point your camera at the sky to get the correct shutter speed, in this case 1/30 sec. But if you took a meter reading from the wet sand, 1/2 sec. would be the correct shutter speed. That's a 4-stop difference in exposure. If you were to go with *f*/22 for 1/30 sec., you'd record a wonderful color-filled sky, but the foreground sand and rocks would be so underexposed they would hardly appear. If you were to go expose for the sand and rocks, on the other hand, the sky would be way overexposed and all its wonderful color would disappear.

One of the quickest ways to "change" the exposure time for the sky so that it gets close to matching that of the sand and rocks is to use a drop-in graduated neutral-density filter. Unlike a "normal" graduated ND filter, which threads onto the front of your lens, a drop-in filter is square or rectangular in shape and drops into a filter holder that you secure to the front of your lens. This allows you to slide the filter up or down, or to turn the outer ring of the filter holder so that you can place the filter at an angle. This, in turn, allows for perfect placement of the filter in most of your scenes.

In the situation described above, a 4-stop graduated ND filter positioned so that only the sky was covered by the ND area would be the solution. You wouldn't want the filter covering anything other than the bright sky. Once the filter was in place, aligned so that the ND section stopped right at the horizon line, the correct sky exposure would be reduced by 4 stops, and you could shoot the entire scene at *f*/22 for 1/2 sec.

Just like ND filters, graduated ND filters come in 1- to 4-stop variations. In addition, they come in hard-edge and soft-edge types, meaning that the clear section of the filter meets the ND section with either an abrupt change or a gradual transition. My personal preference is the soft edge.

ALIGNING THE FILTER

If you have a camera with a depth-of-field preview button, use it as you position the graduated ND filter. As you slide the filter up or down, you can clearly see exactly what portions of the composition will be covered by the density of the filter. Using the preview button will guarantee perfect alignment every time.

THE TRICKY PART *of this scene was the 4-stop difference between the wheat field and the sky. With my camera and lens on a tripod, I chose an aperture of f/16 and set my exposure for the green field. I recorded a correct exposure of the field, but at the expense of the cloud and colorful sky (opposite). In the second try (right), I was able to record a correct exposure of the green field as well as the cloud and sky, but only after placing my Lee 3-stop graduated neutral-density filter on my lens. My exposure time for both of these images was the same: f/16 for 1/4 sec.*

If you don't have a graduated neutral-density filter, you could take two separate, correct exposures (one of the field and the other of the cloud and sky) and then use Layers in Photoshop to blend the two exposures into one and end up with the same thing. But, whew! I don't know about you, but I get exhausted just thinking about this. A word of advice: If you've got Photoshop, then your budget can easily absorb the cost of a Lee graduated neutral-density filter. Buy it now, and the next time, get the right exposure in camera! You'll have more time to spend with your family and friends.

Both photos: 35–70mm lens, f/16 for 1/4 sec.

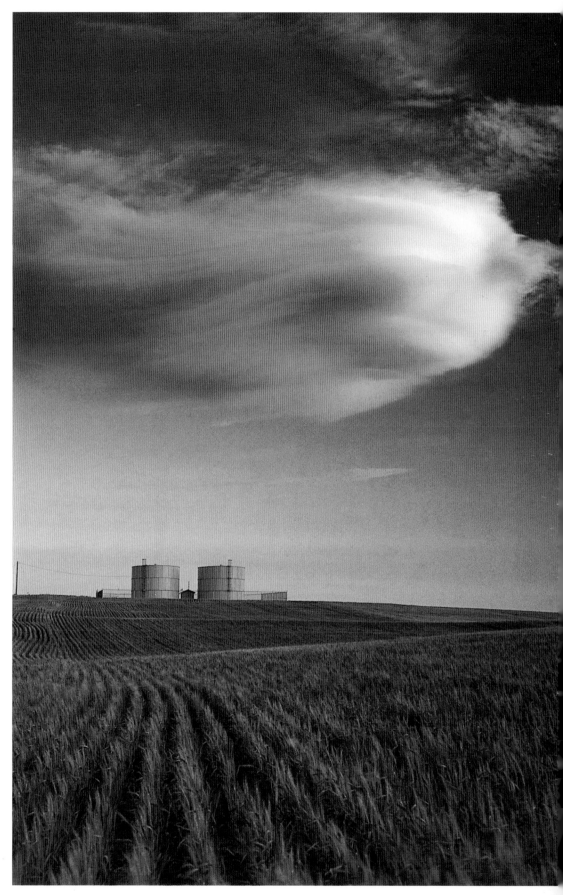

Multiple Exposures

If taking a single exposure of a given scene or subject doesn't quite do it for you, how about taking three, five, seven, or nine exposures of the same subject, stacking all of these exposures one on another, and within seconds collapsing them all into a single image? You can do all this *in camera*, if you own (as of this printing) a Nikon (models D80, D90, D200, D300, D700, D2X, or D3X), the new Pentax DSLR K series cameras, or the Olympus DSLRs. Get out your manual if you have trouble finding this feature, because once you do, you can start exploring the many creative possibilities this feature affords!

I like to inject a bit of implied motion into my multiple exposures, and to do this you simply point your camera at your subject, choose the appropriate aperture (f/16 or f/22 for storytelling, f/4 or f/5.6 for isolation, or f/8 or f/11 for "Who cares?"), and, if in Aperture Priority mode, fire away three, five, seven, or nine times, all the while moving the camera ever so slightly with each exposure. If you choose to shoot in manual exposure mode, adjust the shutter speed until a correct exposure is indicated (as if shooting a single exposure) and then fire away, again moving the camera slightly with each of your three, five, seven, or nine exposures. The camera's "auto-gain" feature will take all of your combined exposures and blend them into a single, correct exposure.

Most any subject can benefit from the multiple exposure technique—even city scenes. Overcast days, sunny days, frontlit scenes, and even some backlit scenes lend themselves to multiple exposures, as well, but most of all, look for scenes that are also colorful and filled with pattern.

As for all you non–Nikon, Pentax, and Olympus shooters, until Canon, Sony, and Panasonic offer up multiple-exposure capabilities (which I'm confident they will at some point), you'll have to resign yourself to calling on Photoshop to put these techniques to work. You can certainly shoot nine various shots of the same scene and "stack" and "blend" them together in Photoshop to get the same effect. And to approximate my moon example on page 141, you can shoot the moon, load the image onto your computer, highlight the moon with the Marquee Tool, choose Inverse, take the Move Tool, and add the moon to just about any photo you choose.

WITH MY CAMERA and 200mm lens mounted on tripod, I chose to focus on an area of flowers and green grass (indicated by the white box above). With my aperture set to f/22 for maximum depth of field, I simply adjusted my shutter speed until 1/80 sec. indicated a correct exposure and pressed the shutter release, which resulted in the single exposure opposite, top. It's a nice shot, for sure, but I thought it also just might be one of those subjects that looks even better as a multiple exposure, because it was an image made up of colors and textures. Plus, on this particular day, with a cloudy sky above, it was a classic opportunity to shoot a multiple exposure, as far as I was concerned! Again, with that same exposure reading, I set my multiple exposure feature to nine shots and fired them all off, moving the camera slightly with each one. Within seconds of firing of all the shots, my Nikon D300 "processed" them as a single correct exposure (right).

Both photos: 200mm lens, f/22 for 1/80 sec.

IN ANTICIPATION OF YOUR QUESTION: *Yes, you can always shoot two separate exposures for those times when the full moon is coming up behind you but you wish to include it in the landscape or cityscape in front of you!*

Set your multiple exposures feature to two exposures, and just as I did here, you can now shoot the full moon up there in the eastern sky (above: 70–200mm lens, f/8, 1/125 sec.), placing it in the upper-right portion of the frame, and then turn around and, with your camera on tripod, shoot the Portland skyline (right: 28–70mm lens, f/16, 4 seconds)—and presto, the Nikon D300 will process both of your exposures into a single, full-moon city skyline exposure! Are we having fun or what?! If ever there were two techniques that allow me to stay true to my motto (Get as Much, if Not All, Done in Camera), these would be it.

Above: 70–200mm lens, f/8 for 1/125 sec. Right: 28–70mm lens, f/16 for 4 seconds

HDR: High Dynamic Range Exposures

What is HDR? Far be it from me to claim to be the expert on the subject, but I can tell you this: HDR is the acronym for *high dynamic range*, and it refers to the types of exposures that one could only dream of—until recently, that is. Until HDR came along, a film camera was capable of recording an exposure of light and dark as long as those areas of light and dark in the scene were within a 5-stop range. With digital, that range has increased to about 6 to 7 stops. But both film and digital cameras fall way short of seeing what the seeing human eye can see, which is a 16-stop range of lights to darks.

HDR is not something you can generate through a feature found on your camera. You need a special software program that will process any number of exposures of the same thing, blending only the "best" exposure details from each of the exposures into one single *perfect exposure*! (You can test out free trials of these programs, available for download online.) HDR assumes that you will first be shooting a range of various exposures of the same scene (for example, from +1 stop to -1 stop or something more extreme from +3 stops to -3 stops for a total of seven different exposures), and once you do, the HDR program will merge these raw or JPEG files.

The shortest route to HDR success, I've found, is to use your camera's autobracket feature and shoot in Aperture Priority mode. How many exposures do you need to shoot for a successful HDR exposure? That's determined by the contrast range of the scene before you. Make it a habit to meter both the highlights and shadows in a scene, and once you determine the difference in stops (for example, 3, 4, 5, and so on), shoot this number of stop brackets. In general on cloudy days, the difference in stops won't be much beyond 5, but for sure, on bright sunny days, especially around midday, the difference in stops can be upward of 11 or 13 depending on the overall subject. Generally, for

WHEN PHOTOMATIX OPENS, *click on the button marked Generate HDR Image in the first dialog box. A new window opens, and you can drag and drop your five, six, seven, eight, or nine bracketed exposures into the window, or simply click on the Browse button to locate the exposures you wish to process. Once you've selected your images, click OK.*

When the Generate HDR–Options dialog box opens, leave all the settings as they are (the defaults), and for now simply click OK. Then, depending on how many exposures you're combining and on the file sizes and format, wait a few minutes while the software does its thing.

AFTER A MODERATE WAIT, *you'll see a single image on your screen, and don't despair if you're not impressed! What you're looking at is an unprocessed image. You must now click on the Tone Mapping button.*

WITHIN SECONDS, *your HDR image is on the screen—immediately followed by your own oohs and aahs! Feel free to adjust the sliders in the box to the left of the image, if only to see how subtle changes can affect the overall image. The choice is yours, of course, in which changes (if any) you wish to apply, but when you feel you have the look you like, click the Process button at the bottom of the dialog box.*

scenes that are backlit or shot at high noon, the contrast range is often extreme. In these situations, I shoot seven 1-stop brackets. If it's a cloudy day (with or without the sky as part of your overall composition), shooting a minimum of three 1-stop brackets is often sufficient. Despite HDR's promise of perfect exposure, you'll quickly discover that some scenes you thought only required three 1-stop brackets needed far more, and scenes that you thought would require seven 1-stop brackets needed fewer.

It's important to stress that when I use the autobracket feature on my Nikon DSLR, I do so in Aperture Priority mode, and *at all times*, I still address the question of appropriate depth of field for the composition before me.

Once I answer that question, I choose the corresponding aperture, and the autobracketing is done with the shutter speed. For example, if the scene before me is a "Who cares?" composition, I set the aperture to *f*/8, and the camera, in autobracket mode, fires off seven full-stop brackets: *f*/8 at 1/125 sec., *f*/8 at 1/15 sec. (+3), *f*/8 at 1/30 sec. (+2), and *f*/8 at 1/60 sec. (+1); then *f*/8 at 1/1000 sec. (-3), *f*/8 at 1/500 sec. (-2), and finally *f*/8 at 1/250 sec. (-1).

It's important to note that a tripod is a *must*, since HDR photography is 100 percent dependent on all of the images lining up with one another. Trying to shoot HDR without a tripod makes about as much sense as playing pinochle with a fifty-two-card poker deck.

WHEN YOU'RE DONE *with any adjustments, click on Save As (in the File pull-down menu).*

ASSUMING YOU'RE PROCESSING *raw files, not JPEGs, choose TIFF 16-bit. Otherwise, choose JPEG.*

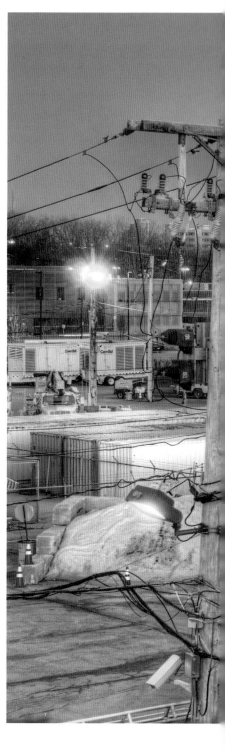

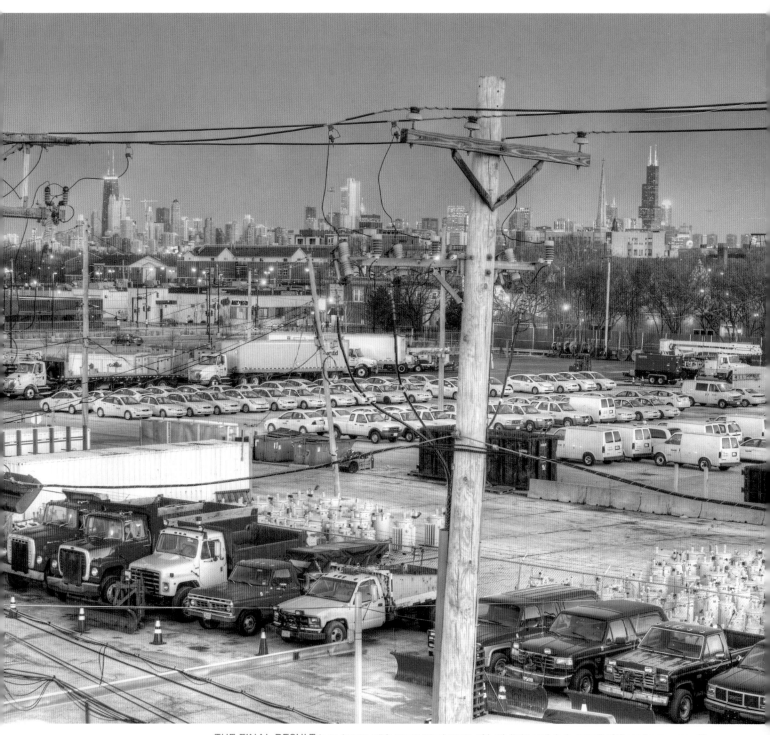

THE FINAL RESULT *is an image with a vast tonal range of both light and dark, yet all of these tones are well within the range of an acceptable exposure. This is one of those "impossible exposures," made possible only by the use of an HDR software program. In this case, I used the HDR software provided by wwwhdrsoft.com.*

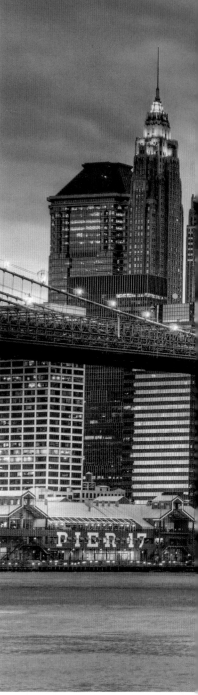

SHOOTING WITH YOUR TELEPHOTO LENS *during the first few minutes of sunrise or the last few minutes of sunset will undoubtedly produce a silhouette of any subject that's in front of the sun, unless you shoot no less than seven different exposures (+3 to -3) and combine them all into an HDR image.*

Such was the case when I shot this scene in Lyon, France, from the short hilltop near the Croix-Rousse. With my Nikon D2X and 70–200mm lens mounted on tripod, I set my aperture to f/32 for maximum depth of field (focusing one-third of the way into the scene with autofocus turned off) and was ready to shoot my seven exposures. Nikon and Canon both offer an autobracket feature, which I use every time I shoot for HDR exposures. It simplifies the whole bracketing process so that all you really have to do is press the shutter release (then autobracket fires off the seven different exposures). Get familiar with your camera's autobracket feature, as it's a real time-saver.

So in this case, my exposures ranged from f/32 for 1/15 sec. (+3) to f/32 for 1/1000 sec (-3). And after blending all seven exposures into the Photomatix program, this is what I got.

BACK IN 1983, *when I first shot the Manhattan skyline from what is now Brooklyn Bridge Park, the area was so rife with crime, that you literally were taking your life into your own hands when shooting there at dusk. Today, however, literally hundreds of photographers, myself included, visit this location and shoot with abandon in relative safety, even at dusk. It's a testament to how New York City has really cleaned up its act. On this particular evening there were no dusky blue skies but rather some really thick storm clouds. But with HDR, I've found that a cloudy sky is actually far more dramatic in the overall composition than a clear dusky blue sky, and for that reason, I was excited about the clouds overhead. As this image shows, the overall mood is something that looks right out of "Gotham City."*

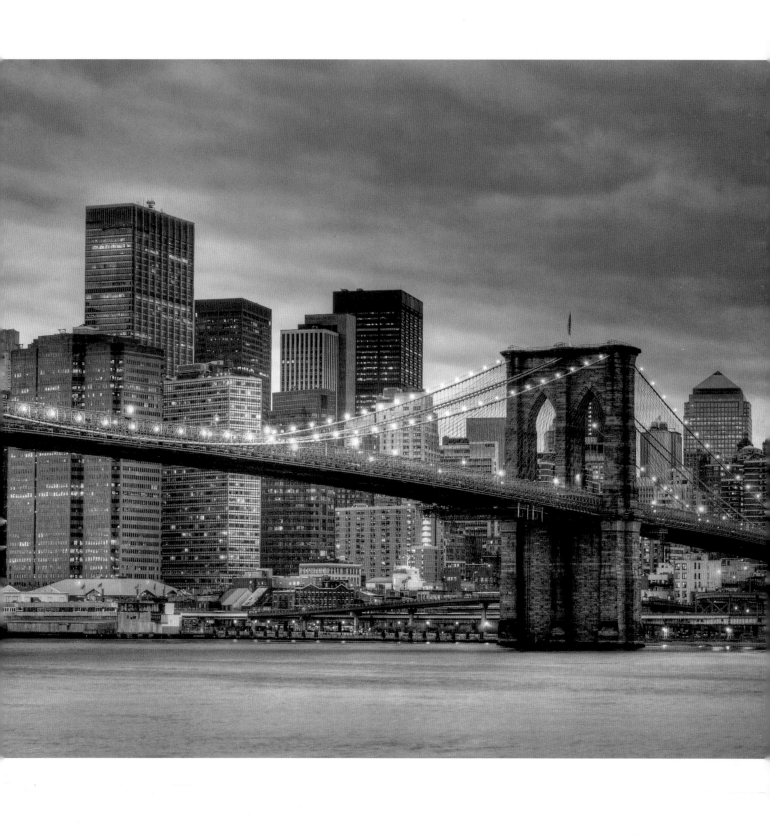

GHOSTING!

HDR & MOTION

HDR photography is, for the most part, limited to scenes without motion; however, I've learned that there are two types of motion-filled scenes that do quite well in HDR: One is a scene of traffic on a highway with the dusky city skyline in the background. Since the traffic "flows" in a repeated fashion, the combination of exposures will still allow for a nice blend of all five to seven—or even nine—images. The other is a waterfall, for the same reason: The motion is repeated in the same area on each exposure. On the other hand, if you shoot a busy street scene with pedestrians on the sidewalks, each exposure will not "line up," since the moving pedestrians *don't* show up in the same spot with each exposure; the resulting HDR image will show "ghosts" on your sidewalks.

IS IT POSSIBLE TO SHOOT *HDR images of motion-filled scenes? Yes, but it's critical that your motion is repetitive and occurring in the same place during all of your exposure brackets. People walking on the street or a chaotic intersection at dusk are not good examples of subjects with repetitive motion, but waterfalls and streams certainly are. These two images offer a good comparison of what doesn't work, what works, and why.*

The street scene below the El in Chicago shows an example of nonrepetitive motion and is filled with the "ghosts" of moving elements that did not align from one bracket exposure to the next. There are two solutions to avoiding the ghosting problem here: (1) Shoot the scene when pedestrians aren't present. Or (2) take out the cloning tool in Photoshop and do your best to get rid of the ghosts. Sure, you could just leave it as is, but that, of course, will invite the question "What are those ghostlike figures doing in your shot?"

By contrast, the stream at right, with its relatively uniform movement, is a more successful subject for HDR. As with the previous example, it was the result of 9 full-stop brackets, here from f/22 for 2 seconds (+4) to f/22 for 1/125 sec. (-4). I opted for 9 stops in this situation, due to the extreme exposure difference that existed between the highlights and the shadows.

Above: Nikon D300 with 12–24mm, f/22 for 1/4 sec. (+4) to f/22 for 1/1000 sec. (-4). Right: 12–24mm lens, f/22 for 2 seconds (+4) to f/22 for 1/125 sec. (-4)

Fill Flash

Those who know me, including readers who've bought many of my books over the years, are all too familiar with my disdain for the use of electronic flash. In fact, until recently, I didn't allow students in my on-location workshops to even speak the word *flash*, which to me represented an artificial approach to light. And I was hell-bent on shooting everything in its natural state, even if that meant shooting longer exposures or bypassing photo opportunities that required the use of flash.

To be clear, when I speak of *electronic flash*, I'm not referring to studio lighting and those wonderfully large flash heads that sit atop tall light stands; rather, I mean the rinky-dink *on-camera* strobes or those even more rinky-dink *built-in* strobes that were on many DSLRs and every digital point-and-shoot. Most of my experience with *studio* electronic flash has been very good, but I just couldn't embrace, let alone place any value on, those small on-camera electronic flashes.

Well, through a combination of technological advances and the plethora of insightful information on electronic flash that can be found on the World Wide Web, I must now confess that I'm a convert. I would even go so far as to say that I've embraced the small, handheld electronic flash with the same fervor with which I embraced available-light photography way back in 1970. I am once again seeing unlimited photographic possibilities, with no end in sight. It is, indeed, a great place to be!

Anyone can appreciate how very easy it is to take a correct exposure with the recent digital advances that have taken place in the form of matrix or evaluative metering. Of course, there's a *big* difference between a correct exposure and a creatively correct one, and the same is true when using electronic flash. Yes, today's electronic flashes will render a correct flash exposure most of the time, without the photographer having to do anything other than aim, focus, and shoot. But knowing where and when to use these highly sophisticated electronic flash units will go a long way toward not just recording a correct flash exposure but recording the far more compelling *creatively correct flash exposure*.

Perhaps the most common and helpful use for electronic flash is in the category of *fill flash*. Fill flash enables the photographer to illuminate areas in a scene that would otherwise be lost due to high contrast (the extreme range of light), when the camera cannot expose properly for both the light areas and the dark ones. It can brighten deep areas of darkness in a scene to balance out the exposure, improving the overall composition and also making possible exposures that would otherwise be impossible.

WHILE WALKING the streets of Chicago the other day, I couldn't help but notice that most everyone looked a bit glum, as we Chicagoans put up with a truly severe winter. To be fair to the many die-hard and loyal Chicagoans, though, the sun does actually shine at times, and one such day, I found myself in a local park shooting some tulips—Papa Tulip, Mama Tulip, and Baby Tulip, to be exact.

In my first attempt, opposite, you can clearly see what I often refer to as a "choppy" background. The stark contrast of sunlight and shadow creates the feeling of a road filled with potholes. These dark "potholes" are a bit jarring to the eye. The easiest solution is to call on flash to fill up those potholes with "sunlight"—the sunlight in this case being from my Nikon SB-900 flash. With the flash set up to fire remotely and on the through-the-lens (TTL) setting, I set the camera's self-timer to a ten-second delay and, during this delay, walked over to the tulips, pointing the flash into the background shrubs. When the shutter fired, so did the flash, and presto, the potholes were immediately filled, resulting in a much smoother composition.

Micro-Nikkor 200mm lens, ISO 200, f/9 for 1/200 sec.

MORE RAIN FELL ON CHICAGO *in the spring of 2009 than at any other time in history, which also meant that the skies were anything but blue. Not one to let weather get in the way, I would call on my Nikon SB-900 flash, using it to fill my foreground subjects with some dramatic light while severely underexposing my skies and background subjects.*

This image made in Millennium Park in downtown Chicago is an example of this. To start, I set up my camera and tripod right in front of some purple flowers lining a walkway. I then made the top image here to show how the scene looks when metered for the flowers (f/22 for 1/15 sec.); the sky goes "hot," or overexposed, since it was brighter than the flowers. You could correct this with a graduated ND filter, but I wanted a dramatic sky. So I metered for the sky, got f/22 for 1/60 sec., and then underexposed this reading by 2 stops to get to f/22 for 1/250 sec. (above). This deliberate underexposure rendered the flowers completely invisible, but it was definitely the exposure I wanted: a dark, foreboding sky and darker buildings than in the first exposure.

All that was left to do was fire up the Nikon SB-900, set it to the remote through-the-lens (TTL) setting, and, with my camera set to Commander mode, hold the flash at arm's length with my left hand while pointing it to the flowers. Voilà! A perfect TTL flash exposure of the flowers that maintained my dramatic underexposed background (right).

All photos: 12–24mm lens, f/22. Top: 1/15 sec. Above: 1/250 sec. Right: 1/250 sec. with flash

Ring Flash

It's called a ring flash, and depending on your eating habits, its shape may bring to mind a powdered donut or a bagel. There's much debate over the health benefits of donuts and bagels—and not surprisingly, the use of ring flash for shooting close-ups seems to be a subject of great debate amongst photographers. As for me, I don't eat donuts, but I do eat the occasional bagel (with cream cheese, of course), so it only makes sense that I would find myself using ring flash *occasionally*, too!

The ring flash is composed of two half-circle flash tubes embedded in a hard-shell plastic circular housing. This hard-shell housing threads onto the front of your lens, while the power source is mounted on the camera's hot shoe. The ring flash was originally invented by a dentist and meant for dental photography, but like most inventions, one thing led to another, and now the ring flash has even grown in size, upward of eight to ten inches in diameter (although this large size is normally found only in the studios of fashion photographers, where the use of a really large ring flash and its related shadowless look creates some really eye-popping fashion shots).

For our purposes, we're talking about the much smaller ring flash—about three to four inches in diameter. These are the ones for photographing both critters (bees, butterflies, dragonflies, caterpillars, and so on) and the flowers among which they live and feed.

The beauty of ring flash is that it provides even illumination—*shadowless*, in other words—and this is particularly important when shooting contrasty macro subjects, as the flash evenly illuminates the scene. Additionally, because the flash is literally "wrapped around" the front of the lens, it's amazingly close to the macro subject; this allows you to work with some really small apertures (f/16 to f/32), thus offering up some great depth of field. And the best part of all is that, since you're using flash, you will find yourself shooting at the fast flash sync shutter speed of at least 1/125 sec., if not 1/250 sec., depending on your camera. At these shutter speeds, who needs a tripod?!

And with today's incredibly sophisticated yet fully automated through-the-lens (TTL) flash metering, which is standard on most DSLRs, exposures are truly a snap! Just put the flash on the camera, set the flash to TTL mode, set the shutter speed to 1/250 sec., then choose your aperture, and fire away! It really is that easy. Sure, you may find that in some situations your flash is too powerful, but no problem: Power it down so that the flash output is reduced. (Consult the flash manual to learn just how easy this is.)

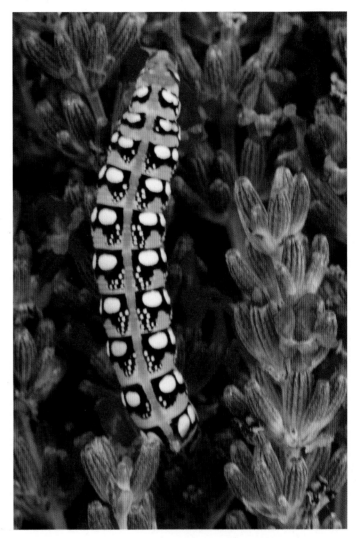

WHEN I STUMBLED ON *this caterpillar in the lavender fields of Provence, I did my best to record a natural-light handheld exposure (above). My tripod was back at the car, several hundred feet away, and I was in no mood to walk back and get it. Needless to say, handholding at this exposure proved to be futile, as it's obviously soft and blurry.*

I did, however, have in my bag my Sigma 140 ring flash, and soon I was recording the shot I was after: a sharply focused image of that same caterpillar. As you can clearly see, the flash took care of all of my lighting concerns, and I had no trouble handholding at 1/250 sec. (opposite).

Both photos: 105mm micro lens, ISO 200. Above: f/11 for 1/8 sec. Opposite: f/11 for 1/250 sec. with flash

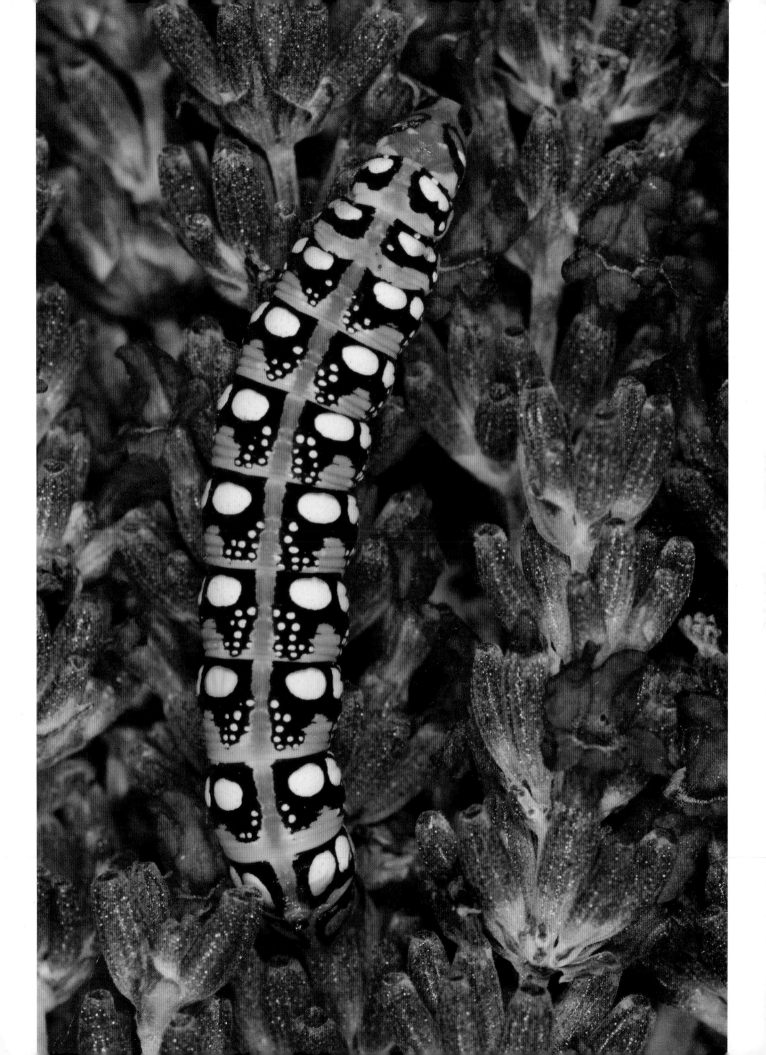

I'M NOT A BIG FAN of fake black backgrounds. Now I know I'll probably ruffle some feathers here, since it can easily be argued that my natural-light black backgrounds are also "fake" (as they're nothing more than severely underexposed areas of open shade behind the sunlit subject). But my argument has more to do with the quality of light on the main subject than on the black background itself. It's natural light that's lighting my subject here, not the "pure white" light of the flash. (Yes, you can use gels to warm the flash light, but that seems like a heck of a lot of work!)

So this example shows the use of natural light in combination with ring flash to get the black background. And I'd be remiss if I didn't share this with you, since you just might be one of those photographers who really like the underexposed backgrounds you can get when using ring flash in low natural light. Here I chose to isolate a single wood violet (indicated by the box at left). My first exposure at 1/4 sec. was all available light, and not surprisingly, I recorded an available-light exposure of the yellow flower and surrounding green foliage (below). Next, I mounted the ring flash, and with the shutter speed now set to the much faster flash sync speed of 1/250 sec., I was assured that the area around the flower would be black (because it was severely underexposed, since the flash output was limited to the flower).

Below: f/22 for 1/4 sec. Bottom: f/22 for 1/250 sec. with flash

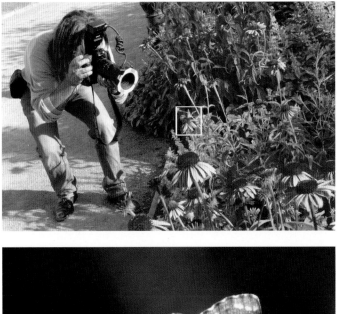

BACKLIGHT IS ANOTHER ONE *of those situations in which the use of ring flash can mean the difference between success or failure—and this applies to flowers and butterflies as well as to simple portraits of friends and family.*

As I turned the corner in one of the local parks, I came on what seemed like a convention of painted lady butterflies, who were all feasting on a number of purple coneflowers. The low-angled, late-afternoon backlight was doing what backlight is noted for: illuminating the butterfly wings and flower petals, making them appear to glow. But as you can see in the first example, this strong backlight also rendered those more solid areas of the composition (that were not as well lit) much too dark, at least for my personal taste (above left). After shooting only a few frames, I abandoned this approach, opting instead for my Sigma ring flash, and soon I was recording a better exposure, since the flash was now doing a nice job of "filling in" the darker areas that the available light could not (above right).

Both photos: 105mm micro lens, ISO 100. Left: f/11 for 1/80 sec. Right: f/11 for 1/160 sec.

Rear Curtain Sync

Rear curtain sync is a really simple idea to understand, and it goes like this: When you use your flash (whether it's an on-camera flash or a hand-held flash unit) set to its default setting, the flash fires at the *beginning* of the exposure. It is, for all intents and purposes, the *main* light source in your photo, and any other lights that might be on, or any other daylight that might be in the overall scene, will take a backseat (in terms of their exposure) to the flash exposure.

However, when the camera's flash is set to fire in *rear curtain sync* mode (called *second curtain sync* on Canon cameras), the flash won't fire until the *end* of the exposure. And the exposure times I'm referring to here last anywhere from 1/250 sec. down to minutes or even hours, depending on what you're shooting.

Do you have any ideas as to what kinds of fun and creative exposures you can achieve with this type of setup? If the many photo contest entries and student images I've reviewed over the years are any indication, the answer is "Probably not." Well, it's about time you get enlightened, pun intended! Look around you, and if it moves, it's a candidate for you to try your hand at rear curtain sync: Your son on his tricycle near dusk or your daughter caught in midair against a dusky blue sky while jumping on a trampoline are just two examples. Or for the really adventurous, set up your tripod in the backseat of your car pointed toward your car's instrument panel, and drive through a busy downtown area. Fire the camera at 1/2-sec. exposures, using a cable release with one hand as you drive with the other. Wow! A tack-sharp instrument panel with the "chaos" of streaking lights seen through the windshield. A shot like this will surely get you sympathy for your horrible commute!

A RAINY NIGHT *in New York's Times Square is not going to draw a crowd of photographers, since most amateur shooters are, first and foremost, concerned about getting their cameras wet and, subsequently, damaged. But most DSLR cameras today are weather-sealed, so don't let the rain get in your way! Any wet surface is like a blank mirror. Nearby neon, car, or traffic lights and storefronts have the chance of reflecting in this "mirror," and therein lies reason enough to go out and shoot these often unusual and colorful, more abstract images.*

Here, for example, you would stand on the sidewalk, await a passing bicyclist, engage your shoe-mounted or built-in electronic flash (set to rear curtain sync), and as the bicycle passes before you, you would pan to follow the motion. And voilà, you'd have the perfect exposure of the subject and the streaked effects behind him.

12–24mm lens at 18mm, ISO 400, f/8 for 1/8 sec.

Index